for Luvie + Stu

all best wishes,

and in memory of a very enjoyable
evening and your just - returned
trip to Rome.

from

Simon + Renée

1/10/98

THE ART OF

SIMON DINNERSTEIN

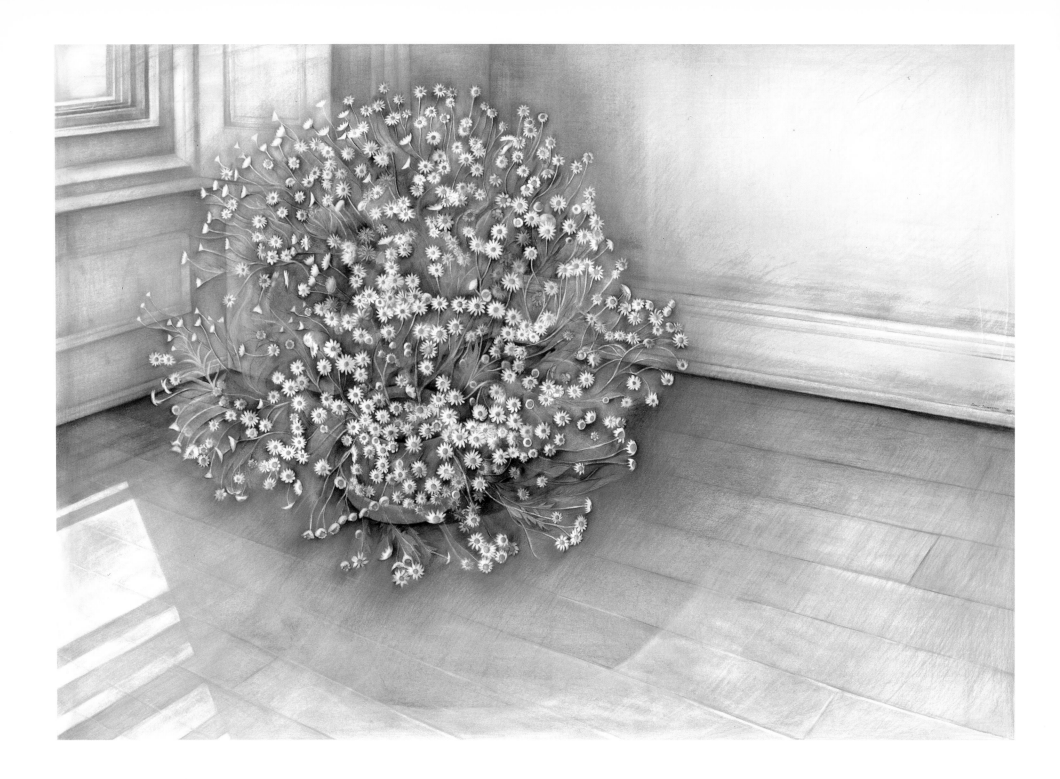

THE ART OF

SIMON DINNERSTEIN

Introduction by Albert Boime

Foreword by Thomas M. Messer

The University of Arkansas Press

Fayetteville · London · 1990

DESIGNER: Chiquita S. Babb
TYPEFACE: Janson
TYPESETTER: G & S Typesetters, Inc.

The paper used in this publication meets the minimum
requirements of the American National Standard for Permanence
of Paper for Printed Library Materials Z39.48-1984. ∞

LIBRARY OF CONGRESS CATALOGING-IN-PUBLICATION DATA

Dinnerstein, Simon, 1943–
 The art of Simon Dinnerstein / Simon Dinnerstein.
 p. cm.
 Includes bibliographical references.
 ISBN 1-55728-142-4 (alk. paper). — ISBN 1-55728-143-2
(pbk. : alk. paper)
 1. Dinnerstein, Simon, 1943– —Catalogs. I. Title.
N6537.D53A4 1990
760'.092—dc20 89-20625
 CIP

‹‹ *Frontispiece*
MID-SUMMER
1987
Conté crayon, colored pencil, pastel
36½″ × 51¼″
Myrna L. Lebov and George Delury

For Renée

And to the question which of
our worlds will then be the *world,*
there is no answer. For the answer
would have to be given in a language,
and a language must be rooted in some
collection of forms of life, and every
particular form of life could be other
than it is.

LUDWIG WITTGENSTEIN

Solitude
Grey and sweating
And only one I person
Fighting and fretting.

GLORIA MINTZ, *aged 13*

". . . Anything can happen; everything is possible
and probable. Time and space do not exist; on a
slight groundwork of reality, imagination spins
and weaves new patterns made up of memories,
experiences, unfettered fancies, absurdities and
improvisations.
The characters are split, double and multiply; they
evaporate, crystallise, scatter and converge.
But a single consciousness holds sway over them
all—that of the dreamer. . . ."

AUGUST STRINDBERG
A Dream Play

CONTENTS

FOREWORD

No one could accuse Simon Dinnerstein of being a fashionable artist. Not at the
time he began, not now, and not at any time in between. Leafing through the
catalogue of his mature work that now spans two decades, one is struck imme-
diately by his total disregard of prevailing taste, his apparent disinterest in the
visual arguments of advanced art circles, and, conversely, by his single-minded
concentration upon the development of a highly personal, creative pursuit. Well
before his thirtieth birthday, the young artist was already in possession of the tech-
nical means and the spiritual motivation that allowed him, in the late sixties, to set
out on a very lonely road toward assertion of his role. It was clear to him that it
had to be played outside of the enchanted circle within which current art and art
criticism was enclosed.

It is difficult therefore to find an appropriate stylistic designation for Dinner-
stein's contribution. He is a "realist" in the sense that intense observation, par-
ticularly in his earliest work, produced meticulous accounts of things, people, and
nature. He was obviously fascinated by objects strewn around the glum habita-
tions of proletarian surroundings. As with his portraiture of the same period, nar-
rative qualities predominate, but not to the exclusion of other aspects that could
be called "expressionist" if one wished to designate thereby a visible concern with
an inner reality that so visibly protrudes onto the smooth surfaces of his walls and
facades. This concern is also mirrored in the mercilessly detailed features of his
models. Likewise, in his rendition of flowers, trees, and botanical elements in
general, Dinnerstein's preoccupation with inwardness at times assumes an almost
magic intensity that approaches the category of "fantasy." And finally, the paint-
er's surfaces are so deliberately arranged, often with obsessive symmetry, and so

carefully calculated with respect to structural ratios, that the term "constructivist" also would come to mind were it not wholly preempted in art historical parlance by abstract imagery. It is evident, therefore, that Dinnerstein's dominant realism is significantly enriched by every principal departure in twentieth-century painting.

There is in the painter's development a discernible movement from dark to light, from an oppressive crowdedness to an unfolding ampleness, from the wholly particular to the somewhat more general, and from a relentlessly unbending truthfulness to a sense of flowing grace. Such a progression is not hampered, nor does it appear to be willed. On the contrary, the artist seems reluctant to shed the rawness of his youthful images, recalling them often in his later work as if to reassure himself of the validity of his point of departure. But he does arrive eventually at considerable effort, at flower still lives and renditions of exotic femininity in idealized surroundings that are far removed from the puritanism of his earlier mood. The joyful light that breaks, tentatively enough, through an undertone of menacing darkness may be seen as a gradual retreat from nightmarish pressures.

Comparable developments are not unknown in the history of art, nor is the artist unaware of that history. Within it, he is easier located and more at ease than in the more limited precincts of avantgardism. It will be of real interest to follow Simon Dinnerstein's art as it evolves further.

Thomas M. Messer
July 1989

Thomas M. Messer retired in 1988 as director of The Solomon R. Guggenheim Foundation and of its two museums in New York and Venice.

Simon Dinnerstein paints with a reverence for life that is rare. The radiance of his light can transform reality into a presence that is essential, mythic, and dreamlike.

George Tooker
July 1989

SIMON DINNERSTEIN'S FAMILY ROMANCE

I interviewed Simon Dinnerstein extensively in the week of August 9–13, 1989, and when we decided to call it quits I felt we had touched only the tip of the iceberg. For me, honed as I was on the construction of an art historical past that had no opportunity for rebuttal, having to confront a live specimen as a primary source—as if the subject of a recent book of mine, Van Gogh, could be reached by telephone—was fraught with complications. Nevertheless, Dinnerstein's openness and analytical mind finally put me at ease and yielded so much intelligence and information that I could convince myself that I had the makings of a case study of the relations—dare I even repeat the old formula?—between an artist's life and work. Hopefully, out of the welter of our exchanges and personal constructions there emerges a mosaic of some shared reality.

In many ways, Simon made it easy for me. His most audacious speculations always emanate from, and return to, a basic core idea that he recapitulates in his life and his art. Both in his everyday experience as spouse, father, and friend and in his cultural practice (what he might call his "visual diary"), he attests to a profound attachment to the people in his life and the immediate material environment in which his human relations unfold. He studies them intimately: the way they look, the way they feel, the way they interrelate. He draws them in tightly defined interiors, close-up and conscientiously, revealing all the lineaments of their existence. Some critics have called his pictures cruel in their ruthless exposure; I think this is an exaggerated general description of his work. What Dinnerstein does is to relentlessly particularize his subjects in their spaces until the macro and the micro become visually one. More often than not, he chooses models with strong personalities who do not flinch under intense scrutiny.

Dinnerstein's work is full of ambiguity and never lends itself to easy labels. But his close scrutiny and claustrophobic environments consistently draw the beholder in close to share in his lifestyle. The centering of the family affection and the links to the rest of the world through this centering becomes an ecumenical mission, as if Dinnerstein wants to draw the whole world into this family center. Thus the family mediates the world for Dinnerstein, but the family on its own terms. This public exposure of his intimate life is meant to "show people that they might get in touch with something in themselves that is deeply and even painfully private." What each of us experiences and suffers in isolation is often the result of conditions—physical and environmental—that are generic to the species. Dinnerstein's awareness of this paradox and need to share it is central to his visual thematics.

This attitude is surely related to the impact of his father on Dinnerstein's intellectual and psychological development. Louis Dinnerstein was an ardent union organizer and committed leftist preoccupied with the social injustices in the United States. Dinnerstein remembers him as somewhat dogmatic, having a single solution for the world's ills and pushing it home at every opportunity. This brand of engaged politics left Simon cold and dissuaded him from following in his father's footsteps: on the contrary, he determined to avoid universal, generalized solutions and instead to satisfy himself with things that were near at hand and manageable, things that he could really change or influence.

Simon observed the despair and the anger and frustration of his father. While Louis Dinnerstein was absorbed in ideas and political solutions, his domestic life fell into disarray. Louis subjected his wife, Sarah, "a very dreamy kind of person," to verbal abuse and intimidation. In reaction, Simon rejected his father's public posture to privilege the world within his jurisdiction, to construct a world he could govern. Instead of trying to remake the conditions of civil society, he shapes a harmonious domestic center around which the family, friends, and neighbors orbit. As against the father, Simon elevates the family space to highest priority and relegates the world problems to the periphery.

In this sense, Simon is a red-diaper baby—a child of a radical parent—who switched to Pampers. Like many of his generation, he was more critical of the failings of the Old Left and New Left than of the recalcitrant and conservative sectors of U.S. society that opposed them. He renounced the Left's global mission as a solution to society's ills, but guarded their social concern for the wider population and their milieu. His work is not only meant to be accessible to a broad audience, but his subjects are drawn from domestic surroundings and local neighborhoods. His range of subjects embraces his pregnant wife, their extended families, an alienated Polish refugee, a childlike and awkward uncle, a meditative black

female student from the West Indies, a reclusive German tenant, and ordinary objects in his home and studio. But if he keeps within a range of experience that was the focus of his father's social concerns, he does not portray it in overtly political terms. His subjects are not the oppressed proletariat, but psychological creations defined by their relationship to his interior, domestic realm. In other words, he does not go out into the world to preach, but rather he strains the world through the sieve of his family circle. Put another way, he curbs his anxieties about the Other by bringing the Other into his life where it may be subject to dominion. Under these circumstances his subjects may enjoy a degree of freedom, humanization, and love denied them in the politicized exterior world. The harshness of his scrutiny then becomes a litmus test of his realism—a realism that feeds back his measure of control.

p. 128

He is equally harsh on himself. His self-portrait, nude from the waist up, betrays a curious expression. Like most self-portraits, it was done by looking at a mirror, but in its finished state it looks out at the beholder. The quizzical look seems to address the beholder as a kind of superego, a surrogate father that says, "Who do you think you are?" A child, aware of parents watching, acts momentarily on his or her best behavior to gain approval. The parent, knowing full well that this is a momentary state related to the surveillance, addresses the child with the answer, "I know who you are and what you are about"—an attitude that persists and becomes part of the challenge to the child's sense of self. Thus the realism of this work presupposes a firm grip on the artist's response to the question: "Who do you think you are?" The artist can allow himself this degree of realistic self-questioning, since he is confident that he possesses the means to respond affirmatively. Dinnerstein's world is subject to this control that begins tentatively and gradually tightens; everything is inevitably marshaled to insure an accurate response. And it is accurate, and can be accurate, within the limited boundaries he sets for himself.

pp. 60–69

His major works, starting with *The Fulbright Triptych*, confirm this hypothesis. His by now legendary bulletin board (really, a storyboard) is filled with items rendered with the meticulous and trompe l'oeil perfection of a Harnett or a Peto. Every autobiographical incident or detail is treated with an unwavering gaze. Here he takes his studio as the center of affection and attraction, with himself, his wife, and child grouped around the work table. It is an unusual painting, and at first sight I kept wondering how it could be so effective with all of its quirkiness and eccentricities. For all of its complexities, however, he conceived of the image as a whole from the start and carried it out without preliminary studies—an image that burned itself into his eidetic memory. Even the wry title contributes to the strange aura of the picture by being both an echo of the past and a statement about

modern artistic patronage: in the Renaissance such a picture would have been named for an individual patron or donor, while contemporary patronage takes the form of institutional grants and prizes that provide a major source of support for the artist. It was while he was studying in Germany with the aid of a Fulbright grant that Dinnerstein began the painting.

Thus the work maps out the autobiography of the artist while under obligation to the Fulbright grant, the enabler of his ambitious enterprise. He received the grant to study printmaking at the Hochschule für Bildende Kunst in Kassel, and in a sense the work pays homage to both the grant and the craft of the print-maker. The entire central panel is built around the table with its clinical organization of the tools of the graphic designer and an engraved copper plate in the center. Thus for his first major painting, Dinnerstein opted to represent a taxonomic chart of the printmaker's profession, an understandably cautious theme for an ambitious first picture. I would call this ironic and sometimes whimsical work "The Taxonomy Lesson of Dr. Dinnerstein." Yet despite its obvious didacticism and cautious thematics, it is spellbindingly intense: a paradox that is a hallmark of the artist's total production.

The painting's energy derives in part from the intrinsic rebelliousness of the project. Dinnerstein was awarded the Fulbright on the basis of a proposal having to do with a printmaking project, and in the end the most important work he did with it ran counter to the proposal. Dinnerstein refused to be stifled by either the stipulation of the grant or his own initial proposal.

As a result, the work was steeped in paradox and ambiguity from the start. It is the story of the graphic designer in paint, as if printmaking itself was incapable of telling this story. Simon, however, refused to capitulate to the academic "hierarchy of modes" before wresting certain concessions from it: the pigment must humble itself to the meticulous replication of the scrawls of preschoolers as well as other crude marks and gestures traditionally alien to it, and it must faithfully delineate kitschy reproductive images. Hence alongside of the figural and landscape signifiers of high art we find the child's crayola sketches, printed texts, magazine, tabloid, and post card reproductions, and the cheap subway mug shot obtained in those fast-disappearing booths that once yielded for a modest price candid photos for passport and wallet. These were not only painstakingly but also painfully duplicated in a recalcitrant medium. It is this struggle between his awareness of the traditional importance of the paint medium and his intrinsic love of the graphic media that is played out in this visual scenario and keeps it from lapsing into genre. He paradoxically elevated the status of his own printmaking experiments to the level of high art that succeeds only on the condition that it too can be transformed into a reproducible object and tacked on to someone's bulletin

board. In this sense, it overcomes the loss of high art aura from reproduction by recreating a "lower" level aura through its own fascinating reproductive properties. It resembles a monumentalized projection of those old newspaper comics with built-in incongruities that asked, "What's Wrong With This Picture?"

Thus, on a deeper level, this collage-like depiction of self-identity is a personal view of the history and nature of perception. The clue to this aspect of the work is the paraphrased quote from the writings of Ludwig Wittgenstein, pasted between the two windows just above the table in the central panel: "And to the question which of our worlds will then be *the* world, there is no answer. For the answer would have to be given in a language, and a language must be rooted in some collection of forms of life, and every particular form of life could be other than it is." The key to Wittgenstein's thought is the emphasized article "the" before the word "world" that suggests the futility of establishing *the* reality. Reality then becomes at any given time the relativized conception of the extent to which our particular "forms of life"—language and therefore ideology as well— delimit our soundings of what's out there in the void.

Hence the reflective Dinnerstein-Wittgenstein persona could hardly take itself seriously within the bounds of its quest for *the* reality. Just as the artist forces high art to come to terms with children's art, he also juxtaposes the text of the philosophical sage with the haiku-like poem of a thirteen-year-old pupil named Gloria Mintz whom Dinnerstein taught at an orthodox girl's yeshiva in Brooklyn: "Solitude / Grey and sweating / And only one I person / Fighting and fretting." Here is precocious recognition that the quest to make existence rational and meaningful in modern society through fixing *the* reality is in itself a subjective solution taking place in isolation. Dinnerstein accepts this as a given, and thus takes as his starting point the personal lens of family (the extension of himself) and its environment.

The Wittgenstein quote forms part of a series of three objects including an aérogramme letter from Dinnerstein's wife Renée (then visiting her parents in the States) and an old broken stopwatch upended on the worktable whose face depicted a male sprinter. The aérogramme's front has the return address of Staten Island and the Dinnerstein address in Hessisch Lichtenau, and, together with the stopwatch, comments on the heightened awareness of the vagaries of space and time in the modern world. Additionally, Renée's letter to Simon describes a bizarre dream about childbirth that involved both their mothers. The reference here to another state of consciousness that seemed "real" at the time amplifies the epistemological issues raised in the painting.

The broken stopwatch suggests that the painting is an attempt to "freeze" or "catch" a moment in space and time, a metaphor that Dinnerstein employs often

in describing his particular realist approach. He imagines himself as a kind of butterfly collector trying to nail the subject in flight. Yet Dinnerstein's trail rarely leads beyond his home or studio interior, so that the specimens he gathers in his net are neither exotic nor rare but those in his own backyard. Within these confines he sees every detail with an obsessive evenness so that, initially at least, the viewer seems to confront a rigorously controlled space seen close-up. In the case of *The Fulbright Triptych*, where the view extends beyond the studio to embrace part of the town of Hessisch Lichtenau (here framed by the windows like two more pictures on the wall and mediated by the perspective of the working table), Dinnerstein deals with the contradictory all-over emphasis by having recourse to his delightful metaphor of the "floating eyeball." He paints as if his eyeball could detach itself from his head and float over the areas beyond his immediate sight and return with the immediately concealed visual information. This is a conceit rooted in childhood fantasy, but it does reveal a good deal of Dinnerstein's desire for a kind of omniscient presence in his own backyard that is the yardstick of his reality.

The voyeuristic impulse is central to both the making and viewing of art. The beholder in the first instance is the painter, in the second it is the public onlooker. Thus the painter makes public that which was private and the audience becomes complicit in this act of exposure. Dinnerstein's awareness of this dynamic in his own work comes through in an astonishing childhood recollection that he revealed to me in the course of our interview in August 1989. It occurred to him *pp. 199–201* recently while he was drawing a nude female model (*Dream Palace*), and they discussed their earliest fantasies of their possible futures. Dinnerstein then recalled that the first time he had a "vision" of himself was when he was about four years old. He was alone in the apartment and seated on his parents' bed, when he had the sensation of floating outside of his body and looking down on himself from the ceiling. He remembers thinking something like this: "Boy, this is amazing! This is what it feels like to lie on my parents' bed." Then he floated all around the room, taking account of how the dresser, the drawers, and the window shades looked, as if seeing them objectively for the first time. By the time he floated back into his head, Dinnerstein knew that he "wanted to do something with my life that was the equivalent of that."

Henceforth Dinnerstein committed himself to being an observer, someone who is able to see oneself and others "in situations." While explaining the curious detachment of his visual practice, his childhood fantasy is also a wonderful modern parable of the origin of art, updating the fabulous accounts recorded by Pliny. According to Freud, about the time our nascent sexuality reaches its first peak, between the ages of three and five, we begin to indicate signs of the activity that

"may be ascribed to the instinct for knowledge or research." This activity corresponds on the one hand to the sublimated need to obtain mastery over the environment, while on the other it is impelled by the energy of scopophilia. Its relations to sexual life are of fundamental importance since curiosity in children and the quest for knowledge are inevitably linked to sexual drive. What Freud calls "the riddle of the sphinx"—the nagging question of birth—is a vivid memory of many people during the prepubescent period. Although children cannot make the direct connection between the sexual act and having children, they develop an interest in sexual relations in order to unravel the mystery of marriage itself and discover their role in the process. This early childhood research is always carried out in solitude. At this point, the child takes a crucial first step of independence and displays a high degree of detachment from both parents and surroundings.

Thus it is probably not a coincidence that Dinnerstein's experience occurred in the parental bedroom when mother and father were absent. The "floating eyeball" emancipates sight from walled-off ignorance enabling the child to uncover the mysteries and hidden objects on the forbidden side of closed doors, concealed in dresser drawers and behind drawn window shades. (Simon spent many of his lonely childhood hours gazing out of windows, and the window became a fundamental metaphor for his work. Not surprisingly, a favorite movie is Alfred Hitchcock's *Rear Window*.) The discovery of the private realm of the parents, the wish to be able to gaze unflinchingly into all of its labyrinthine manifestations, must be an integral psychic component of Dinnerstein's quest for self-discovery.

Dinnerstein noted in our interview that at the time he recounted his childhood memory to the model, her expression had something "dreamy" and "vulnerable" about it. These are precisely the terms that he used throughout our interview to characterize his mother, whom he credits for his own creative disposition. Indeed, he often seeks in his female models precisely this sort of expression that resonates with his memories of his mother. (These very often are sexually charged expressions that produce a type of oedipal displacement that may be also signaled in the reproduction of Larry Clark's erotic photograph of "Teenage Lust" that appears on Simon's side of *The Fulbright Triptych*.) Although this look coincides with a traditional patriarchal attitude, Dinnerstein also gives his male figures a similar mood of reverie and pensiveness. Thus this particular expression, and the mystery of it associated with his mother, may have triggered the childhood associations that led him directly to the parental bedroom.

The most cursory examination of *The Fulbright Triptych* reveals that the maternal and domestic theme is central to a number of the images affixed to the walls of the studio: the Virgin Mary, Madonna and Child, Pietà, primitive fertility figure, a paternal surrogate for a mother (described as "warm, melancholy, and

tender") with his daughter, a reproduction of Seurat's mother sewing (according to Dinnerstein, Seurat rendered it with "lots of mystery and expression for his mother"), a domestic scene by the artist's brother, Harvey Dinnerstein, entitled *In the Kitchen*, a Käthe Kollwitz portrait that resembles Dinnerstein's mother, and the critical left panel depicting his wife holding their infant daughter. Hence this first attempt is inextricably linked with the Mother image and the domesticated environment, a visual manifesto that sets the direction for Dinnerstein's subsequent production.

There is a starkness and alienation in this studio space so clinically arranged and artfully prepared. Renée and Simon occupy the left and right panels, gazing at us out of their extreme isolation. This quarantined look of the space speaks in part to the curious status of the Dinnersteins: American Jews, residing on their Fulbright in the Protestant German town, Hessisch Lichtenau, just outside Kassel. One photo on the wall of the panel representing the artist shows a despairing figure confined to a cell-like interior. It reminded Dinnerstein of the scene in Camus's *The Stranger* in which the protagonist is incarcerated and feels his world rapidly shrinking and consoles himself by investigating his ever-diminishing and restricted space. The Dinnersteins' provisional standing and sense of confinement is demonstrated in part by the need to fix their self-identity so insistently through the bulletin board motif, and to invent their own environment within the unfamiliar geographical and topographical entity. On the wall just behind and to the right of Simon's head is a Soviet émigré's passport (Dinnerstein's mother was a Russian immigrant, as were his paternal grandparents), metonymically pointing to the conditional and relative nature of national identity. Again, this sense of identity is filtered through his maternal side: the artist claimed that the document reminded him somewhat "of a passport photo of my mother." In a sense, Dinnerstein has sought to create a sympathetic Motherland within the alien Fatherland.

It is through the mediation of this reinvented space that we are allowed a glimpse of the outlying town. The sides of the neatly organized table are extended outside by the edges of the main street, leading us along a residential row of compact houses and gardens as tidy as the arrangement in the studio interior. The one-point perspectival scheme that orders the composition leads ultimately to the hills on the distant horizon, finally asserting in metaphorical terms the Dinnersteins' place in this domain. But the view out remains rigorously controlled by the two windows that subordinate it to the exigencies of the bulletin-board motif, in effect transforming it into another collage component.

The stringent organization of the composition is part of the artist's acknowledged contradictory attempt to grasp the data of everyday phenomena through a

personalized construction. The broken stopwatch in effect is the mocking metaphor for the desire to "slow down" and "stop" reality in order to pin it down on the pictorial surface. The conscientious arrangement of the engraver's burins, burnishers, scrapers, and measuring instruments pointing toward the outside world signifies the imagined potential of human artifice to objectify the surrounding reality. The centerpiece of the table is the oval copper plate, which has a landscape design inscribed in reverse of the actual print. Seen up close, the brickwork and foliage engraved on the plate with the burin are clearly visible, thus creating an equivalency with the phenomenal world as depicted in the picture (though lacking color) and submitting it to the dominion of the printmaker. Thus reality in this crazy quilt tapestry becomes a multilayered texture of images woven within images.

The appearance of Flemish and Northern Renaissance clippings on the wall clues us in to the kind of obsessional quality Dinnerstein admires in the work of other artists, from Van Eyck to George Tooker. (He satirizes his own obsessive impulses in a passage from *Moby Dick* tacked on his side of the wall, quoting an exchange between Ahab and Starbuck.) His methodical replication of reproductions of works by Rogier van der Weyden, Hans Holbein, Jean Fouquet, as well as more modern painters such as Jean-Dominique-Auguste Ingres, Georges Seurat, and Edwin Dickinson pay homage to his idols but also serves to measure his own performance and ability to "see" against their own. Thus his self-identity asserts itself in this embrace of the history of art that forms as significant a part of the environmental texture as the town outside. Indeed, his own meticulous rendering of his studio space attests to his wished-for position in this history at an insecure moment of his career.

Part of *The Fulbright Triptych*'s power attains through the hermetic representation of commonplace subject matter. I found it challenging to reconcile what comes off to me as a medieval or Renaissance allegory with the excessive familiarity of the motifs. The accessibility of the persons and things is contrasted with the remoteness of the space and its clinical rendering. This ambiguity rescues the work from anecdotal genre.

Yet if it is the evocative character of the commonplace that empowers the painting, it achieves this at the expense of topicality. The arrangement of the familiar in the guise of tradition suggests the deliberate effacement of the topical. Except for the image of a photograph of two men clipped from the *New York Times* that addressed the issue of mistaken identity in a controversial rape case (thus relating to the work's basic theme of perception), little in the picture points to an awareness of the burning political topics of the day. This is all the more surprising when we recall that the picture dates from the period 1971–74, a critical stage in the

war in Vietnam. Dinnerstein's sympathies were clearly on the side of social justice, and he continues to oppose the jingoist and nationalist expressions of the Right. He had participated in protest demonstrations (including the Civil Rights March on Washington in 1963) and did everything possible to get himself exempted from the draft. Furthermore, his own rejecting of nonrepresentation and involvement in figuration shares the cultural ideals of those turbulent years when the need to communicate with the broadest possible audience became an imperative for the generation of the sixties.

But at the peak of the Vietnam and Civil Rights period he grew disenchanted with the public process. At this moment, the anxieties he inherited from his paternal side predisposed him to be suspicious of what could be accomplished by protest. (His own investigations reveal that consolidation of the national wealth increased dramatically during the decade, as if to hint that the wealthy elite encouraged protest as a diversion from their own power play.) He articulates his fear of the rhetoric and sloganeering of groups and movements that espouse drastic change achieved through collective action by an expressed horror of a certain kind of extreme "idealism," the idealism that leads to the creation of exclusionary fraternities such as the Ku Klux Klan and the Nazis. Here he rationalizes his position by assuming the pose of the skeptic and realist; indeed, distrust of idealism he interprets as the only sensible form of modern realism. The misplaced idealism and what he felt to be its shallow rhetoric he associated with the political posture of his father, whose dogmatic public role prevented him from maintaining a rational private world. Hence Simon's commitment to the private as against the public: the desire, whether conscious or unconscious, to succeed in that realm where his father had failed. His self-identity had to be mediated through the narrower world of the family rather than through public demonstration. At the same time, Simon brought all the instruments at his disposal to depict this intimate private life with the scientist's objectivity, as if to lay bare its dynamics for systematic analysis. As in the case of Camus's protagonist, Dinnerstein focused on the walls around him in proportion to the receding of the public world.

If Simon's work shuts out his world from this kind of topicality, it is nonetheless modern in its presentation of the tension between the private and the public realms and in its deadpan representation of the familiar. (In this he shares the qualities of the painters he most admires, George Tooker, Lucian Freud, and Antonio López García who unite the grand figurative tradition with the contemporary commonplace.) Above all, he is modern in his openness to other visual media—film, photography, and television—that have decisively affected his mode of seeing. Throughout our interview Dinnerstein returned again and again to the influence of Ingmar Bergman on his work. Dinnerstein has viewed the Swedish

director's films many times over since he first encountered them in the mid-1960s, and he is especially fascinated by the filmmaker's investigation of various levels of self-identification, the intermingling of complementary viewpoints within one identity, and the fusion of dream and reality as a part of identity.

The double portrait of himself and his daughter, in which the two are shown in a half-length view close up to one another but moving in opposite directions, exemplifies the Bergmanesque influence of such films as *Persona* (1966). Dinnerstein and his daughter occupy the same shallow space, with their heads drawn up tightly together akin to the colossal double close-ups of Bergman's optical field, while preoccupied with their personal thoughts. Within the domestic foyer Dinnerstein visually unites father and daughter, but also emphasizes their divergent orientations. This convergence and divergence of the two generations may be seen as analogous to the theme of splitting and fusion in Bergman's film.

Dinnerstein's fascination with the tension between and the intermingling of identities, as well as his fascination with the ambiguous space between the dream and waking states, is explored further in the monumental drawing, *A Dream Play*. As in *The Fulbright Triptych*, the artist has located himself and his wife and daughter at either end of the picture to frame the central action that in turns links them like two ends of a Japanese scroll unfurling across time and space. The panoramic ensemble depicts members of the Dinnersteins' extended family entering and exiting in dream, rather than real, time. Thus deceased ancestors mingle with the living, and the living are seen in multiple stages of youth and adulthood. Renée Dinnerstein is glimpsed not only as a mother watching over her daughter, Simone, but appears also as a child of nine years when she bore a remarkable resemblance to the daughter. Dinnerstein depicts himself at the far left at his drawing table recalling the self-references of Velázquez and Goya in their royal group portraits. In this case, however, the subject is his own family and leaves no doubt that he is the choreographer of this Dance of Life and Death. He alone is conscious and aware—the "dreamer" who sets the dream play into motion as he "narrates" the text of his extended self-portrait.

The motif of the artist taking over the main narrative function was inspired by a newspaper photograph of Iranian pilgrims. An unveiled matriarch wearing black in the immediate foreground plane addresses the viewer-photographer, while the other figures are self-absorbed in the background. Her full, intelligent face is brightly lit, while the background tourists move almost trancelike in the murky shadows. As a kind of mediator between the beholder and the pictured crowd, she functions as interlocutor and chronicler of events. Perhaps it is significant that a maternal image sparked the germinal idea of the familial *A Dream Play*.

The title was suggested by August Strindberg's drama of the same name, which

pp. 194–97

a friend recommended to Dinnerstein after hearing his explanation of the subject. Strindberg's "Note" at the beginning of the play states: ". . . the Author has sought to reproduce the disconnected but apparently logical form of a dream. Anything can happen; everything is possible and probable. Time and space do not exist. . . . The characters are split, double, and multiply; they evaporate, crystallise, scatter and converge. But a single consciousness holds sway over them all—that of the dreamer. For him there are no secrets, no incongruities, no scruples and no law."

The bizarre coincidence of Dinnerstein's design and Strindberg's conception took an even eerier turn when, in the course of executing the elaborate drawing, Dinnerstein watched a televised showing of Bergman's last film, *Fanny and Alexander* (1979), which itself merges dream and reality in a frankly autobiographical work. As the last scene fades, the screen blacks out, and what appears is the quotation cited above from Strindberg's play read by Helena, the family matriarch (in voice-over). Since the source of the quote was not cited, Dinnerstein experienced an uncanny sensation of *déjà vu*. Bergman's picture (one that Dinnerstein has viewed several times), in fact, was deeply influenced by Strindberg's play, and the filmmaker staged the play for the theater several times in his career. He uses the play in the last scene as a pretext for reconciling the generations through the participation of the grandmother and daughter-in-law ("There are parts for both of us") on a plane that blurs the boundaries of theater, dream, and actuality.

Both the play and the film stress the dreamlike state of earthly existence and the burden of the past that weighs on the minds of the living. Dinnerstein was especially struck by the scene near the climax of the film when the ghost of the recently deceased stepfather rudely reminds Alexander that he will not be rid of him so easily. The anxieties of his own childhood continue to haunt Dinnerstein as he depicts the memory traces of the associative sights and sounds of the past hovering behind the claustrophobic familial procession. A prolonged row of squalid brownstones marches across the distant horizon like an elevated subway, reminiscent of a long horizontal tracking shot in film that suggests time unfolding.

Dinnerstein's realism grows out of his sense of a kind of foreordained trajectory that each individual existence must follow, and *A Dream Play* creates his own world of necessity through kinship, class background, and environment. The psychological vectors of mother and father that shape the personality for further encounters are rhythmically choreographed across the surface. Acceptance of, and facing up to, this "fatalistic" view of existence implies a strategic form of modern realism. Dinnerstein relentlessly depicts his motifs with the documentary quality of old passport photos and amateur snapshots, achieving a montage of the family

photograph album. As a result, he establishes a persuasive matrix that predisposes us to accept improbable juxtapositions and anachronisms.

Dinnerstein's sense of predestination does not mean that one must yield wholly to blind destiny: in dreams positive images arise that alert the dreamers to those personalities who may play a beneficial role in their lives. As he stated in our interview: "If one truly believes in fate . . . then you dream in your dreams of the person that you will be linked up with; you don't need to search for that person— you just dream of that person; when that person comes along they fulfill what they match in the dream you've had. There's something very beautiful in that." This implies to me that Dinnerstein feels that he can control his own fate through the recreation in another medium of mental images.

A Dream Play's atmosphere suggests a loosening of the stringent gaze that marked *The Fulbright Triptych*. In addition to opening his art to the possibility of representing other states of being, this change also coincides with a shift in thematics beyond the nuclear family to extended kinship associations. Dinnerstein examines the historic strengths of the extended family: the respect for one's elders (here indicating a more tolerant attitude towards his father), the communal nurturing of children, and the labor of parents to guarantee their children the fulfillment of their creative potential. Allowing for the indirectness of Simon's visual construction that tends to prevent the work from lapsing into outright didacticism, we may perceive that the work's content stresses relations in its various forms: sexual, parental, filial, brotherly, and by extension social and political relations. By the 1980s even the militant Left had caught up to Dinnerstein's position and abandoned an exclusively economic-oriented program in favor of a profamily analysis. In *A Dream Play*, Dinnerstein has added a vignette of two African-American children gazing out of a window into the Brownsville street, a motif inspired by a *Life* magazine photo. The vignette is placed just above the portraits of himself and his brother and father to the left. Albeit a personal allusion to Dinnerstein's own daydreaming propensities as a child, its incorporation here evokes another side of family life in America. (This would not be the first time that Dinnerstein situated desolate individuals near windows as symbolic of their isolation; another example is *Nocturne* [1982] that depicts a displaced Polish refugee suffering from his sense of being "alien" in a foreign land.)

p. 133

The year before he began the picture Dinnerstein organized an exhibition of his work at Gallery 1199 in the Martin Luther King Jr. Labor Center, New York City. The gallery is named for the adjacent Hospital and Health Care Employees Union, local 1199. The artist's father, Louis Dinnerstein (who appears twice in *A Dream Play*), had been an active member of this organization during its stormy period in the sixties and seventies when issues of civil rights and black partici-

pation dominated the agenda. Older members of the union recalled that Louis had energetically agitated on behalf of gaining a fairer proportion of African-Americans (the majority of the union's membership was black) among the leadership. Dinnerstein, in a gesture that indicated a greater awareness of his father's role in his choice of career, proudly dedicated the exhibition to the elder's memory, "an ardent supporter of 1199 and a man who followed his deep convictions."

p. 179

It is no coincidence that the subject of three of Dinnerstein's most important recent works in the Gallery 1199 exhibition was a young black woman named Cheryl Yorke. She modeled for *In Sleep*, the work reproduced on the exhibition's flyer that carried the dedication on the verso. Yorke had been a student of the artist at New York City Technical College and profoundly impressed him with her "inner peace and depth" and her "extraordinary outer, formal beauty." The third work in the series, the one that provoked the most comments, depicted her asleep and dreaming. At first glance, the work presents the viewer with the Western stereotype of the exotic languid woman, vulnerable and exposed to the patriarchal male gaze. Dinnerstein, however, plays with the stereotype in wanting to represent the model "in her fullness"—including the "baggage" of the past that she carries into the present. Above her reclining form Dinnerstein repeated the model in an interwoven chain of recumbent poses that almost cinematically trace her bodily shifts in sleep. These less conventional postures—such as one on the right in which she cups her chin in her hand while hunching her shoulders forward—reach beyond the Gauguin-like cliché of the native woman. In the zone directly above the garland of sleeping poses, Dinnerstein inserted representations of the model's childhood memories of her homeland, the island of Saint Vincent in the Caribbean Sea. On one end of the panorama is a portrait of her father as a youth, while at the other are snapshot vignettes of herself alone and one showing her together with her mother and sister. Just left of the father's image is a scene of the construction of the family dwelling with the help of the extended family and friends. Thus the intricate dream imagery evokes multiple associative memories of the communal experiences on the island of Saint Vincent, building on the motif of the *Nocturne* and anticipating *Night* and *A Dream Play*.

There was a good deal of comment regarding *In Sleep*, with contradictory interpretations offered depending on the point of view of the spectator, "from plantation scene to migrant workers, to William Blake and Gothic entombments, to Caribbean mysticism and Mexican realism," according to the artist. One black woman wrote emphatically in the visitor's book, "Unfortunate Reality of Our Past, Hopefully not Our Future," while a white woman commented that the woman is "asleep like her people are asleep." Dinnerstein was surprised by the variations of these interpretations from his own "vision" (no artist can predict the reception of work

because, like the weather, the political climate changes constantly), but clearly he and the model are partly responsible for these reactions. One of the vignettes in the zone of reverie portrays a group of workers cutting and harvesting sugar cane, a scene the model remembered as common when she was growing up. Although blacks on the island (who constituted the majority of the population) would have been wage laborers at that time, the rising stalks in the background are metaphorically inseparable from the history of slavery in the West Indies. The reason that Africans were wrenched from their homeland and transplanted to the New World in the first place was because of the voracious demand for sugar in European markets. Thus the complex visualization allows for the multiple levels of association carried by the model in the deepest recesses of her memory, embracing not only the immediate recollections of parents and indigenous community, but the earlier trauma of disrupted family life and the building of a new life under radically altered environmental conditions.

Yorke's dreamy, introspective traits evoked Dinnerstein's reminiscences of his mother even while linked in his thoughts with his father's efforts to make Local 1199's leadership more responsive to black participation. It is not surprising that her contact impelled him to recreate her extended family as a fundamental component of the picture's content. The year following the 1199 exhibition he commenced *A Dream Play*, which amplifies the same theme in an autobiographical context while maintaining the link to *In Sleep* by the introduction of the two contemplative African-American children gazing out the window.

Thus the question of the nature of the family unit was very much in his mind the year (1986) Bill Moyers presented his negative CBS Special Report, *The Vanishing Black Family—Crisis in Black America*, that stacked the deck for a pathology in black families so overwhelming that they seemed beyond redemption. Moyers's viewpoint would have been adverse to that of Louis Dinnerstein, who had long ago perceived that behind the familiar "blaming-the-victim" syndrome lay race, class, and gender discrimination in America. Simon's own recent connection with Local 1199 and the critical presence of his father in *A Dream Play* would have predisposed him, if only inadvertently, to consider some of the wider implications of the "crisis" in the American family structure.

Despite the affirmative theme of the drawing, Dinnerstein unfurls an examination of the politics of the family that is about power and domination even at its most positive moments. The human family is almost predominantly defined in sociological terms by males, who generally posit as its foundation the fundamental presence of the father. Yet the "ideal" of traditional family structure and the values on which it is built is becoming singularly rare in this society, thus belying the narrow definition of family Moyers accepted in his documentary. While images

are always multivalent and rarely reducible to single explanations, to my mind Dinnerstein's *A Dream Play* is especially significant in its metaphorical restoration of the power of the family model so recently degraded to a symbol for exploitation by opportunistic politicians. Through the complexly nuanced figuration of an extended family of mothers, fathers, grandparents, uncles, and aunts, Dinnerstein establishes the family as a unifying principle, the essential nurturing unit from which human beings draw their mental, emotional, and physical sustenance. It is perhaps the renewed sense of kinship and communal ties developed within the traditional extended family that can make room for single-parent units, especially mothers, and the homeless.

But it is women who give birth, and it is children who represent the one entity absolutely indispensable to any notion of human family. Dinnerstein's frank acknowledgment of the tensions of childbirth had been expressed in 1972—when still at work on *The Fulbright Triptych*—in his astonishing pair of drawings of his pregnant wife, entitled matter-of-factly *8th Month* and *9th Month*. Their shallow fields, almost wholly filled with the dilated body and accentuated by the riveting focus on accessory detail, convey a distinctly claustrophobic atmosphere. Although the swollen torso relates his wife to the great Earth Mother, few artists have made their studies of the naked model such a vivid and disturbing experience for the beholder. These large, ungainly, looming portrayals of his wife near to term, and therefore representative of their intimate private life at that moment, surprised me in the public space. Ordinarily, it runs counter to expectation to see the nude model pregnant (an exception like Gustav Klimt's *Hope I* manages to keep within tradition by making pregnancy erotic), but in this instance Dinnerstein probed the female body with such relentless and uncompromising objectivity and from such unflattering angles that one becomes less aware of the academic tradition than of a tense vigilance bordering on the grotesque. Dinnerstein's commitment to microscopic realism in this period inclined him to view the depiction of his pregnant wife as a clinical and historical obligation. It is as if the artist deliberately set out to debunk the mythical notion of the blissful state of pregnancy near parturition and capture the *angst* of the experience. In this sense, the distended abdomen and enlarged breasts with their taut network of veins complement the overstretched nerves of Renée-Simon sharply registered on her face. In *9th Month* the carefully executed chain lock on the door follows the curve of the breast and abdomen, metonymically pointing to her "confinement." Yet the rawness of the study with all of its awkwardnesses and lack of conventional decorum infuses the older tradition with new power by repositioning the nude in a modern context.

p. 52
p. 53

p. 85 Mother and child are the subjects of another innovative attempt at the nude, done five years later as a fellow at the American Academy at Rome. *Roman Afternoon* is a startling and unexpected composition of Dinnerstein's nude wife and child listlessly stretched out at opposite ends of their couch in a kind of mirror image. There is a distinct sculptural quality in the sharply defined mattress edge, akin to a marble slab, that runs parallel to the horizontal axis of the work. Draped with crisp white folds of the bed coverings silhouetted by the dazzling Indian red wall behind, the setting is reminiscent of eighteenth-century neoclassical interiors.

This time sensual warmth is restored to his wife's body, as well as an appreciation for the smooth contours of the body in relaxation. Mother and daughter gaze out of the picture, intent on fixing the artist-viewer's gaze, who happens to be both spouse and father of the models. Hence they must vie for his attention. The work is singular in its equal emphasis on the nudity of the mother and prepubescent child. Traditionally, the mother is depicted clothed and holds and/or attends to the nude child without being conscious of the viewer. Thus did religious sanctity and bourgeois decorum dictate the figured modesty of the maternal role. But Dinnerstein overrides the convention by representing mother and child with their respective fully developed and nascent sexuality.

Rome clearly represented a more affirmative historical moment in the family's evolution. The Vietnam War had ended, Nixon had resigned, and the bicentennial celebrations seemed to hold out the possibility of national reconciliation. On the personal side, Dinnerstein had found a perceptive and sympathetic dealer, George W. Staempfli (who purchased *The Fulbright Triptych* when it was still unfinished and paid monthly installments until its completion), had his first one-person exhibit, was a member of the faculty at The New School for Social Research, and in 1976 ran off with a Rome Prize Fellowship. Formally, this chronicle is recorded in Dinnerstein's new delight in textured and painterly surfaces, and in his exhilarated response to the brilliant colors of his new environment.

In the ritualistic interview of the Rome Prize candidates, Dinnerstein explained to the committee that he believed it still possible to create a modern figurative art on a par with the work of the past. His ambition was to go to Rome and produce a "total vision" of the contemporary world with the intensity of the old masters. *pp. 89–95* His major project at the American Academy, *Flower Market, Rome*, attests to a sense of elation and well-being marked by a more public theme and the explosive colorations of fifty identifiable species of blooms. This is demonstrated by the artist's own impulse to jump into the floral ensembles as if they were a sea of cushions when he first discovered them in the Campo dei Fiori in Rome. He

wanted to recreate this sensation or vision of himself "jumping into the painting and lying on the flowers." Dinnerstein's definitive work is ten feet wide and took nine months to accomplish. It depicts one of the characteristic flower stalls swarming in the Campo dei Fiori, where the retail florists set up their booths for locals and tourists alike.

Dinnerstein was struck by the iridescent play of flowers in these stands, which seemed to "float off the ground." Their endlessly varied hues and textures, set off by the ochre-orange–tinted stucco of the walls, "would just glow." Returning to the studio, he reconstructed one of the flower stalls on canvas by building up the surface with a dense mixture of pigment, marble dust, and stone to capture the variegated textures. As a result, the rich layering resembles a fresco with its heavy relief underneath. Although the pervasive relief is justified because so much of the canvas is given over to the luminous floral passages (standard academic practice calls for the highest relief in the brightest lights), the final effect gratified Dinnerstein by amusingly duplicating the avant-garde look of the dense, all-over webs of Milton Resnick's nonobjective paintings without the loss of the subject.

Both the theme and the title suggest a more public content than we have heretofore seen in Dinnerstein's work, but in fact it enlarges upon the personalized vision we have identified with the theme of the family. The figure of the flower vendor was posed by Teresa Gregorini, a native of Trastevere and close friend of the Dinnersteins, who stood in for the actual owner of the stall. The cropping of the outdoor space at the very edges of the flower ensembles creates the familiar claustrophobic space of the painter's indoor scenes and in fact yields a "hothouse" effect. Gregorini, seated in the center, presides over the tiers of flora like a venerable matriarch of a family portrait. Traditionally, flowers are metaphors for childbirth, sexuality, and regeneration, and here they suggest surrogate children. Indeed, the work could easily be entitled "The Madonna of the Blossoms." The madonna image is invoked by Gregorini's stately frontal presence, her dark sedate costume, the crossing gesture of her right hand which preserves her modesty, and the ingeniously contrived halo formed by the arc of the window behind her.

Teresa Gregorini's subtle smile recalls the preclassical Greek Kore, and brings us back again to the characteristic expression of Dinnerstein's mother. Gregorini, however, represents the more ambivalent attraction of woman/mother embedded in a matrix of efflorescences. We may recall the artist's vision of himself jumping into the painting and lying among the flowers—a wish to be "absorbed sexually or sensually in the painting." Dinnerstein also stated at one point in our interview, "I'm a real sucker for flowers," referring to a desire to compensate for the absence of flowers in his childhood. Surely, the association of mother/Madonna/woman and flower is central to the unfolding dynamic of Dinnerstein's work and

relates back to the parental space. The regenerative ideal is further implied in the simultaneous display of nearly an entire year's growth of flowers—autumn chrysanthemums, spring dahlias, and otherwise ephemeral forget-me-nots thrive side by side—so that Dinnerstein's picture becomes a "real allegory" about blossoms that perpetually glow; a flower stand that could not exist in actuality. The work took exactly nine months to complete, and in a real sense, Dinnerstein gave birth to his ideal environment centered on the maternal memory trace.

pp. 188–91 The flip side of this affirmative and brilliantly illuminated picture is the large drawing known as *Night*, representing the eruption of nightmare or infantile anxiety caused by the absence of the parents. A procession of pre-kindergarten children marches out of the drawing trance-like in the direction of the spectator. They are enveloped by a vast terrifying landscape that recedes rapidly into space towards a pale crescent moon spreading its eerie network of lunar beams over a universe haunted by dreaded creatures of the night—demons, skeletons, witches, bats, and a frightening subway "El" screeching around a curve. This is a world of children without parental presence and the security of the family embrace, a world that is, according to a friend of the painter, "unsafe." Dinnerstein himself recalled that in making the drawing he "wanted to get at things that I felt as a child made me anxious."

Dinnerstein's unusual mixed-media drawing was based on an incident that occurred in Renée Dinnerstein's preschool class. She had organized a dramatic representation of Maurice Sendak's children's book, *Where the Wild Things Are*, and each child went to work eagerly creating his or her own mask from supermarket bags. But a startling thing happened after they donned their makeshift costumes: they began to grow frightened by the sight of each other and by their own claustrophobic reactions to being enclosed within a mask. The wearing of the masks had transformed the world of the secure classroom into the world of their nightmares. The result was a sense of apprehension and alarm that led to a quick removal of the disguise. That this experience resonated with Dinnerstein's memory traces is registered in the terror-stricken expression of the child at the extreme left, the artist's "surrogate" who serves as interlocutor for the visual scenario.

As in *The Fulbright Triptych*, Dinnerstein wanted to express a childhood vision in a style consistent with the subject. He executed the chimerical figures with the "scratchout" technique, which consists of laying down a multicolored surface with crayola crayon, covering it with black tempera, and then scratching through the black layer with a pin to reveal the underneath. This interception of "high art" with children's imagery and drawing style is made possible through Dinnerstein's mastery of graphic techniques which contest the established boundaries of high art.

pp. 118–19 The painting known as *Gregory's Party* further attests to Dinnerstein's desire to

conjoin the child's world with the realm of high art. In this case, the pretext was the "party" organized by the artist's daughter for the Raggedy Andy toy she had named Gregory. Children create their own fantasy world within the "real" domain of their parents, in effect acting out the role of "parents" towards the minia-ture world they create. This is especially evident in the dollhouse (a conspicuous

p. 131 emblem of Simone's world in the later *Sonatina*), where the child stands in rela-tionship to the dolls as the parents to the child. The fearful presence of towering adults is now worked through in the child's analogous relationship with minia-turized toys. This is most vividly observed in Simone's table-top community of every conceivable type of figurine arranged in a hierarchical society (*The City, the*

p. 123 *Town, the Emperor of China*). The child, powerless in the adult realm, now exer-cises control over a Lilliputian realm set up on a table top or floor.

For Dinnerstein this type of children's play is yet another instance of the blur-ring of the boundaries between dream and reality. The organized play space that Gregory inhabits is subjected to the dominion of Simone who in turn estab-lishes the composition for Simon. In this sense, the artist's own cultural practice relates to the childhood fantasy of governing a reduced version of the adult en-vironment. The sheer delight of the artist in the crisp colors and outlines of the toys takes us right back to the invented world of *The Fulbright Triptych*. Here again the depicted and actual are not sharply distinguished: the contrast between the casual—almost "natural"—pose of Gregory and the more formal pose of Simone suggests that the artist telescoped the distance between play and actuality. Reminiscent of the scene in *E.T.* where the extraterrestrial creature conceals him-self among the toys, Dinnerstein subjects the unknown to the known.

p. 205 The whimsical but macabre self-portrait entitled *Emerging Artist* reconciles many of his anxieties and intellectual aims under the rubric of a powerful meta-phor. Dinnerstein portrays himself as a hybrid creature, with his head issuing from the body of a turtle. He crawls hesitatingly across the foreground space fum-bling for his pencils and crayons, while in the background the immense landscape falls away to infinity under the radiating lunar network of the crescent moon. The frightening atmosphere of *Night* is linked with a crisis of professional self-identity.

As in *Night*, it was Renée's preschool class that inspired the work. The turtle was the class pet and totem, and the children even read books to it. Renée sug-gested the turtle as the subject of a picture, and this sparked a vision of the hy-bridized self-portrait of the merging and emerging artist. (Renée also suggested that he add the pencils and show himself wearing glasses.) Dinnerstein thinks of the portrait as an example of a Quixote tilting at imaginary windmills. No matter how determined we are to make life meaningful, the "shell" we carry about al-ways constrains us from "delivering the goods."

Hence Dinnerstein reveals in this autobiographical parody his innermost anxieties: the concern for the "baggage" of the past that haunts the present, the fear of losing control over the environment, and ultimately, fear of immobility at the moment of self-understanding. The metaphor of the turtle answers to more than one facet of the artist's self-portrait. He claims to work slowly, and he talks often of wanting to slow down the pace of reality to the point where he can capture it on the drawing surface. Finally, Dinnerstein talks of making works so intense that spectators are stopped in their tracks. What could be more natural, then, to choose as his totemic emblem, the animal that sums up so many sides of his personality? In the race between the tortoise and the hare, who would not place their bets on the tortoise?

Albert Boime
Washington, D.C.
1989

Albert Boime is professor of art history at the University of California, Los Angeles, and is currently working on a multivolumed social history of modern art.

THE PLATES

›› *page 26*
TREE STUDY
1967
Pencil
8¾″ × 7″
Sophie and Ernst Tritsch,
New York

›› *page 27*
WINDOWS #1
1967
Pencil
8⁵⁄₁₆″ × 11⁹⁄₁₆″
Renée Dinnerstein,
Brooklyn, New York

THE KELTON PRESS
1969
Charcoal
25½″ × 39½″
Howard and Harriet Zuckerman,
Monroe, New York

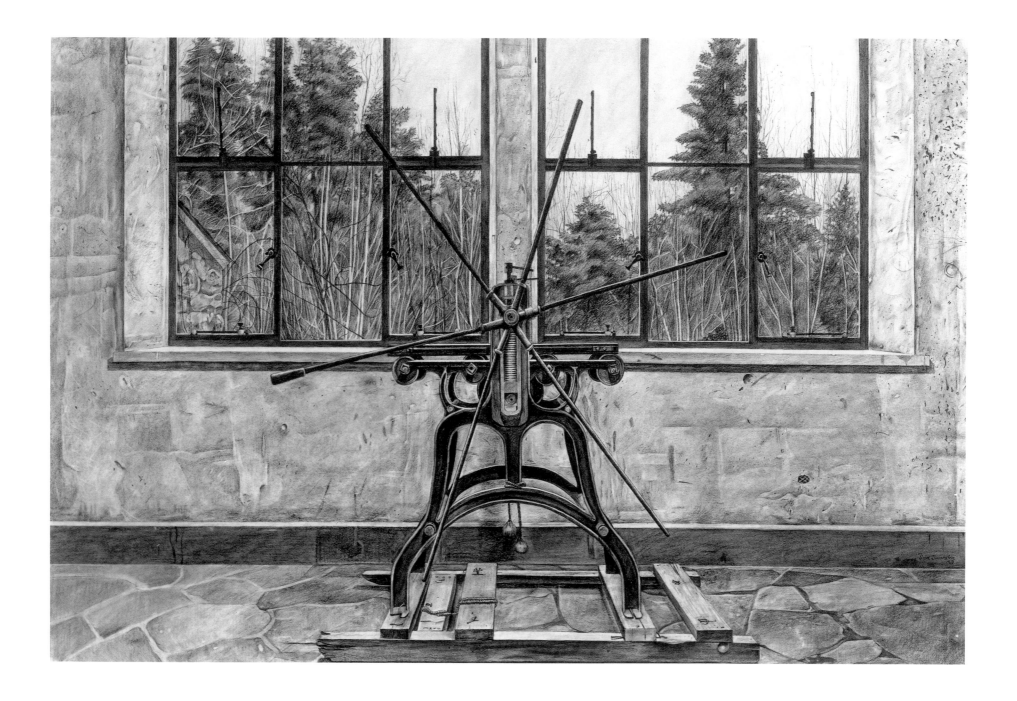

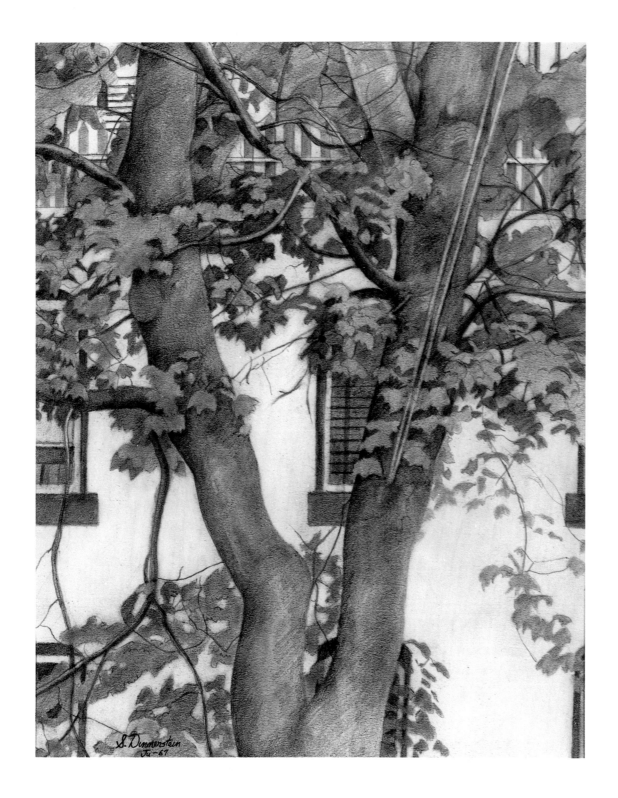

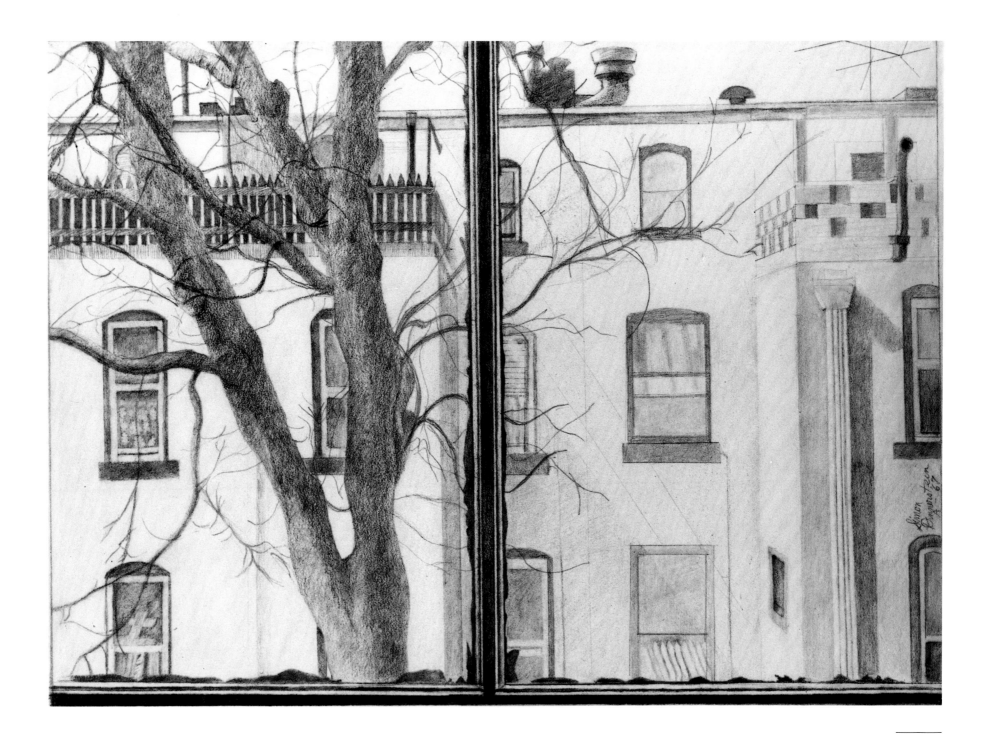

‹‹ *page 28*
FROM NAOKO'S WINDOW
1968
Pencil
13″ × 39¾″
Minnesota Museum of Art,
St. Paul, Minnesota

‹‹ *page 29*
1:30 AT DAVE AND NANCY'S
1969
Pencil
10″ × 39¼″
Daniel H. Renberg,
Los Angeles, California

GARFIELD PLACE, BROOKLYN
1970
Charcoal
30″ × 59″
Donald and Audrey Stier-Adams,
Scarsdale, New York

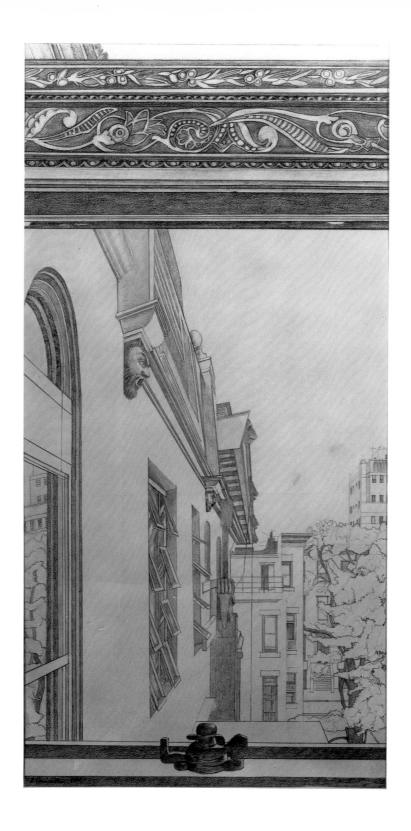

<< *page 32*
MacDowell Window
1969
Pencil
15½″ × 10″ (11¼″)
Lawrence and Irene Lezak,
Monroe, New York

<< *page 33*
Windows #3
1967
Pencil
16″ × 8″
Pauline and Walter Trasin,
Great Neck, New York

Roxbury Summer
1969
Charcoal, pen and ink
25″ × 39½″
Howard and Harriet Zuckerman,
Monroe, New York

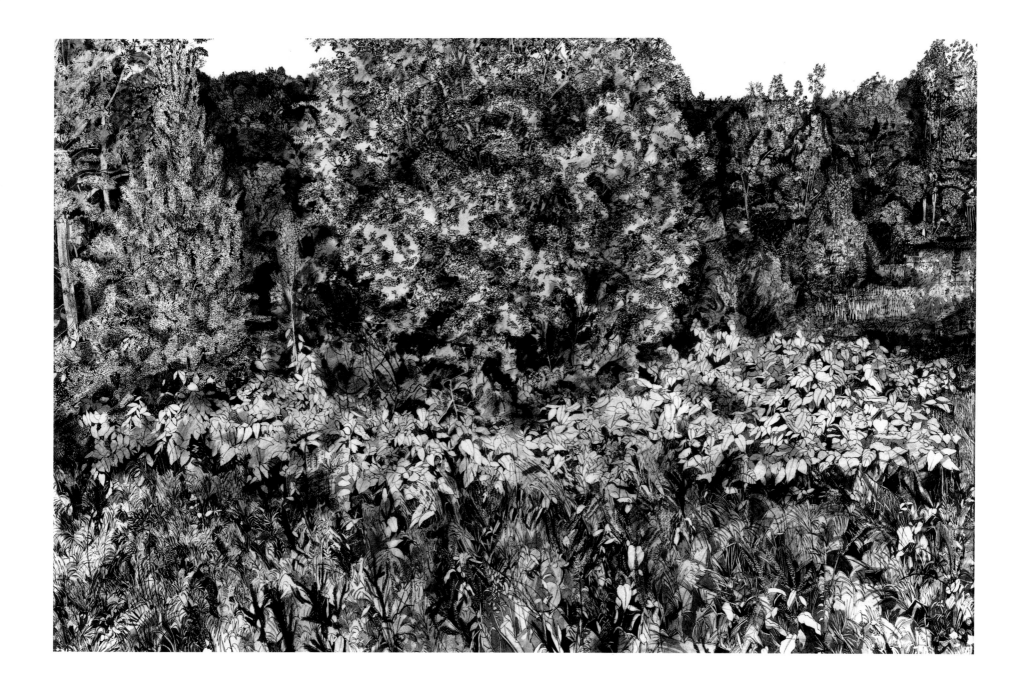

35

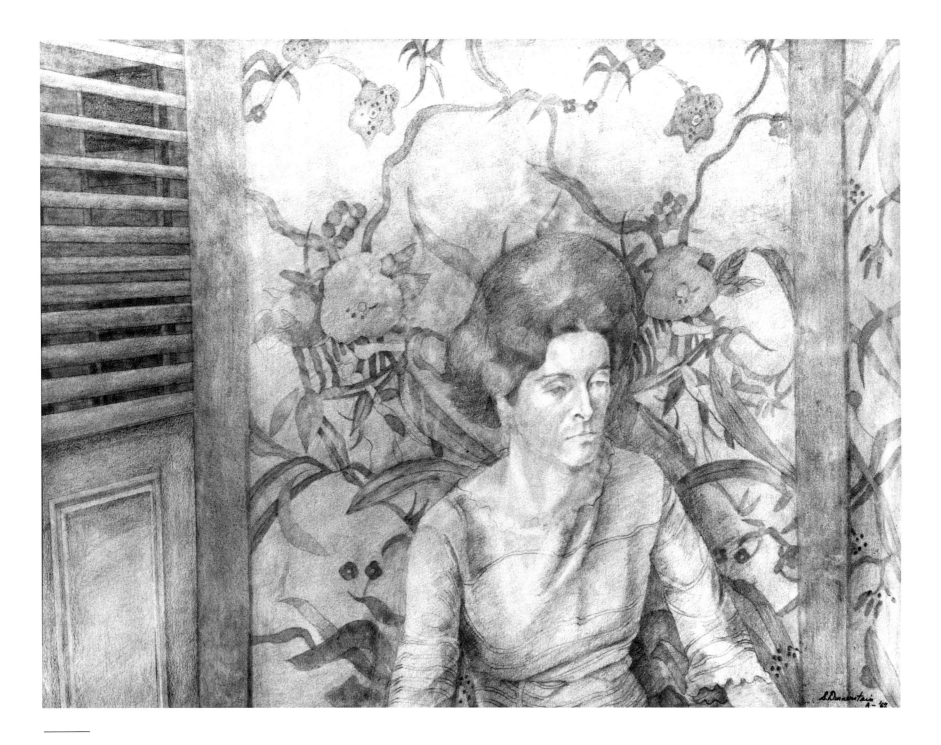

PAT
1967
Pencil
11¼″ × 13⅝″

ANGELA'S GARDEN
1969
Silverpoint and pencil
14″ diameter
Capricorn Galleries,
Bethesda, Maryland

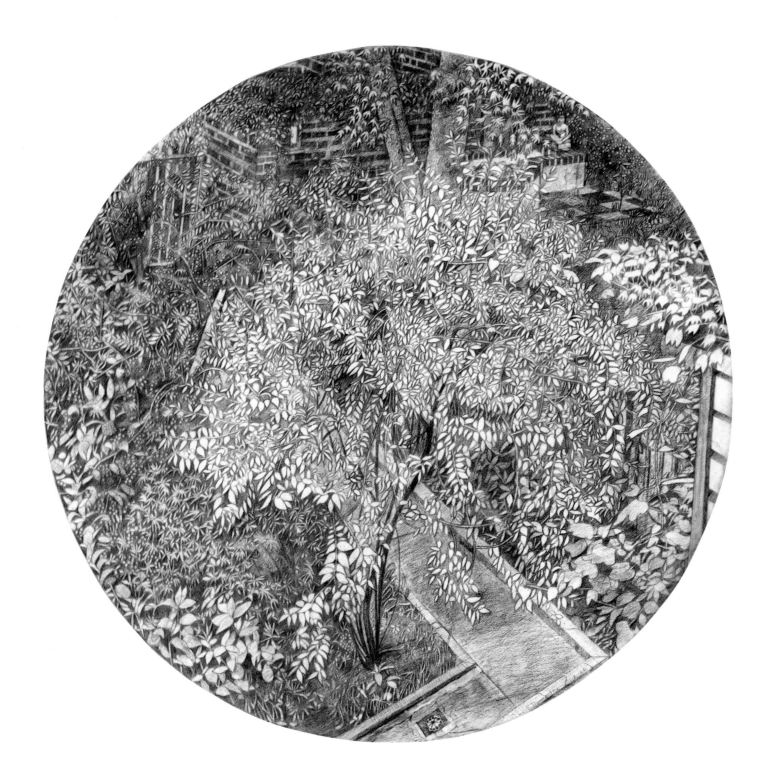

WINDOWS #2
1968
Pencil
16″ × 17¾″
Albrecht Art Museum,
St. Joseph, Missouri

N's Kitchen
1970
Mixed media (Silverpoint, gouache, tempera)
and assemblage
55½″ × 31⅞″
Mr. and Mrs. Richard M. Dearnley,
Little Rock, Arkansas

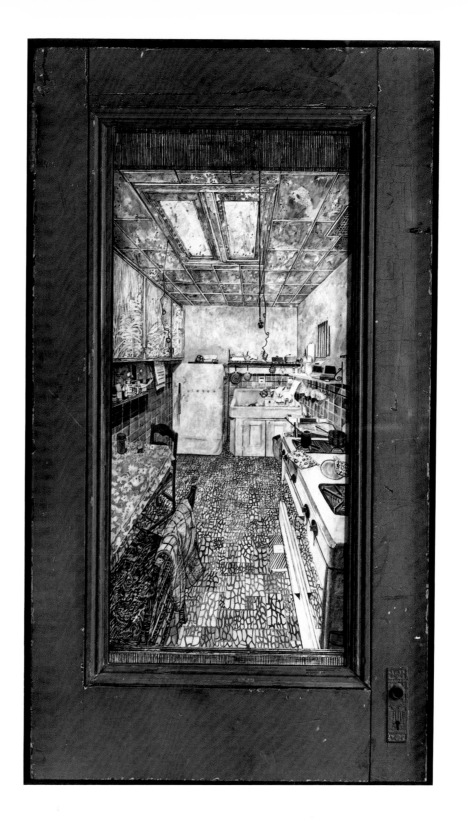

RENÉE
1970
Charcoal
25″ × 39″
Lawrence and Irene Lezak,
Monroe, New York

›› *page 46*
BRUNO'S MOTOR
1971
Charcoal, conté crayon
39½″ × 25½″

›› *page 47*
MANSARD KITCHEN
1971
Charcoal
39½″ × 25½″
Stephens, Inc.,
Little Rock, Arkansas

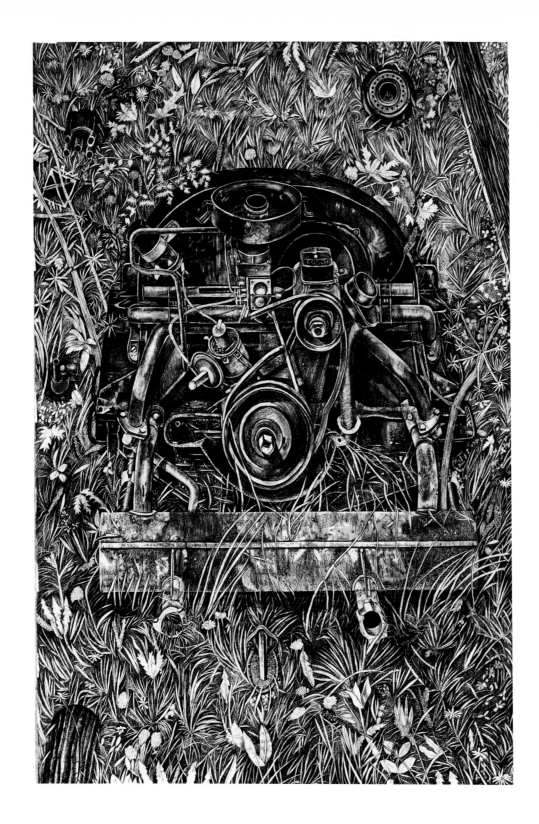

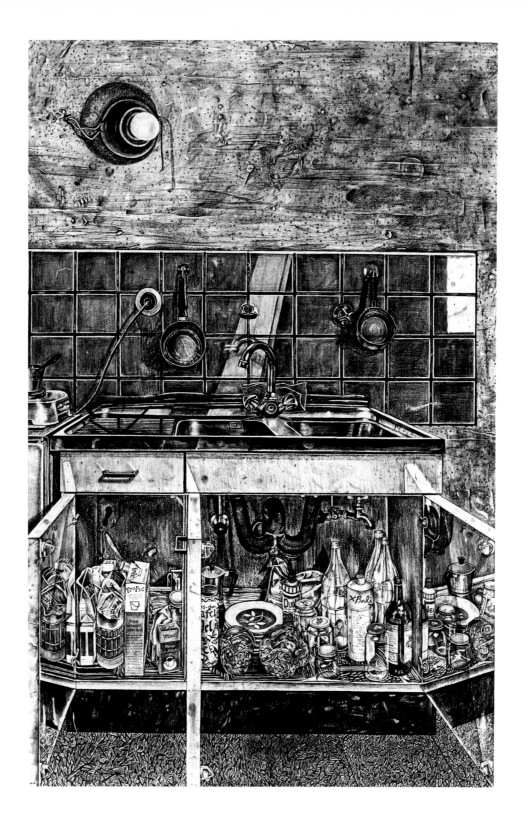

GERMAN VEGETABLES
1971
Charcoal, conté crayon
23½″ × 33″
Ms. Alice Kelly,
Westfield, New Jersey

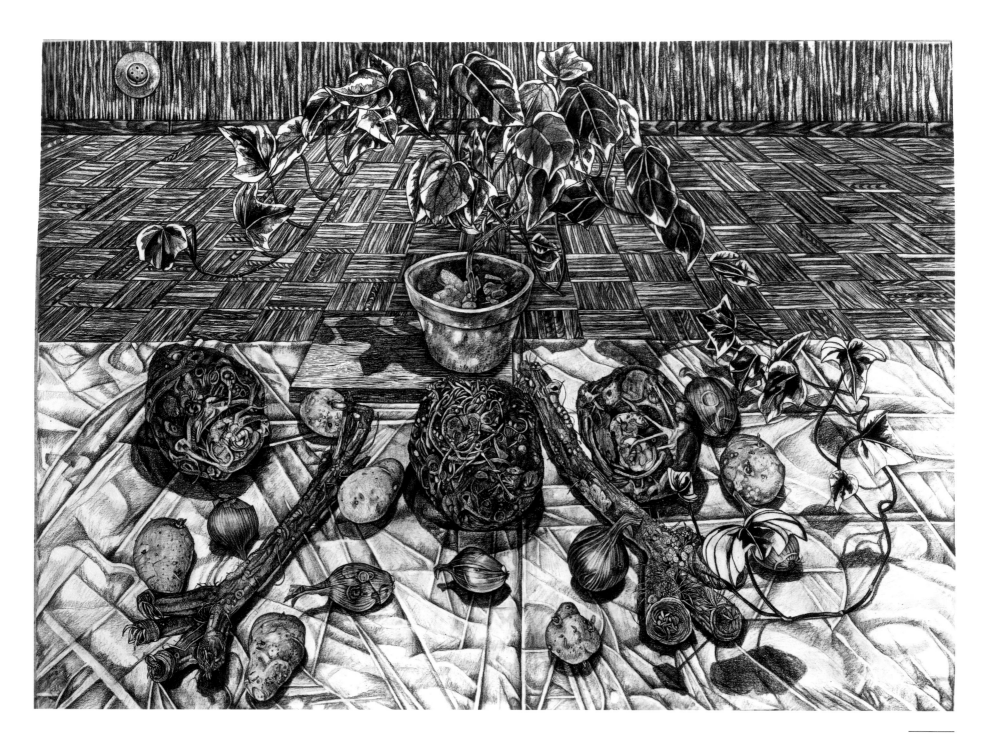

›› *page 52*
8TH MONTH
1972
Charcoal, conté crayon
38¾″ × 26⅞″

›› *page 53*
9TH MONTH
1972
Charcoal, conté crayon
39½″ × 25¼″

MARIE BILDERL
1971
Charcoal, conté crayon
41½″ × 49½″
Minnesota Museum of Art,
St. Paul, Minnesota

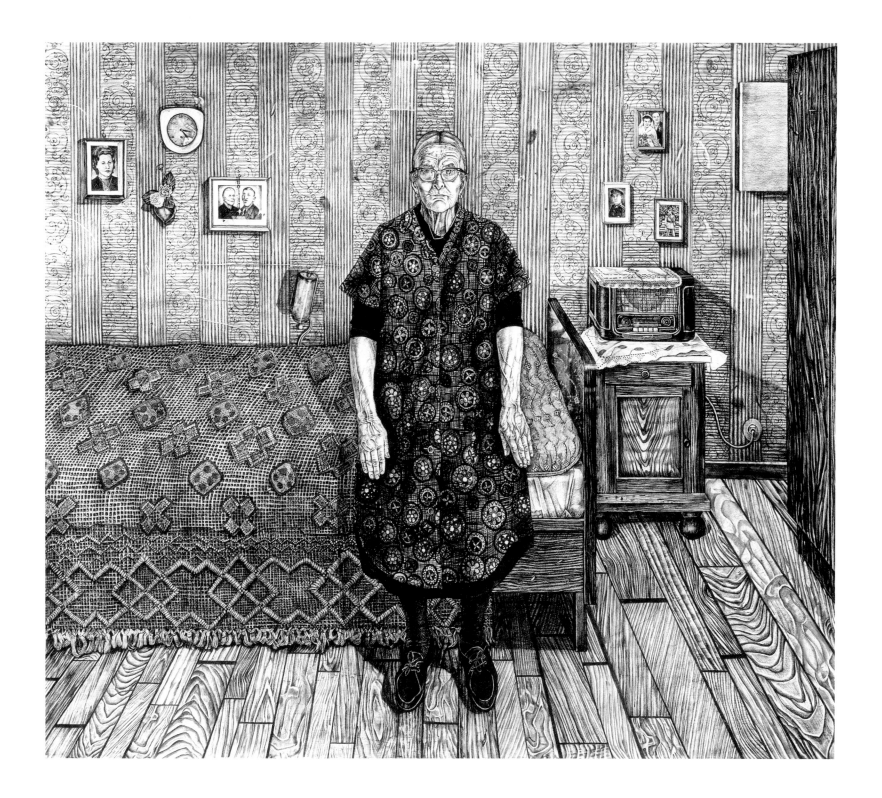

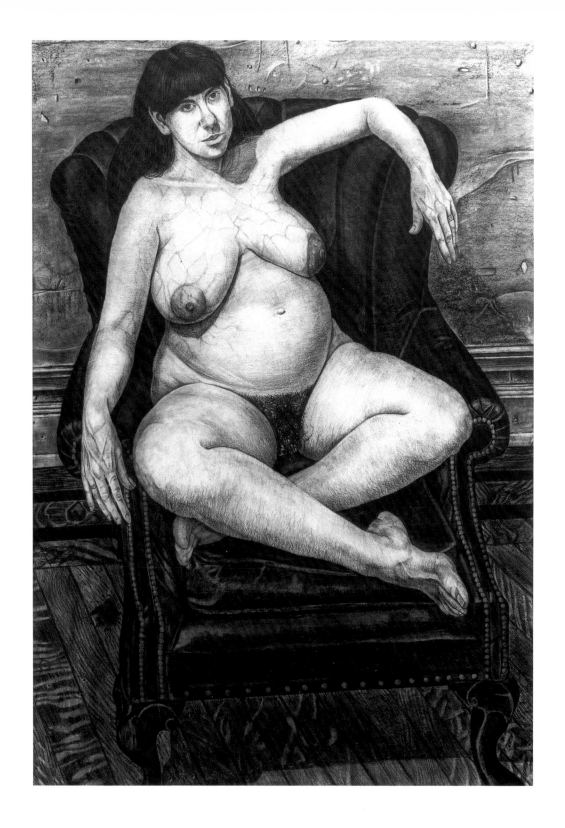

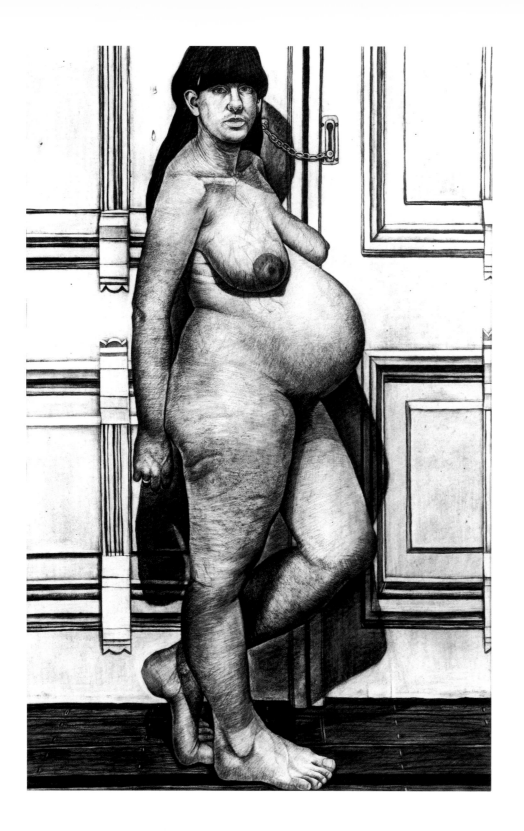

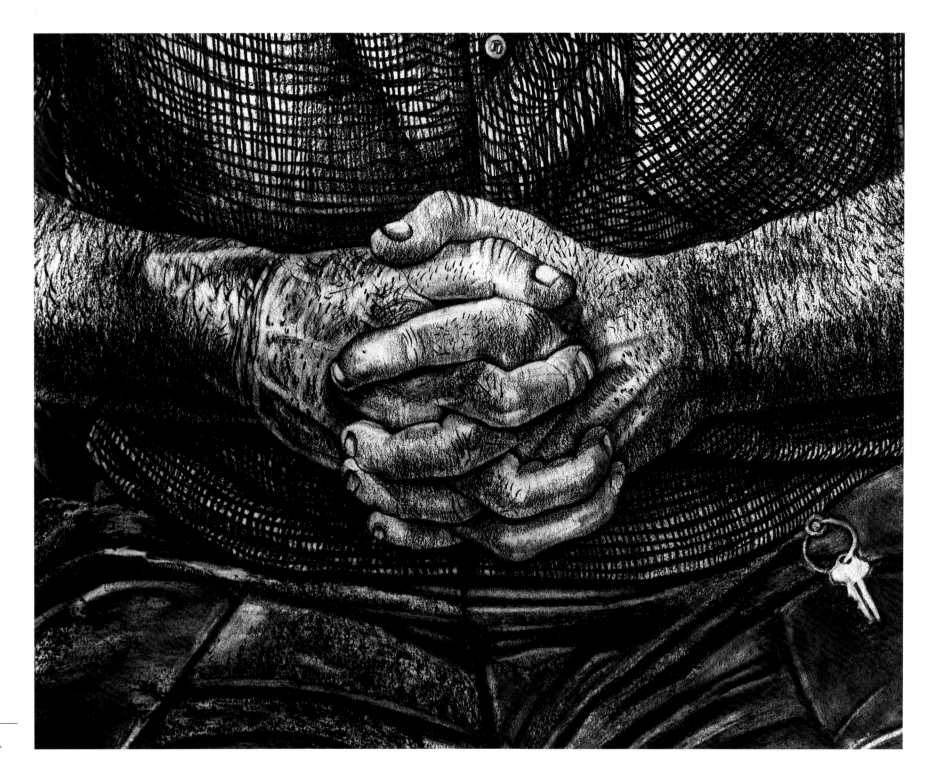

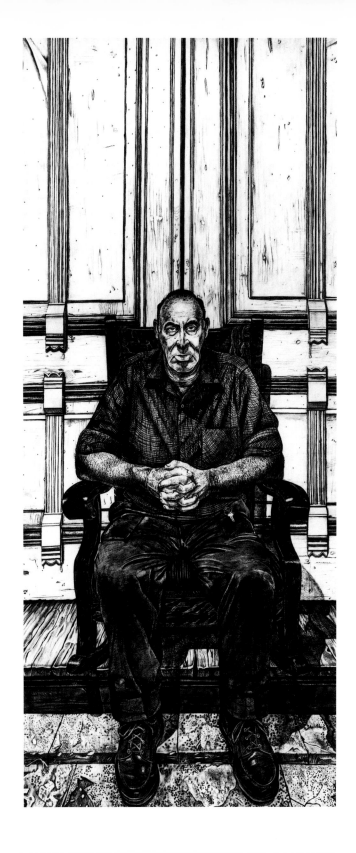

‹‹ *page 54*
Arnold
Detail

‹‹ *page 55*
Arnold
1972
Charcoal, conté crayon,
lithographic crayon
84″ × 36″

Arnold
Detail

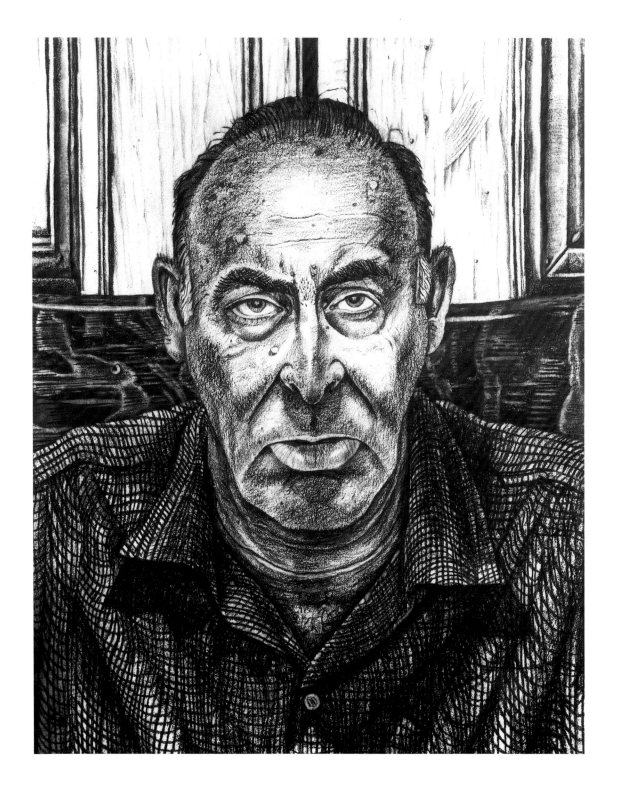

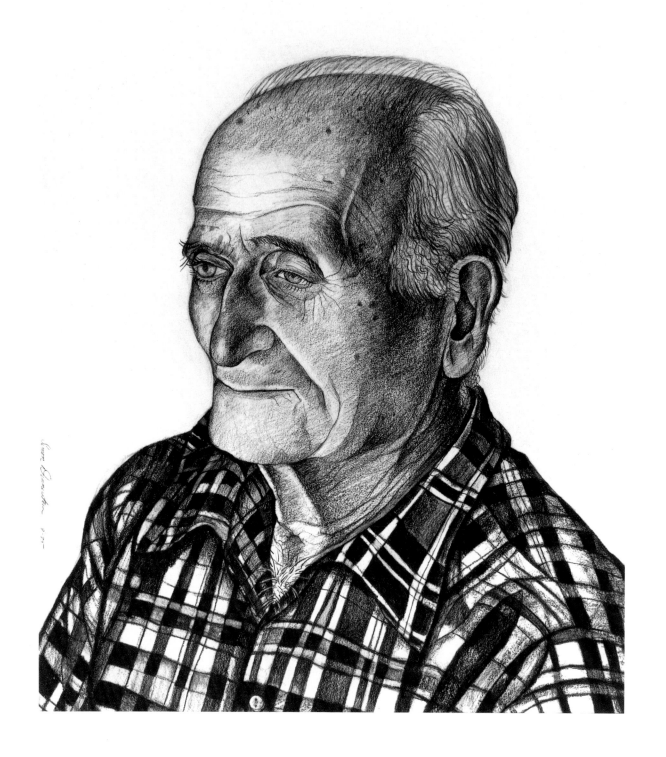

DAVID
1976
Charcoal, conté crayon
14″ × 10″
Susan and William Pardue,
Huntington, New York

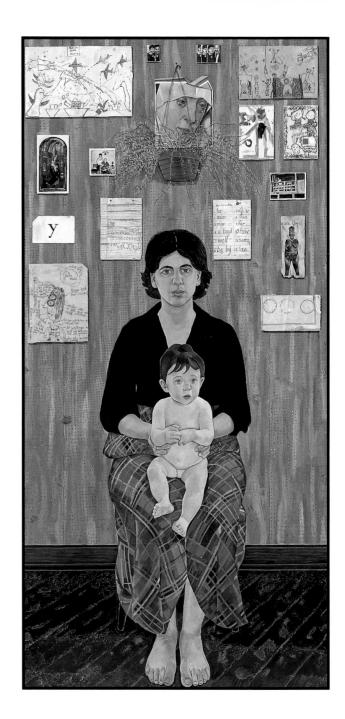

THE FULBRIGHT TRIPTYCH
1971–74
Oil on wood panels
79½″ × 156″
(79½″ × 38¼″)
(79½″ × 79½″)
(79½″ × 38¼″)
79½″ × 168″ (Framed and separated)
Palmer Museum of Art,
Pennsylvania State University,
University Park, PA,
gift of the Friends of the Museum of Art,
Pennsylvania State University

›› pages 62–69
THE FULBRIGHT TRIPTYCH
Detail

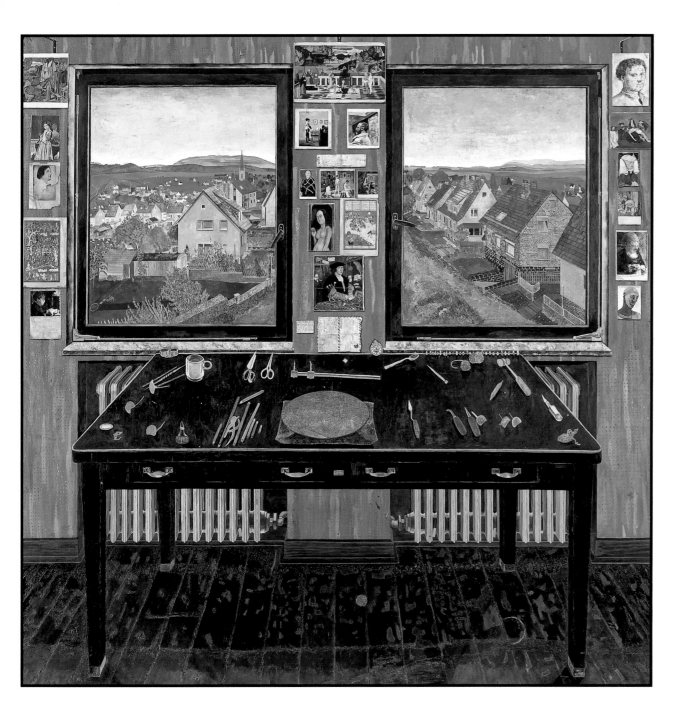

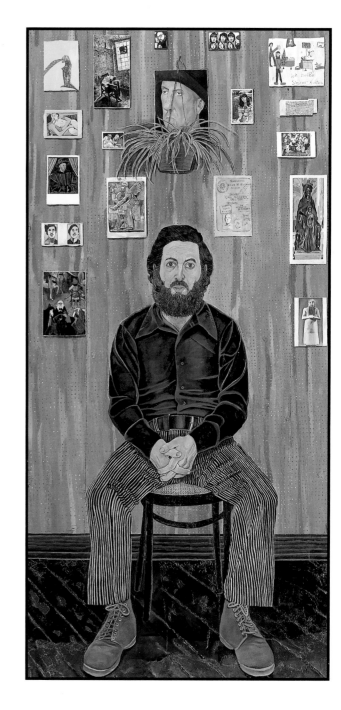

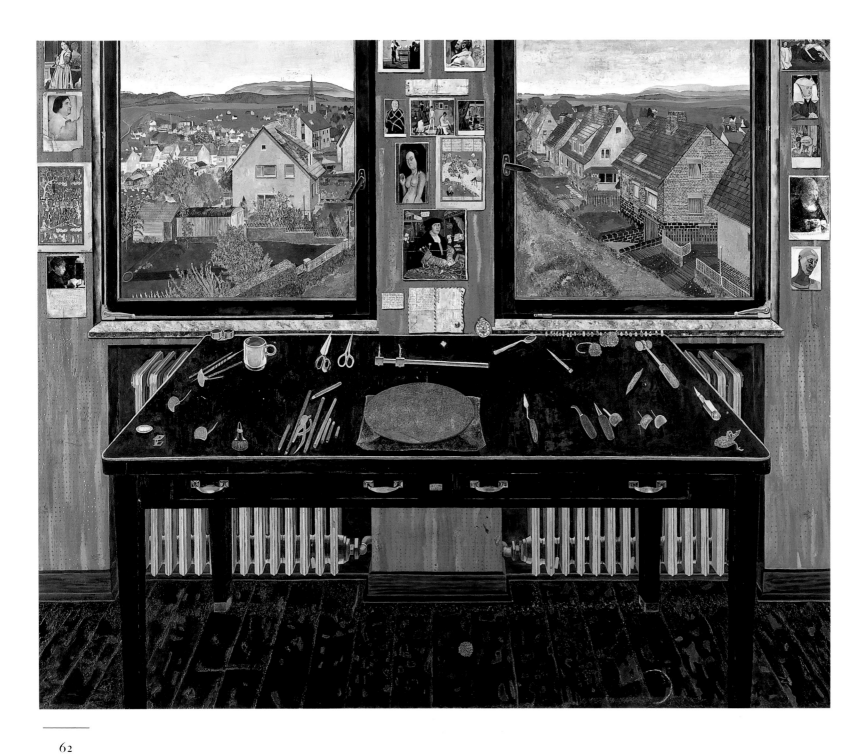

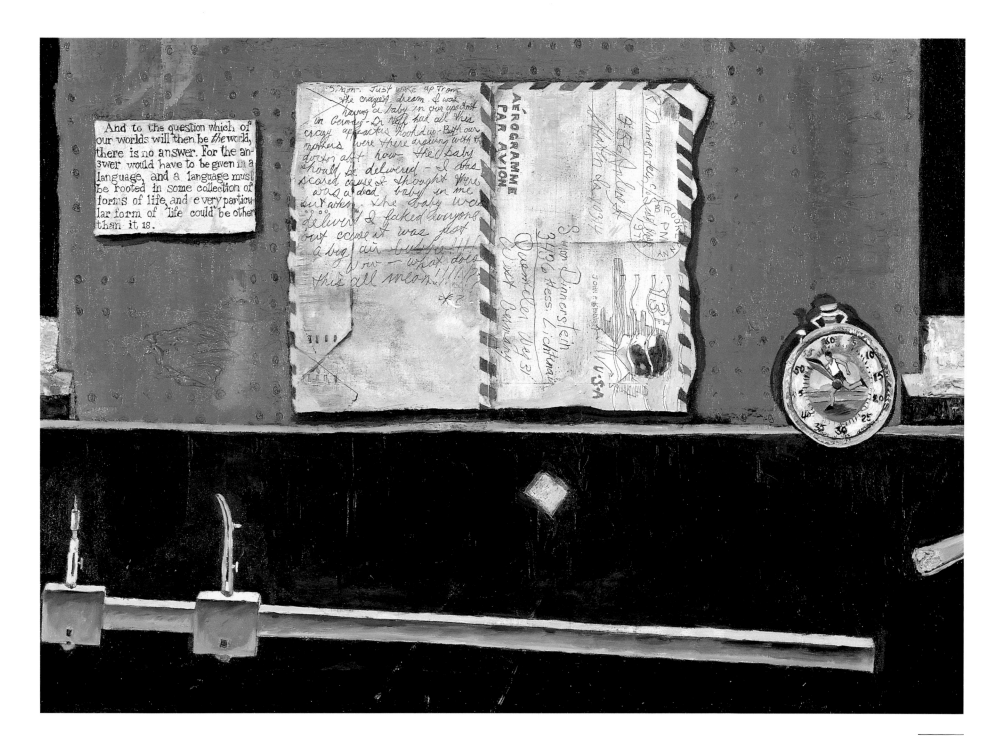

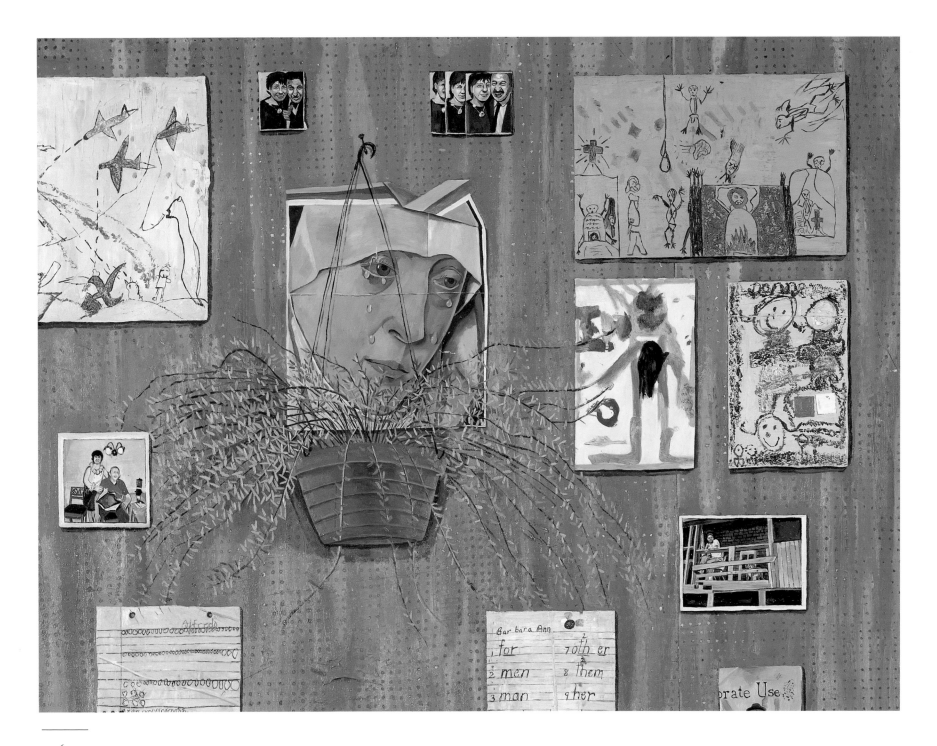

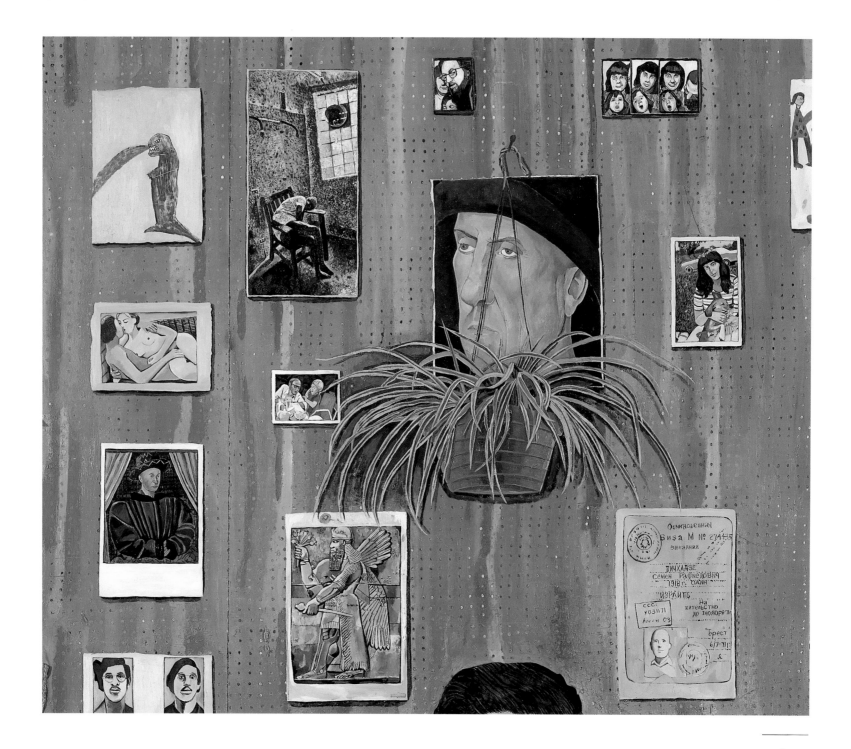

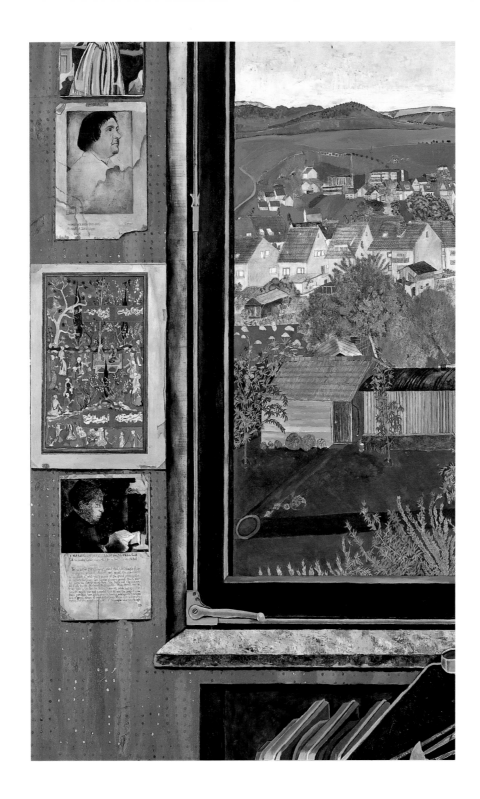

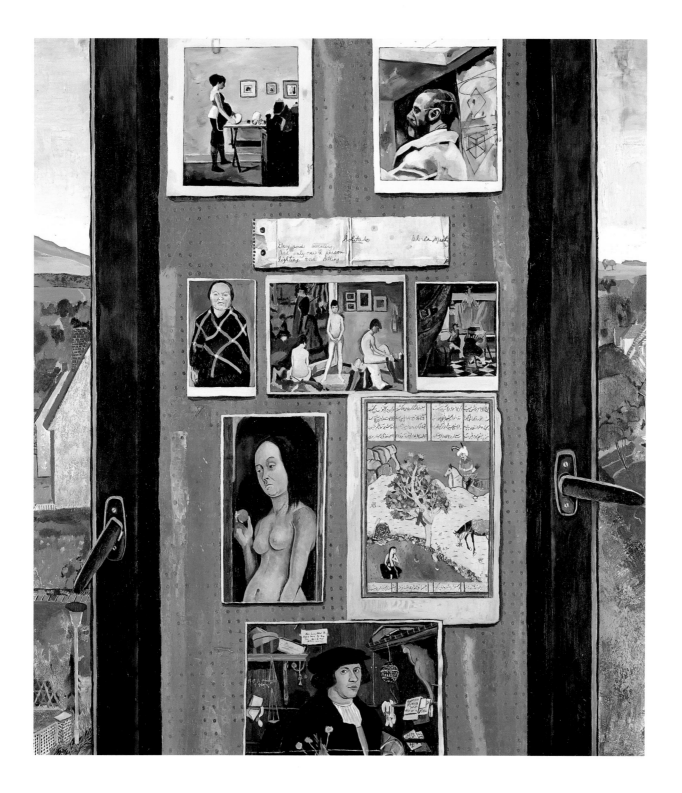

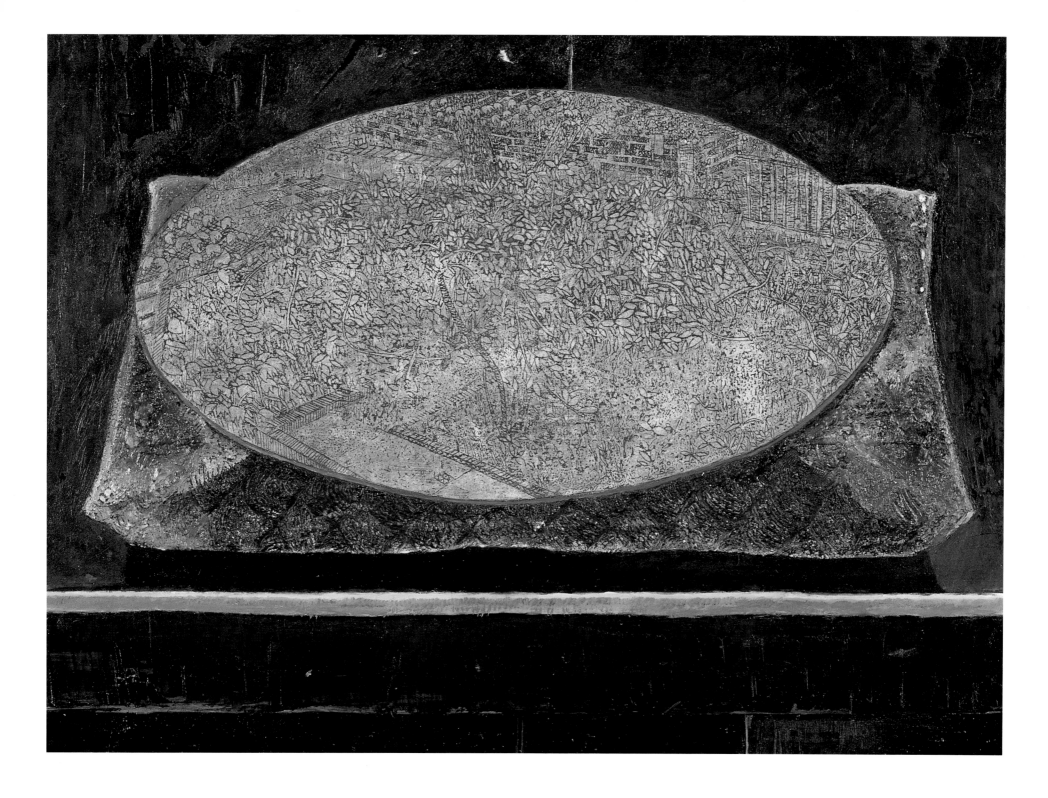

THE SINK
1974
Oil on wood panel
96″ × 48″
Museum of Art and Archaeology,
University of Missouri-Columbia,
gift of The American Academy &
Institute of Arts & Letters,
through the Childe Hassam Fund

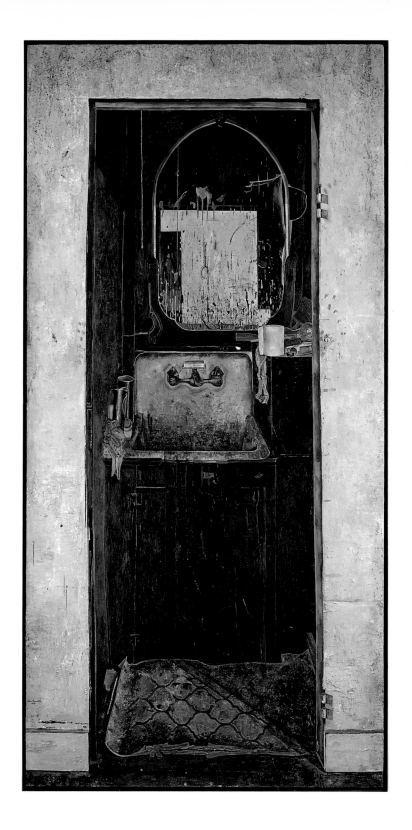

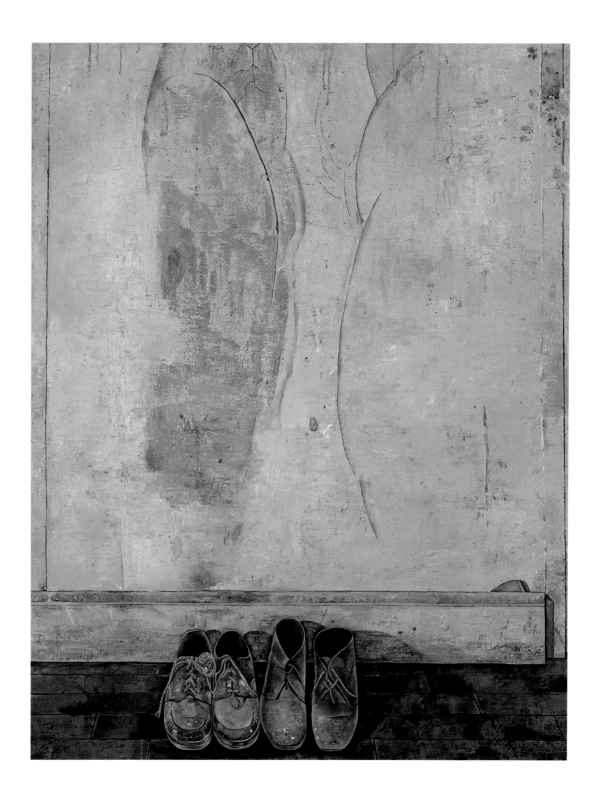

ALEXANDER STUDIO
1979
Oil on wood panel
42″ × 64″

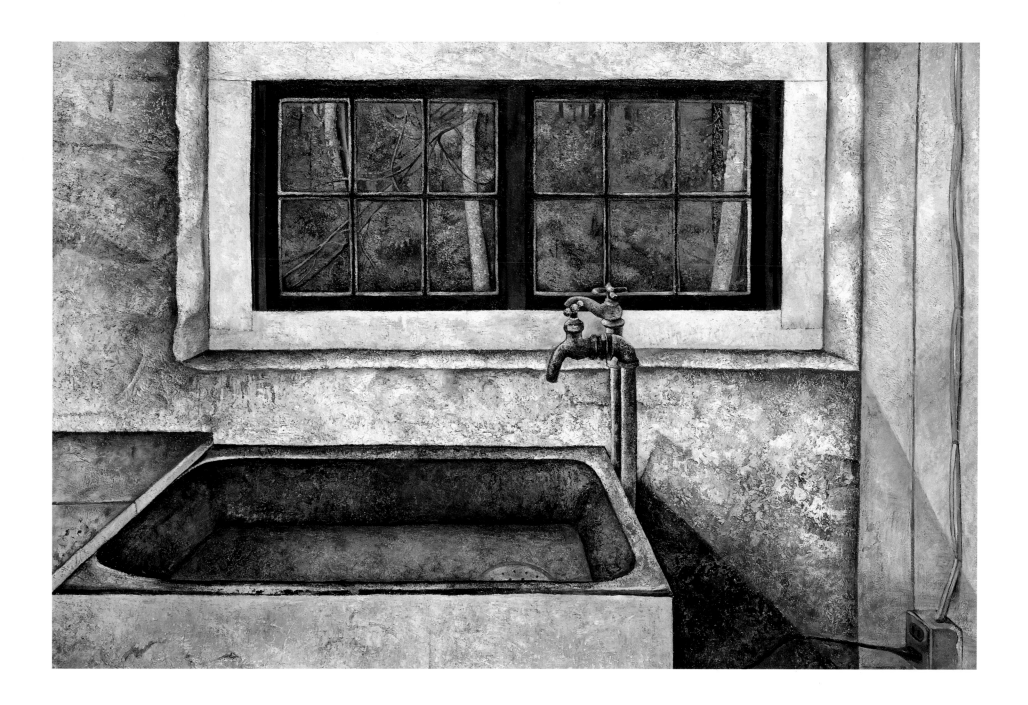

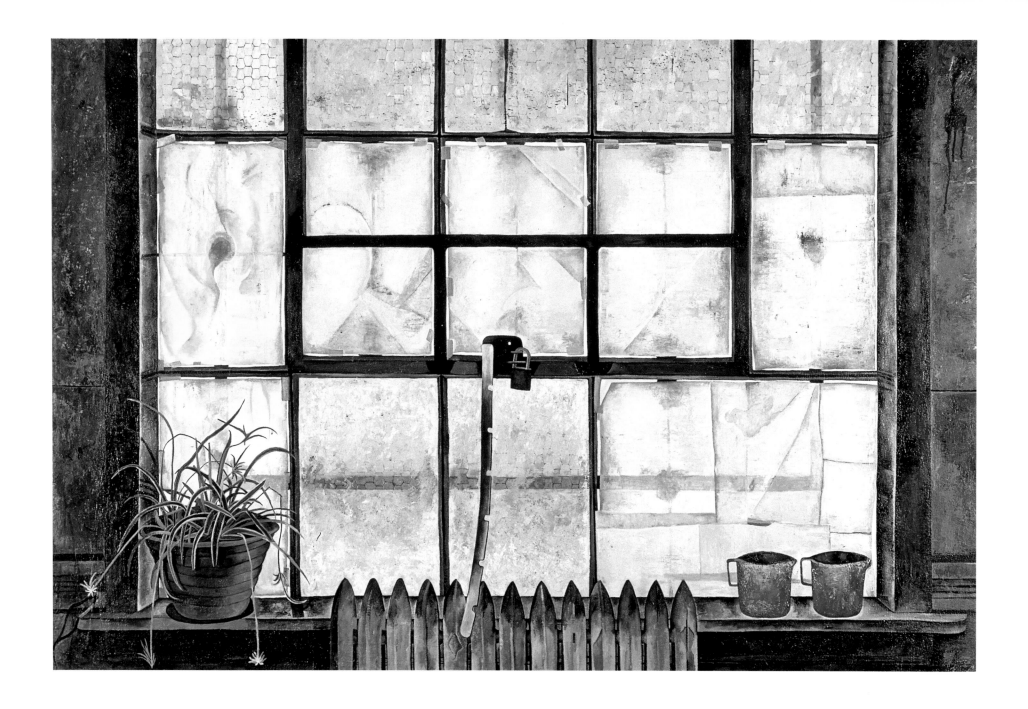

STUDIO WINDOW
1975
Oil on wood panel
43 ½″ × 66″
Private collection

STUDIO STILL LIFE
1976
Oil on wood panel
48″ × 63″
Muncie Williams,
Proctor Institute,
Utica, New York

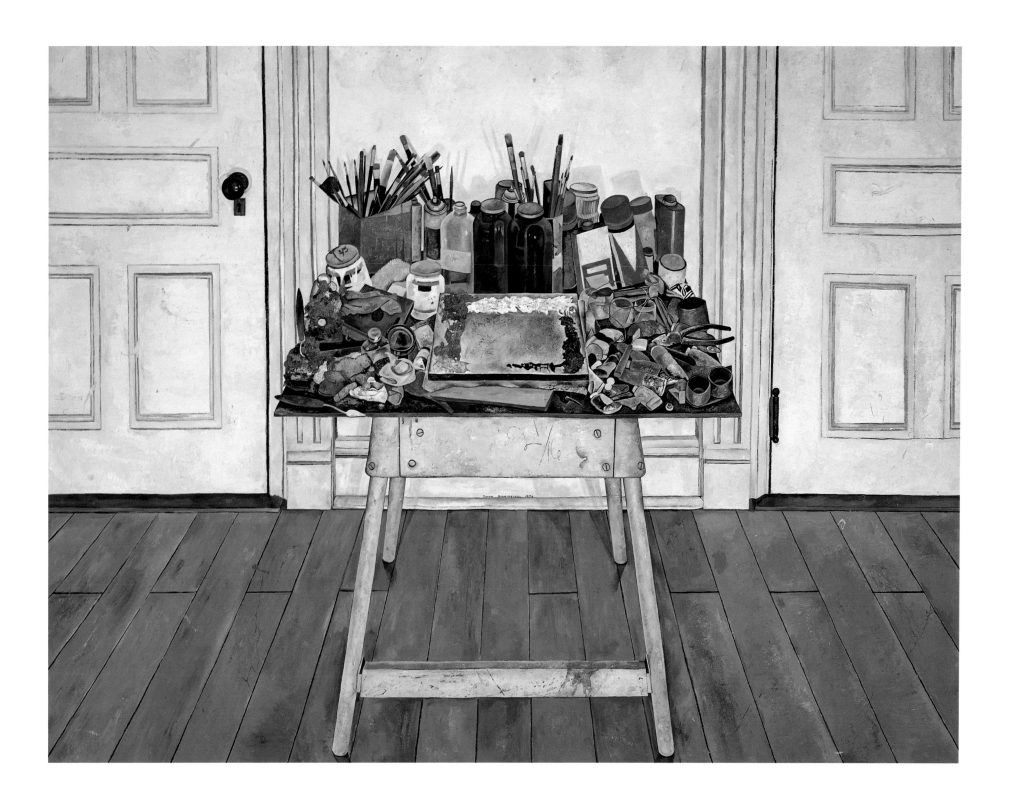

›› *page 82*
JOANNE AT TWENTY
1976
Oil on wood panel
70¼″ × 34″
The Art Gallery,
University of Maryland,
College Park

›› *page 83*
TERESA
1977
Oil on wood panel
76″ × 45¾″

COLEUS PLANT
1975
Oil on wood panel
16¼″ × 48″
Private collection

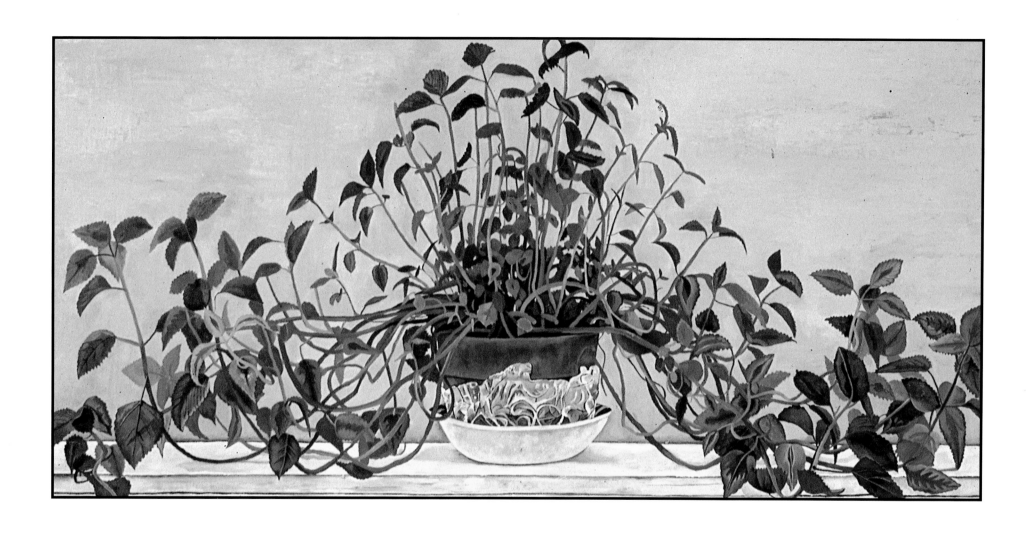

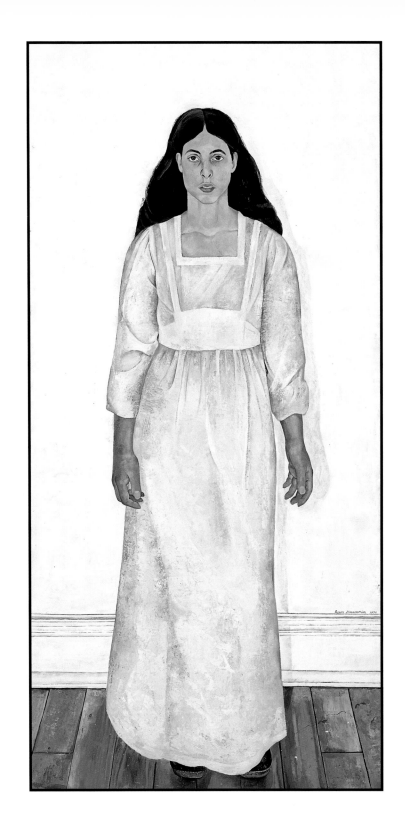

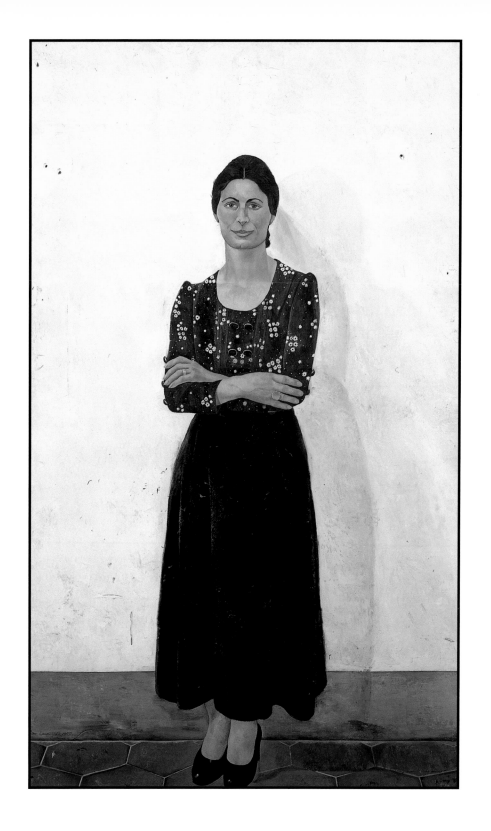

ROMAN AFTERNOON
1977
Oil on wood panel
48¼″ × 67¼″
Ms. Elyse Vitiello,
Brooklyn, New York

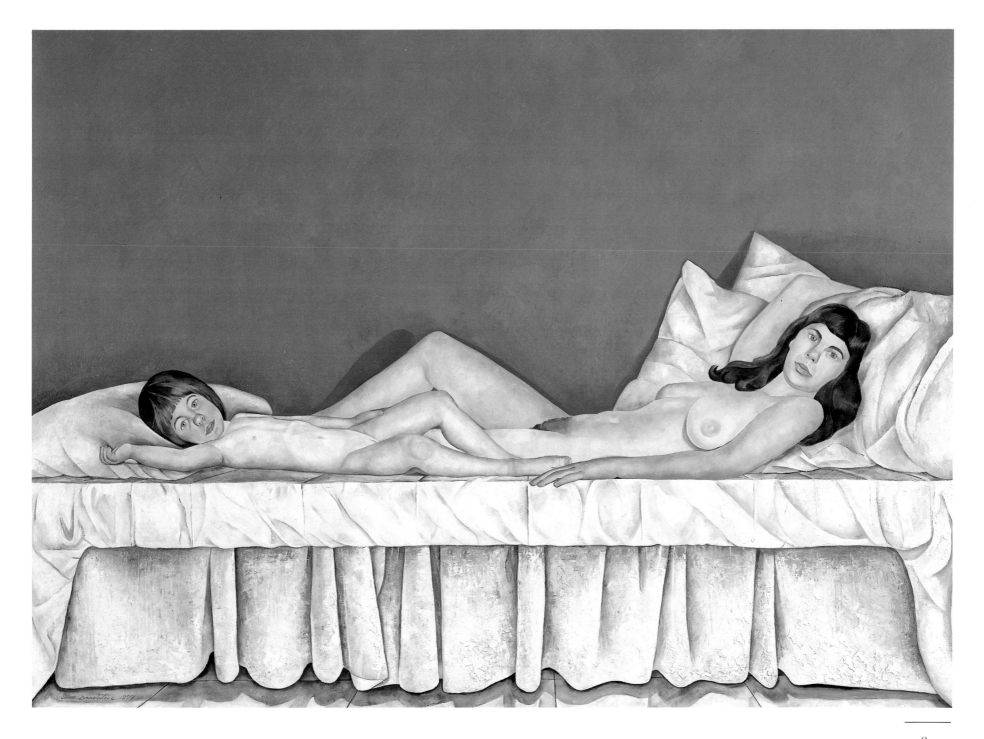

A Carnation For Simone
1982
Oil on wood panel
4⅜″ × 6⅜″
Reproduced to size
Simone Dinnerstein,
Brooklyn, New York

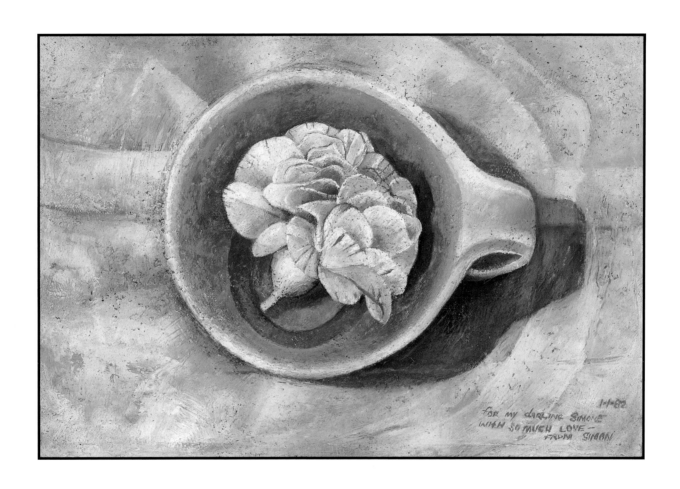

›› *pages 90–95*
FLOWER MARKET, ROME
Detail

FLOWER MARKET, ROME
1977–78
Oil on canvas
76″ × 121″

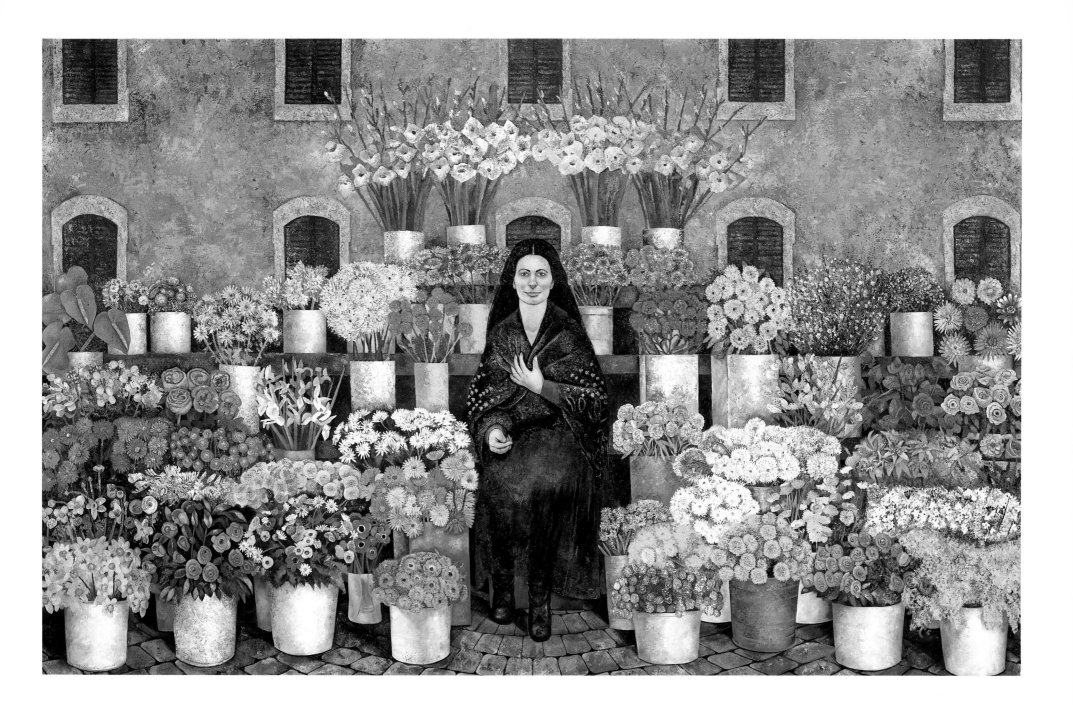

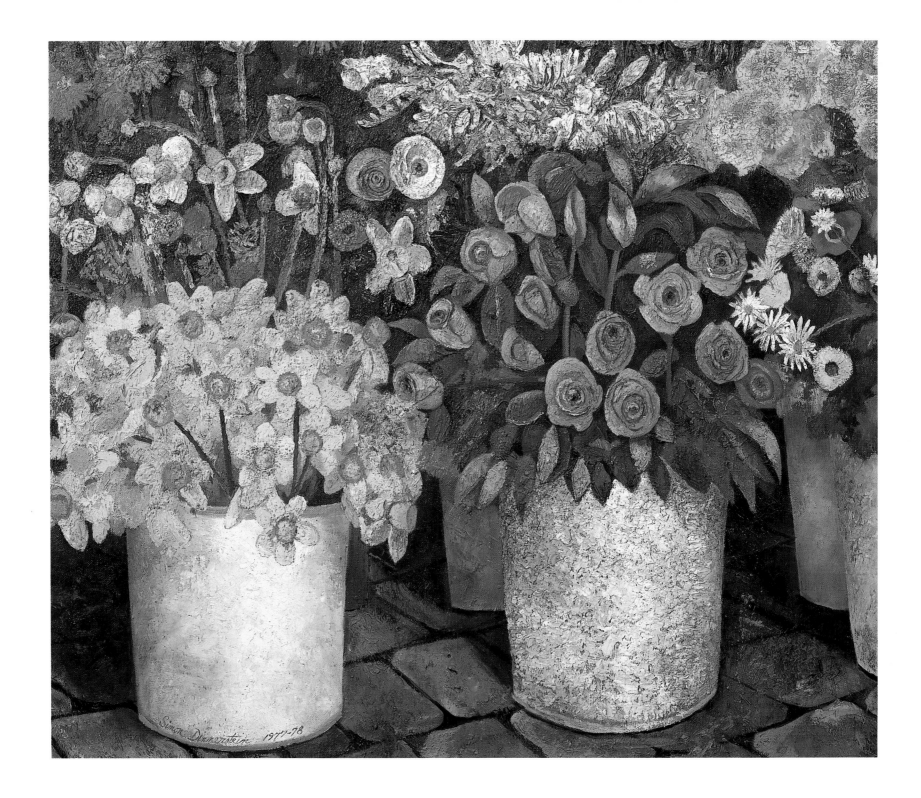

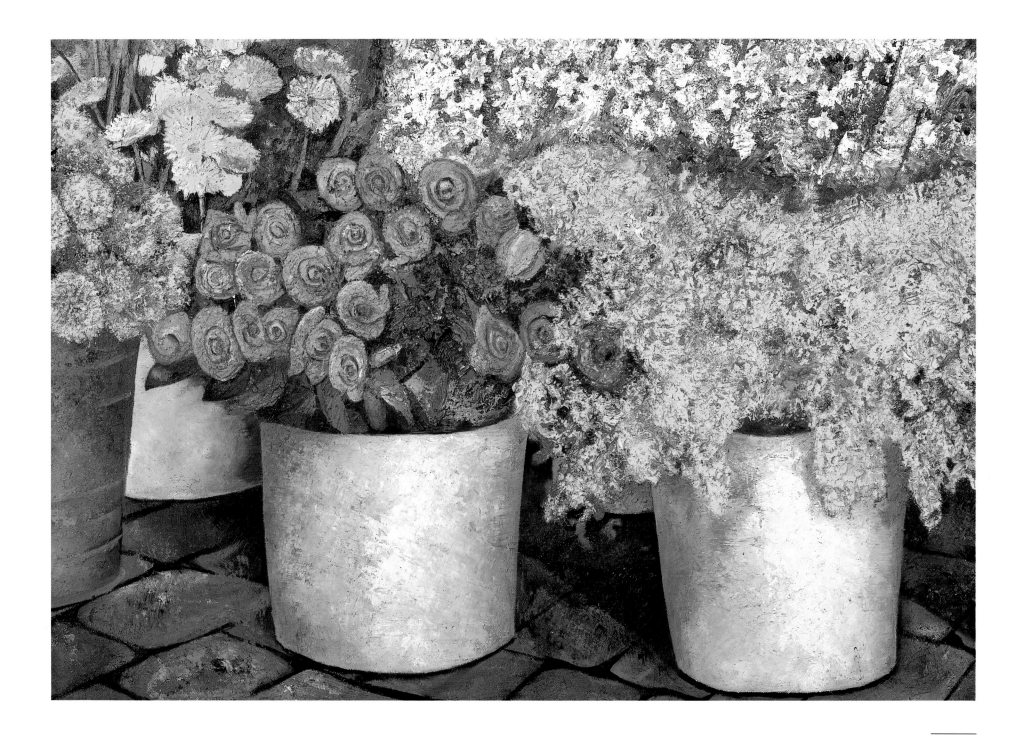

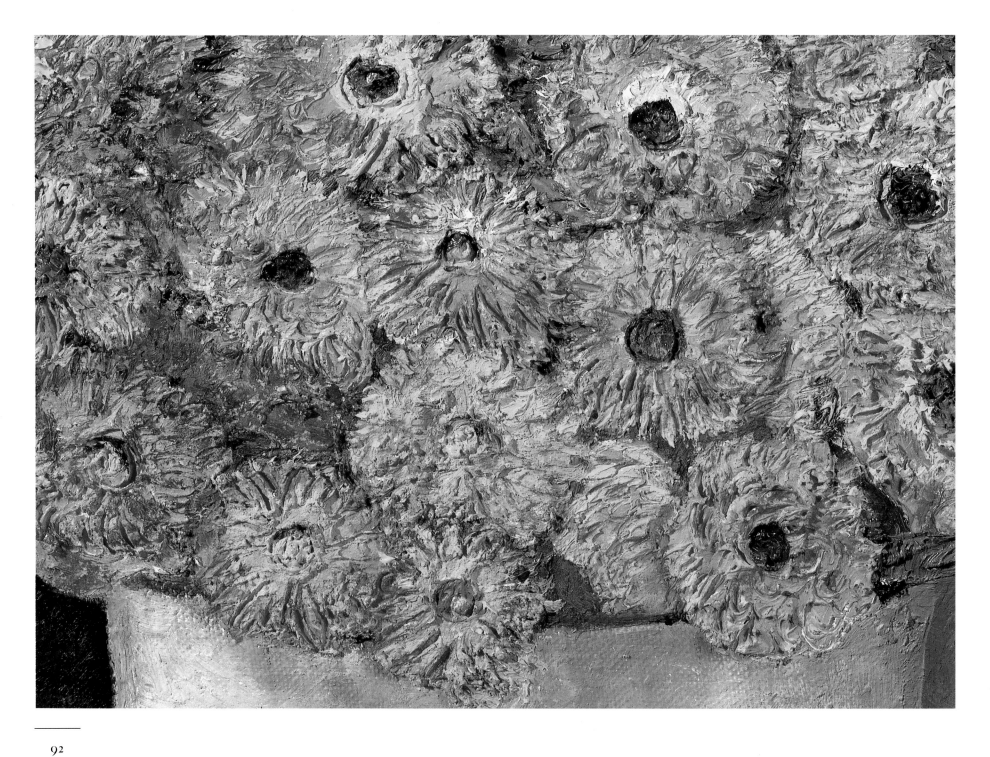

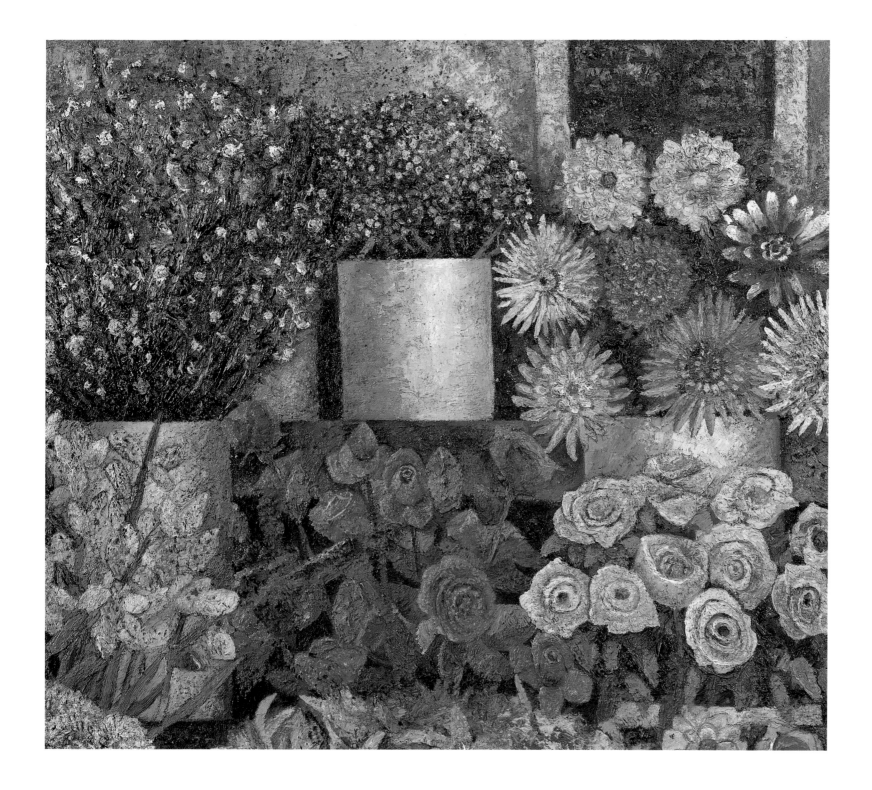

93

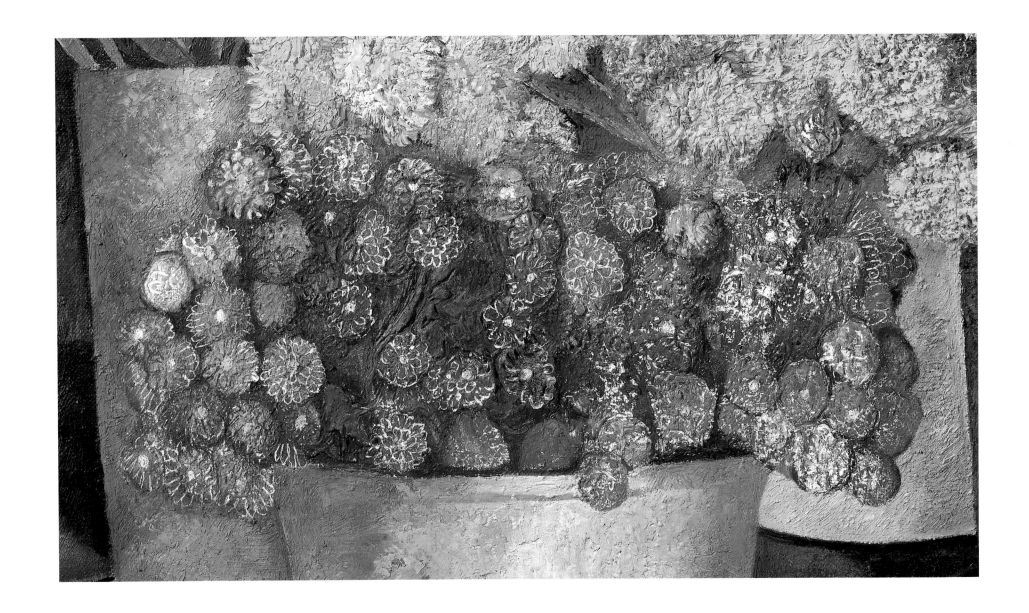

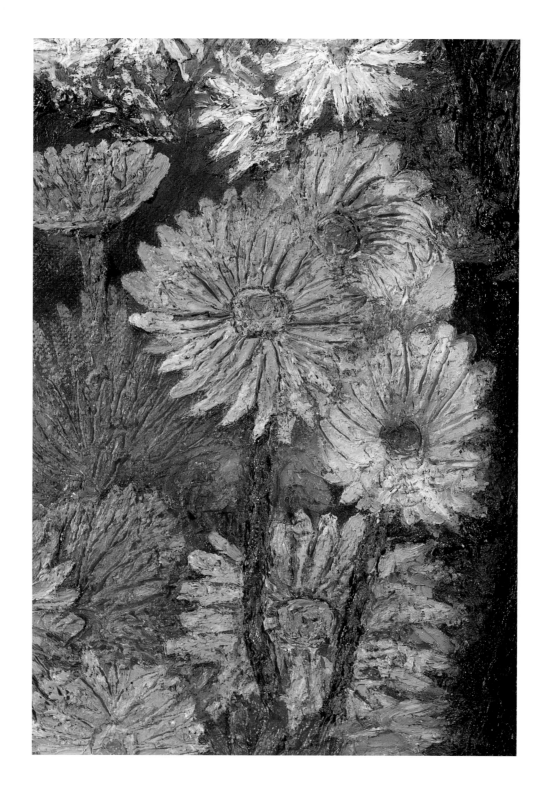

SELF-PORTRAIT (WITH FLOWER MARKET)
1978
Oil on canvas
25½″ × 39″
Maryann and Robert Baron,
Danville, California

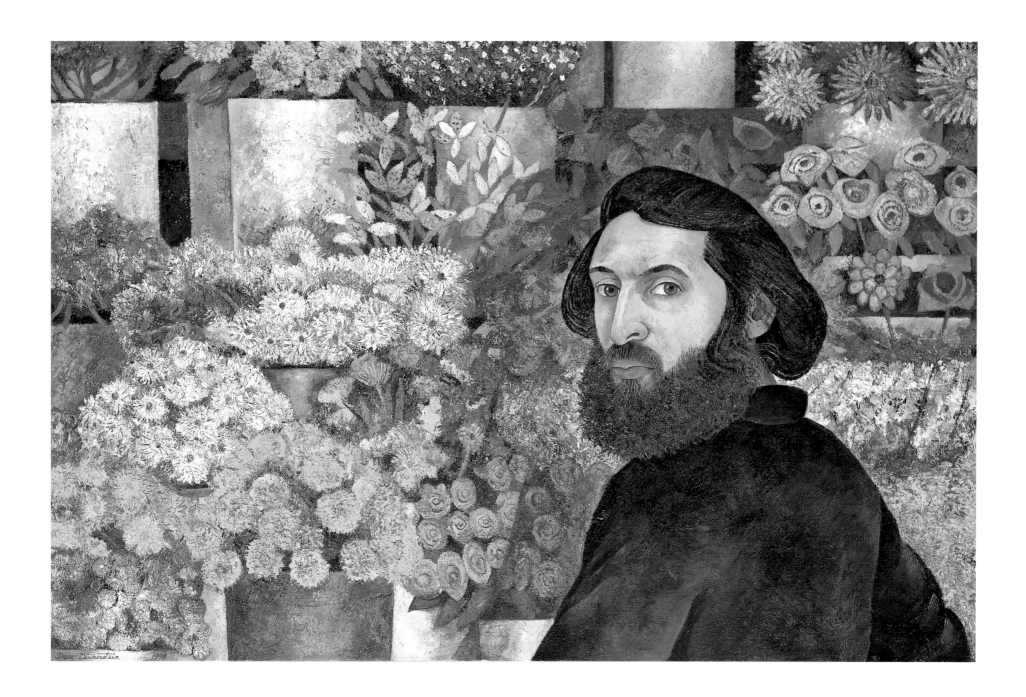

PURPLE PRIDE
1980
Oil on wood panel
23⅜″ × 32⅜″
Private collection

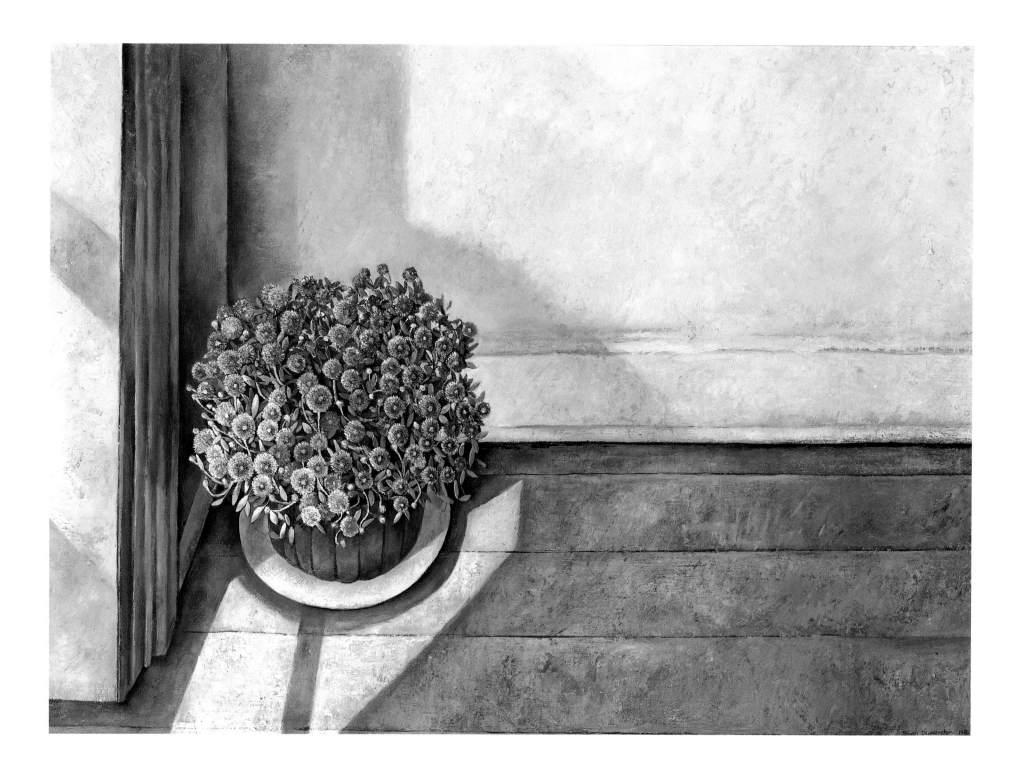

›› *page 104*
Two Musicians (*L'homme armé*)
1980
Oil on canvas
50″ × 75″
Lucy Bardo and Ben Harms,
New York

›› *page 105*
Two Musicians (*L'homme armé*)
Detail

Calling Card
1980
Oil on wood panel
25 ½″ × 33 ⅜″
Lorraine and Harry Shatz,
Huntington, New York

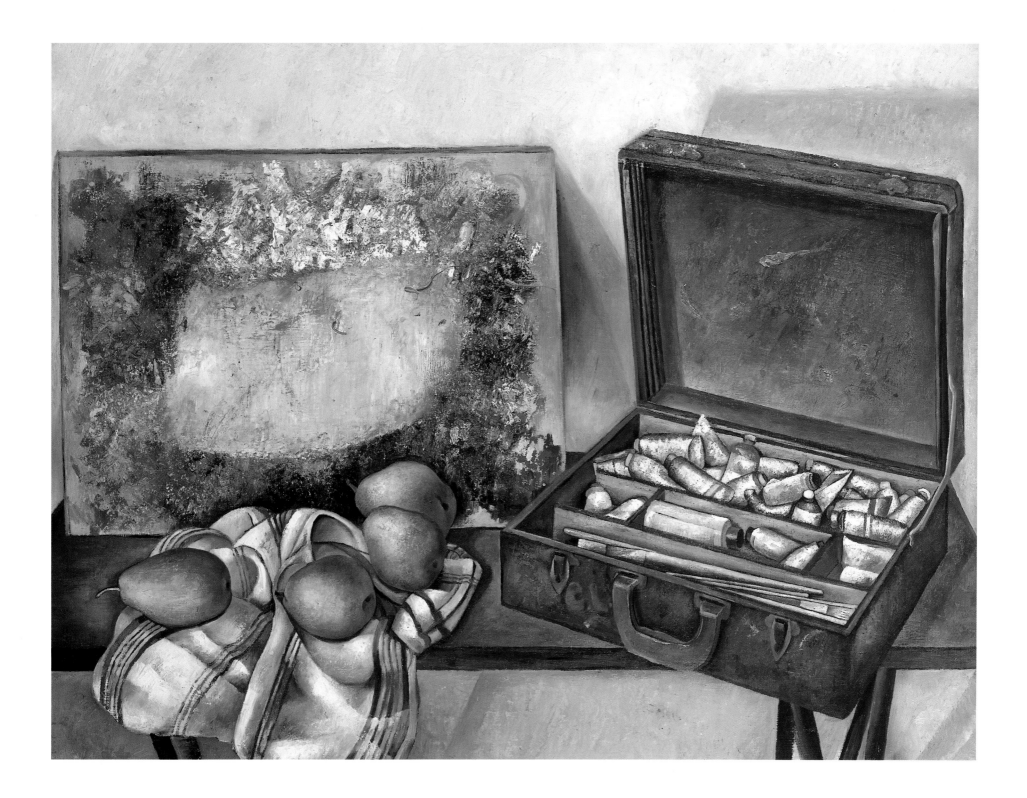

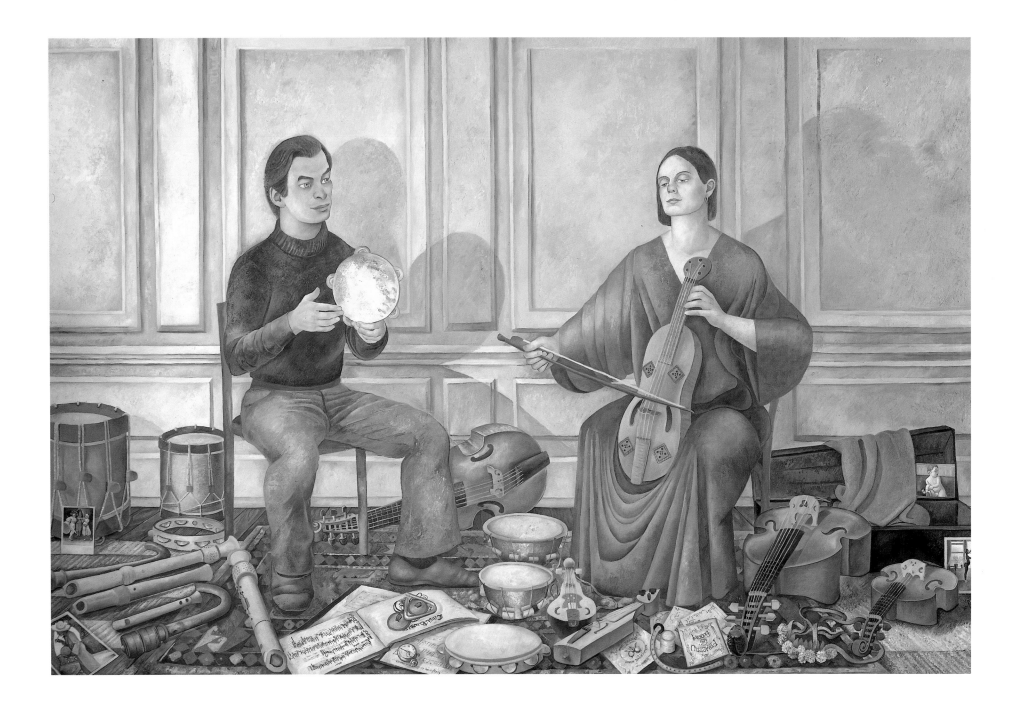

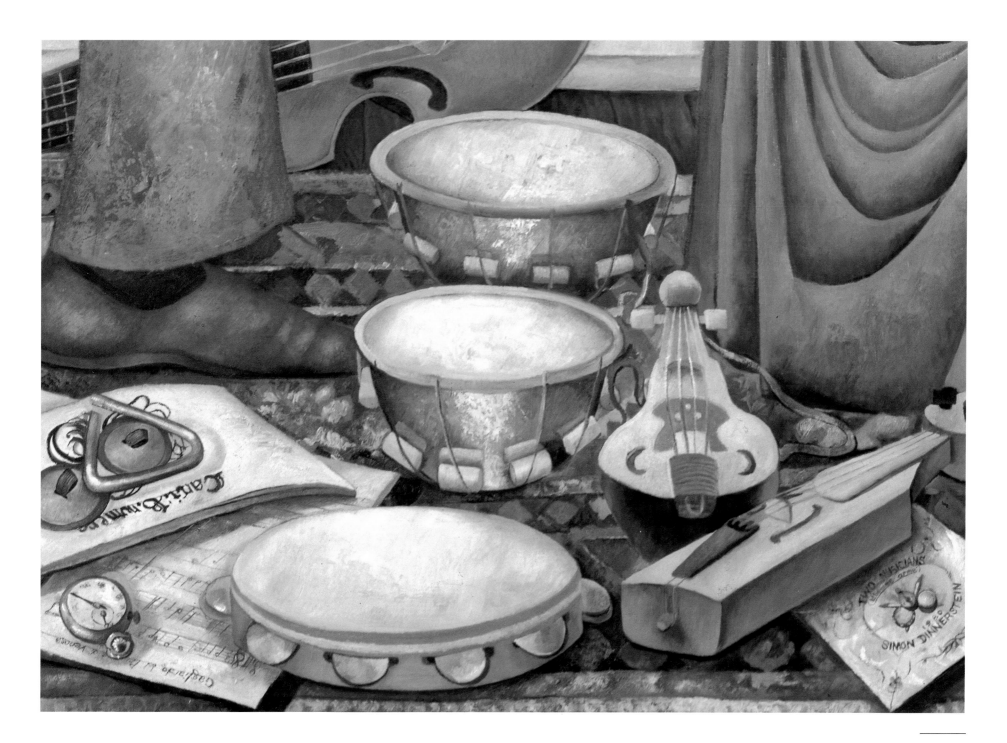

WHITEFISH
1979
Oil on wood panel
5 7/8″ × 12″
Howard and Harriet Zuckerman,
Monroe, New York

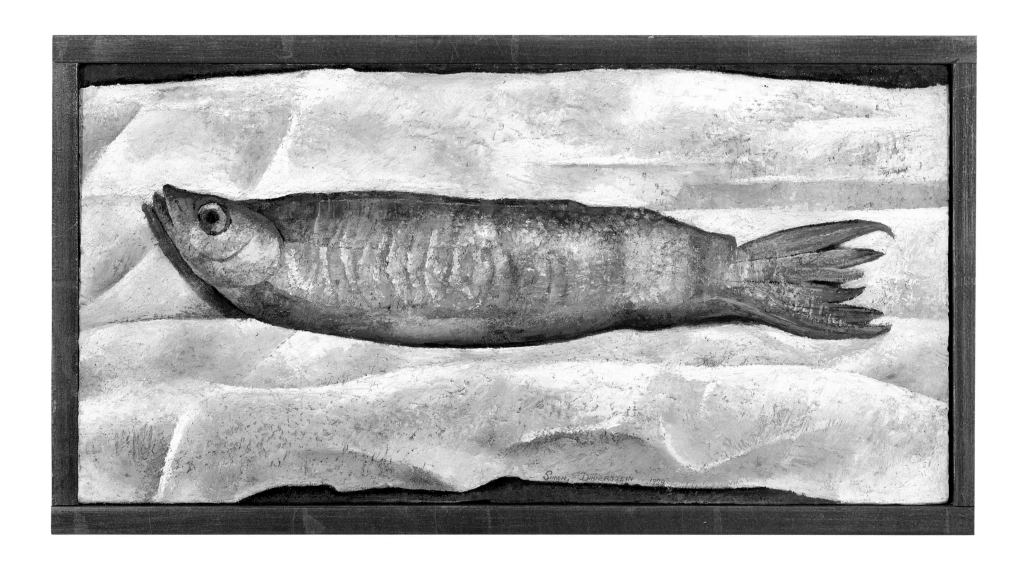

4 Pears
1981
Oil on wood panel
6½″ × 12¼″
Dr. Solomon Mikowsky,
New York

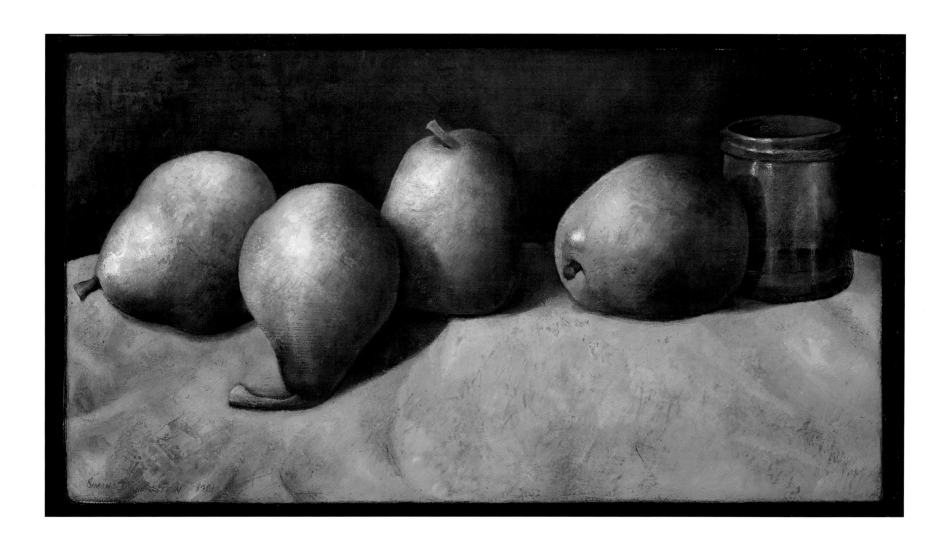

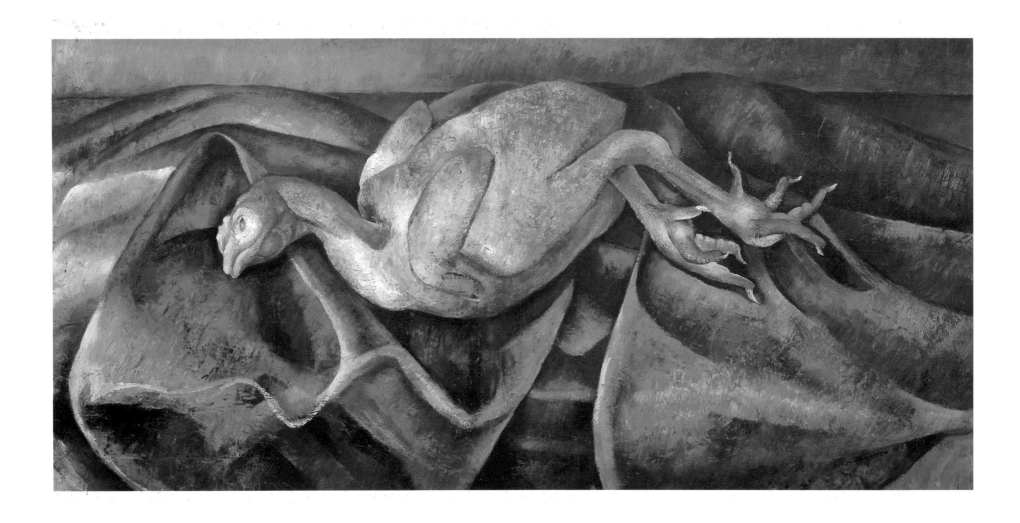

THIRD AVENUE POULTRY
1981
Oil on wood panel
11″ × 23⁵/₁₆″

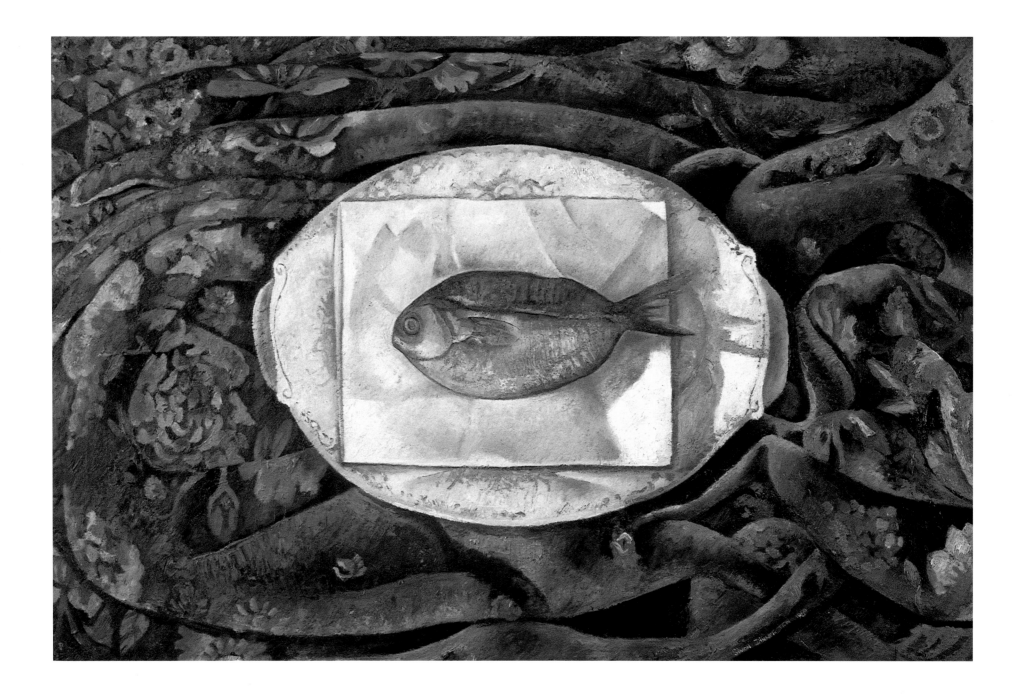

BUTTERFISH AND RUSSIAN SHAWL
1980
Oil on wood panel
17″ × 25″
Private collection,
Connecticut

BREAD AND ONIONS
1981
Oil on wood panel
9¾" × 15⅞"
Isme and Marcello Poletti,
New York

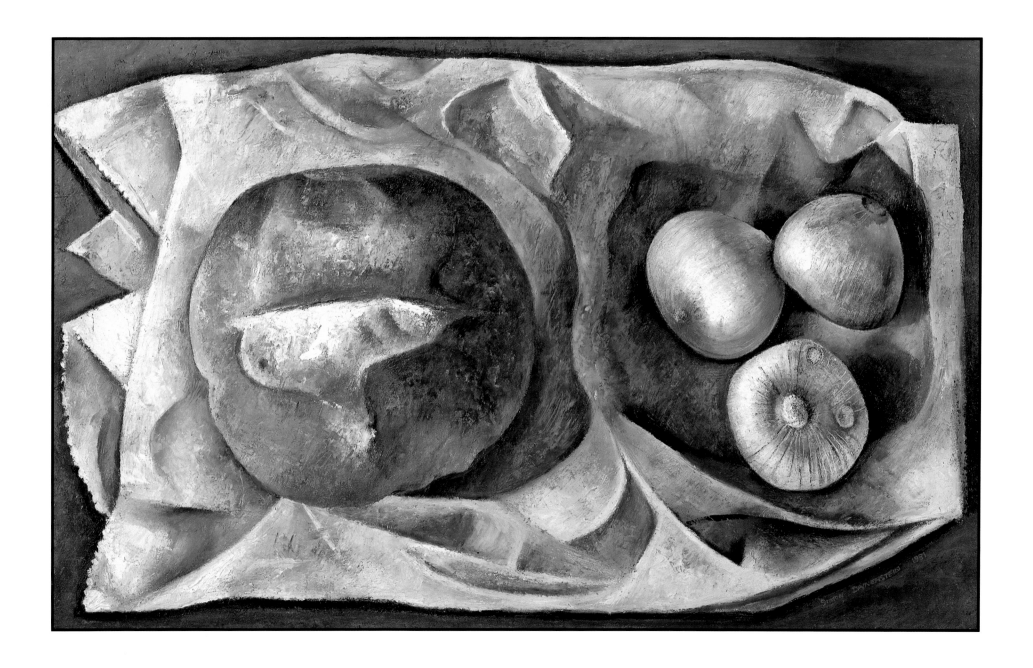

›› *page 118*
GREGORY'S PARTY
1979
Oil on wood panel
42″ × 64″
Private collection,
Brooklyn, New York

THE BIRTHDAY DRESS
1977
Oil on wood panel
55″ × 36″
Howard and Harriet Zuckerman,
Monroe, New York

›› *page 119*
GREGORY'S PARTY
Detail

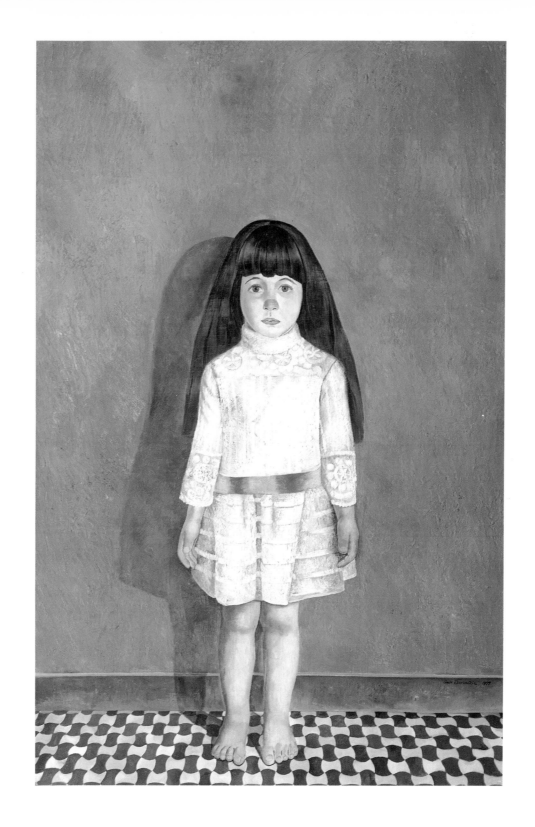

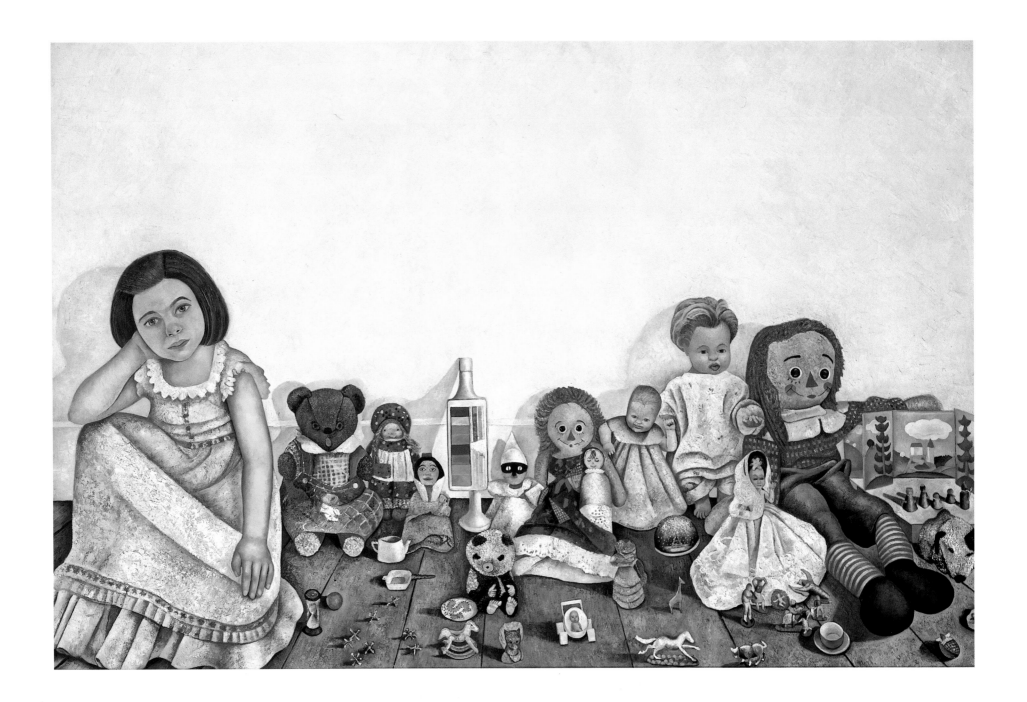

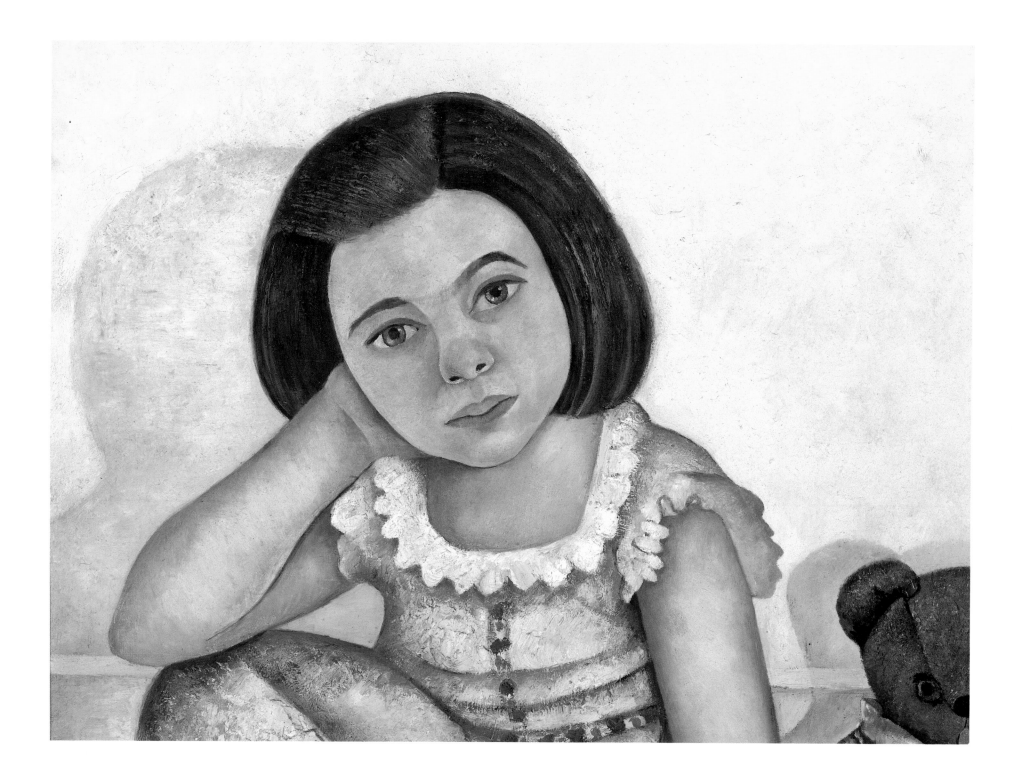

FLORAL STUDIES
1983
Silverpoint
9⅛″ × 13″
Thea Tewi,
Queens, New York

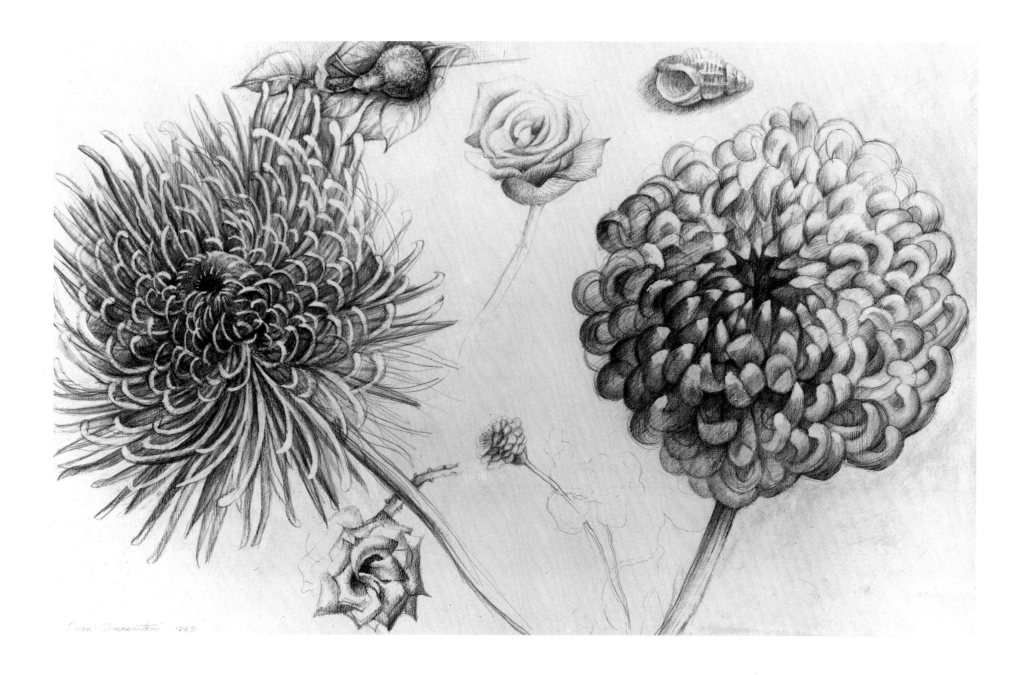

Simon Dinnerstein 1983

›› *page 124*
TIMMY

1977
Conté crayon
24⅛″ × 18⅛″

›› *page 125*
JOHANNES FELBERMEYER

1977
Conté crayon
24⅛″ × 18¼″

THE CITY, THE TOWN, THE EMPEROR OF CHINA

1983
Silverpoint
24¾″ × 39″

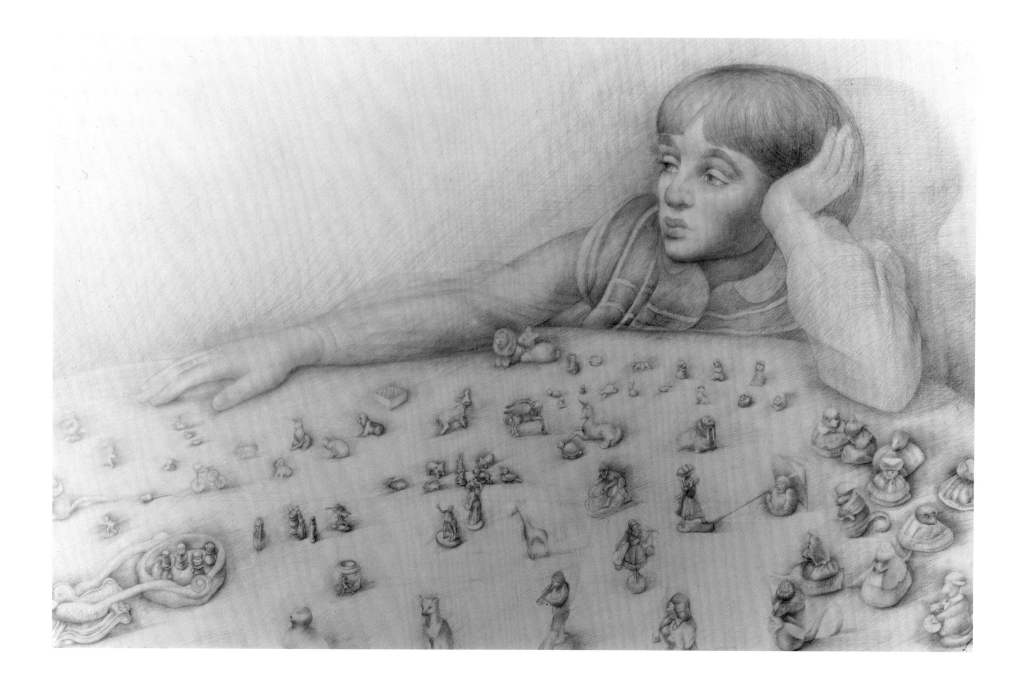

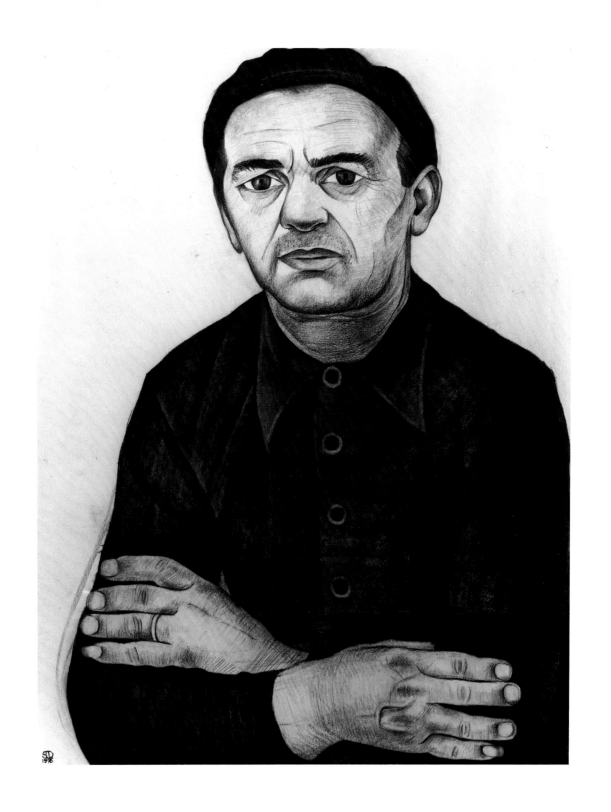

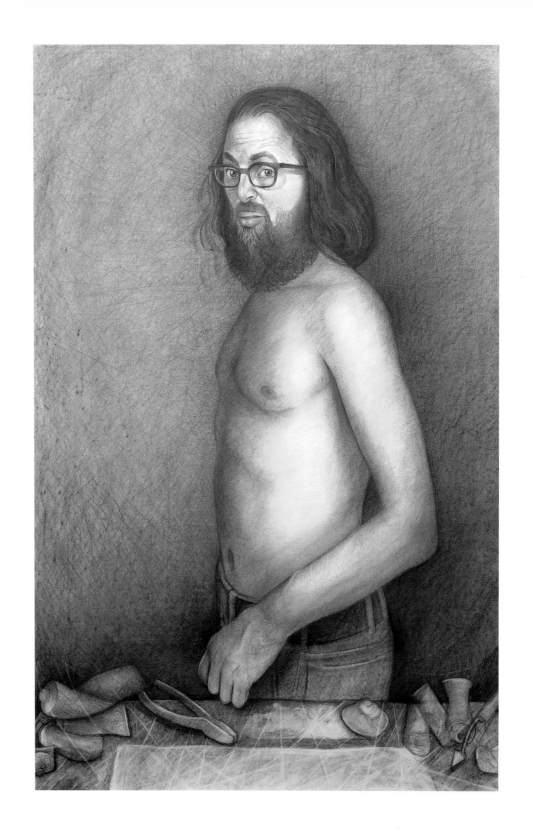

‹‹ *page 126*
TERESA
1976
Conté crayon
24⅛″ × 18¼″

‹‹ *page 127*
UMBERTO
1976
Conté crayon
24⅛″ × 18¼″

SELF-PORTRAIT, SUMMER
1981
Conté crayon
39½″ × 25⅝″

SONATINA
1981
Conté crayon
26½″ × 40½″
Ms. Elyse Vitiello,
Brooklyn, New York

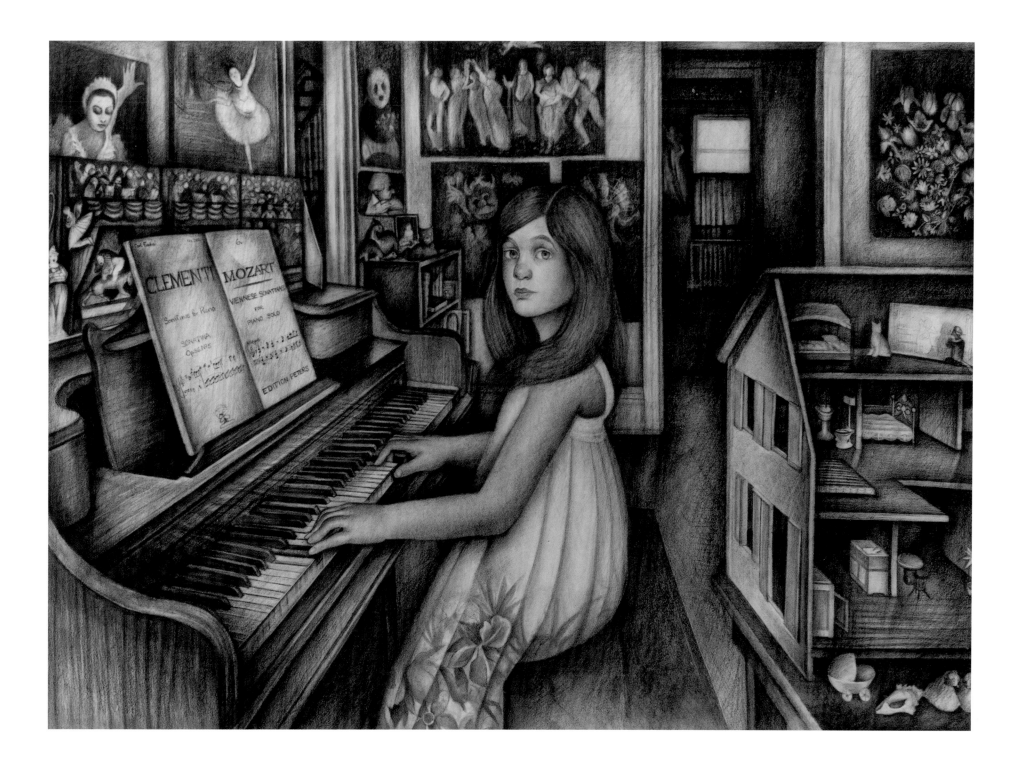

NOCTURNE
1982
Conté crayon, traces of colored pencil
29½" × 43⅞"

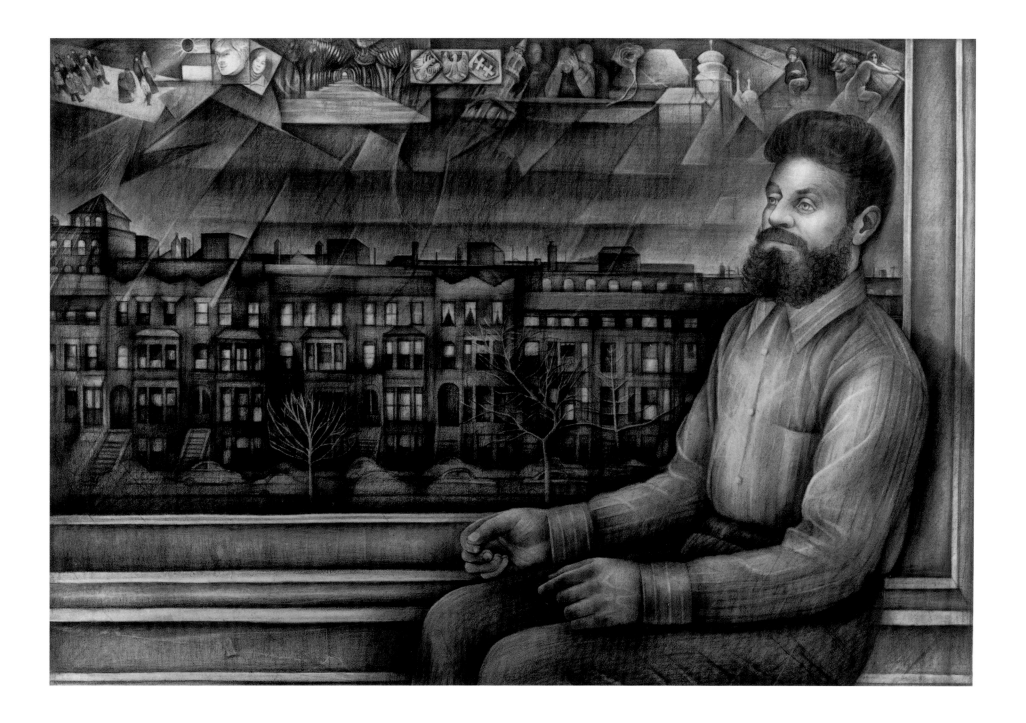

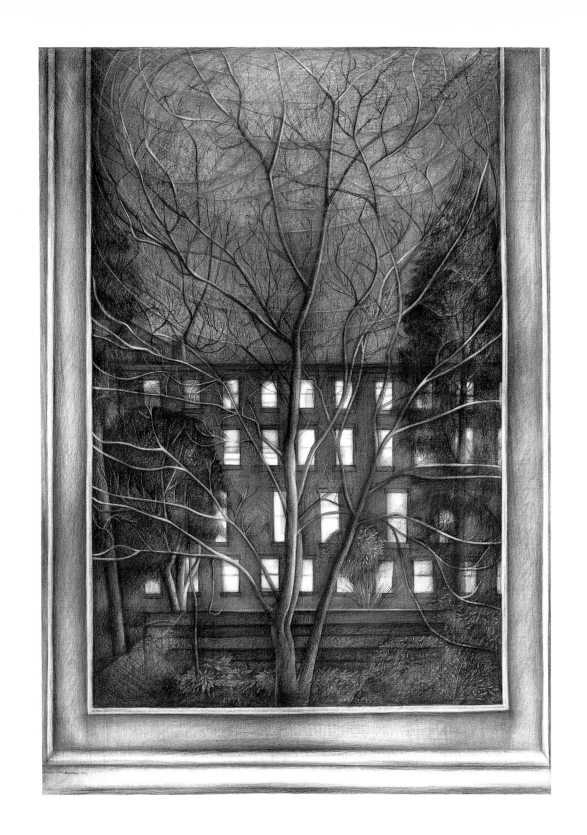

Night Scene I
1982
Conté crayon, colored pencil
41¾″ × 29¾″
National Museum of American Art,
the Smithsonian Institution,
gift of the Sara Roby Foundation

NIGHT SCENE II
1983
Conté crayon, colored pencil, pastel
30⅜″ × 39⅛″

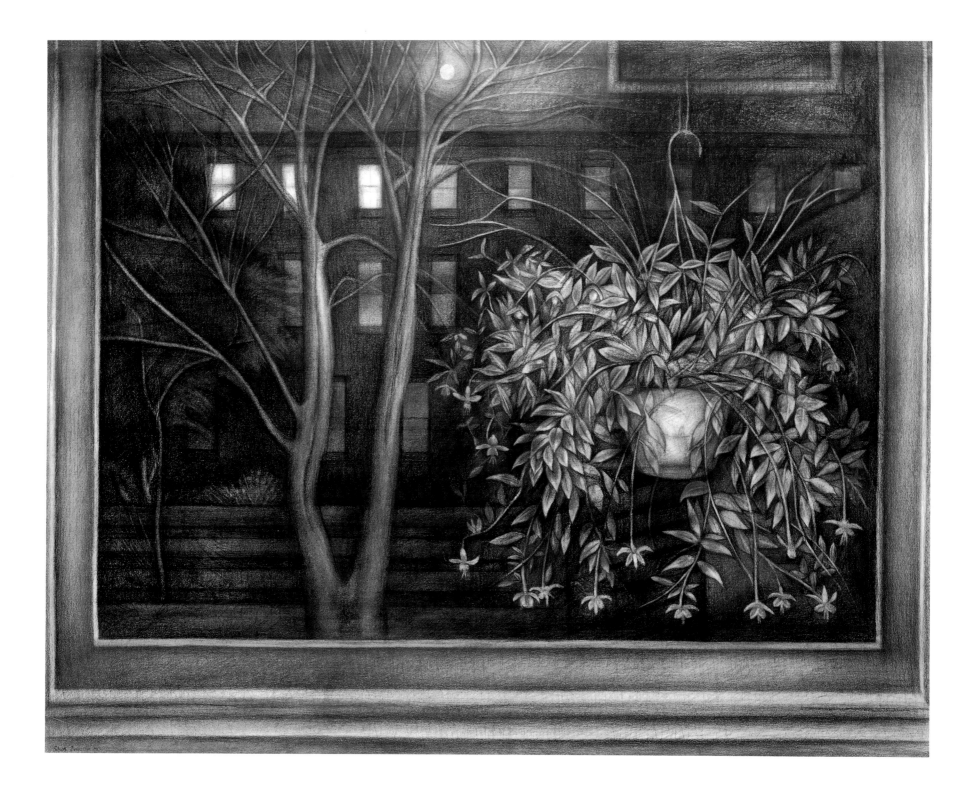

YVES
1982
Conté crayon, colored pencil, pastel
14″ × 14⅛″
Yves Deetjen,
Brooklyn, New York

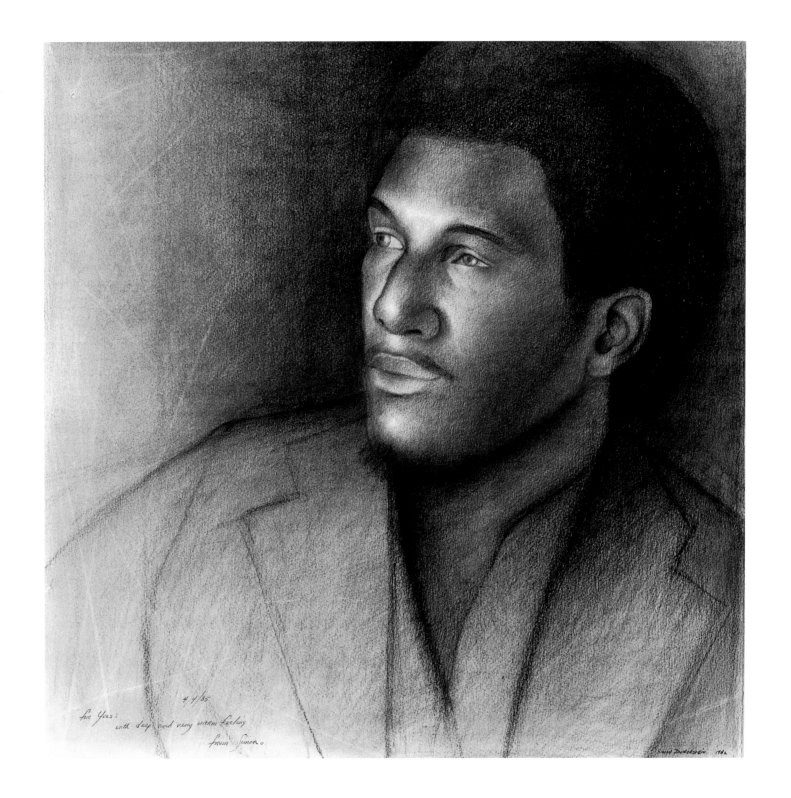

For Yias:
with deep and very warm feeling
from Simon.

4/4/85

Simon Dinnerstein 1982

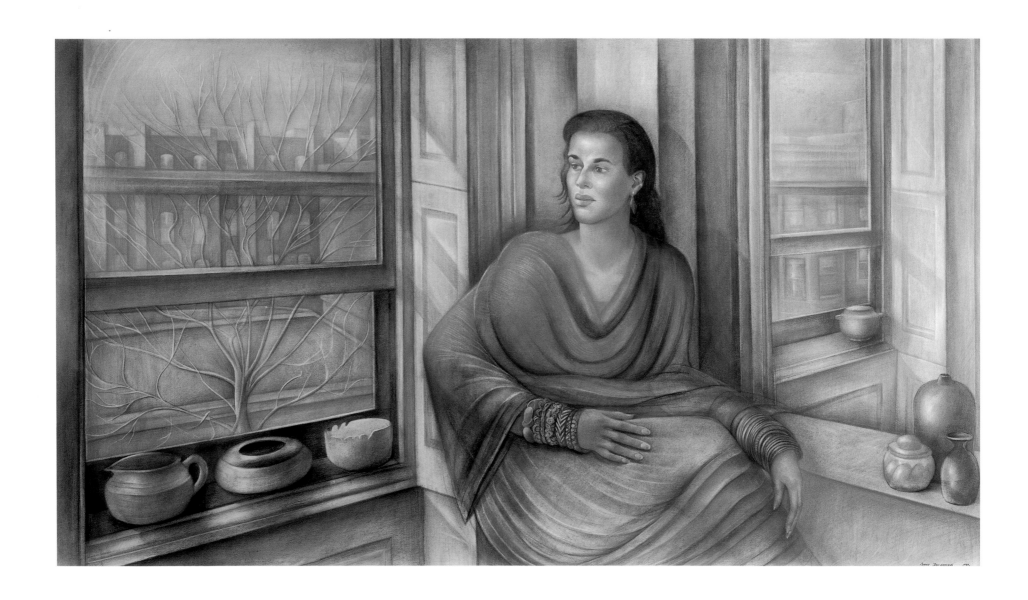

›› *page 142*
STILL LIFE WITH SMALL FRUIT
1986
Conté crayon, colored pencil, pastel
19⅛″ × 24¼″
Pamela Sztybel and Stephen Winningham,
Brooklyn, New York

KIM
1984–85
Conté crayon, colored pencil, pastel
32½″ × 58½″

›› *page 143*
PEARS, AUTUMN
1984
Conté crayon, colored pencil, pastel
16″ × 24″

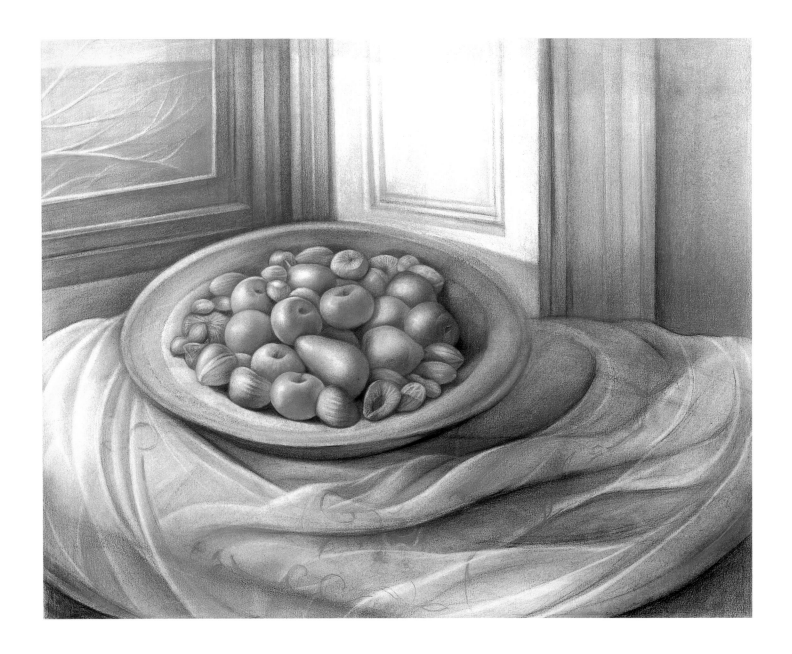

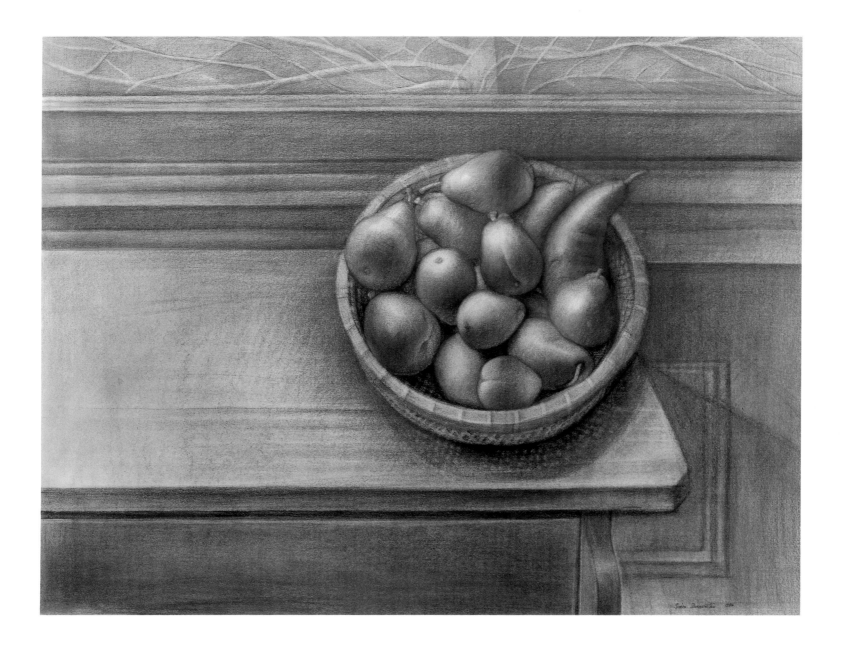

ROME BEAUTIES
1985
Conté crayon, colored pencil, pastel
20″ × 25⅞″
Private collection,
New York

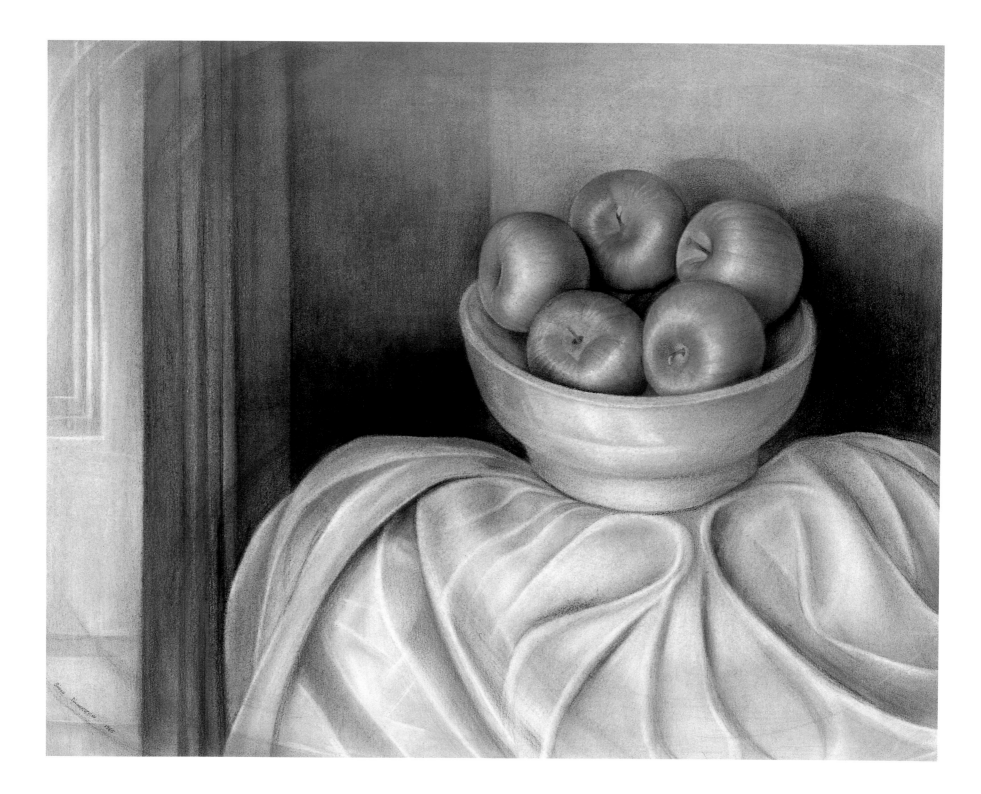

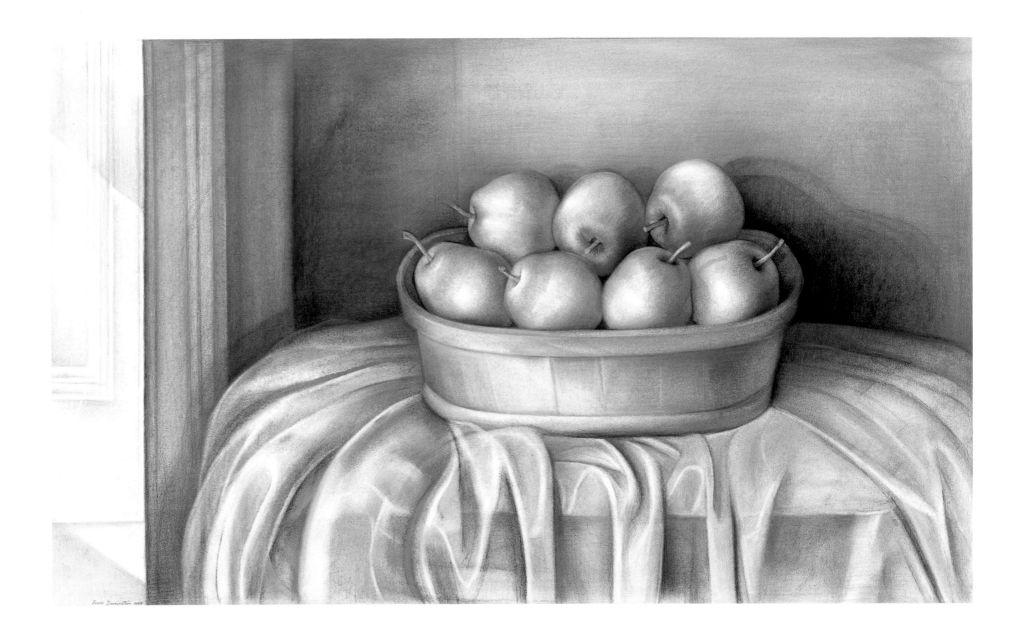

FRENCH PEARS
1987
Conté crayon, colored pencil, pastel
19⅞″ × 33¾″

>> *page 150*
RED POTATOES
1982
Conté crayon, colored pencil, pastel
17⅝″ × 28⅞″
Maryann and Robert Baron,
Danville, California

>> *page 151*
GOURD AND ONIONS
1982
Conté crayon, colored pencil
8⅞″ × 14⅞″
Lucy Bardo and Ben Harms,
New York

WINTER APPLES
1986
Conté crayon, colored pencil, pastel
18⅞″ × 28⅛″
Pamela Sztybel and Stephen Winningham,
Brooklyn, New York

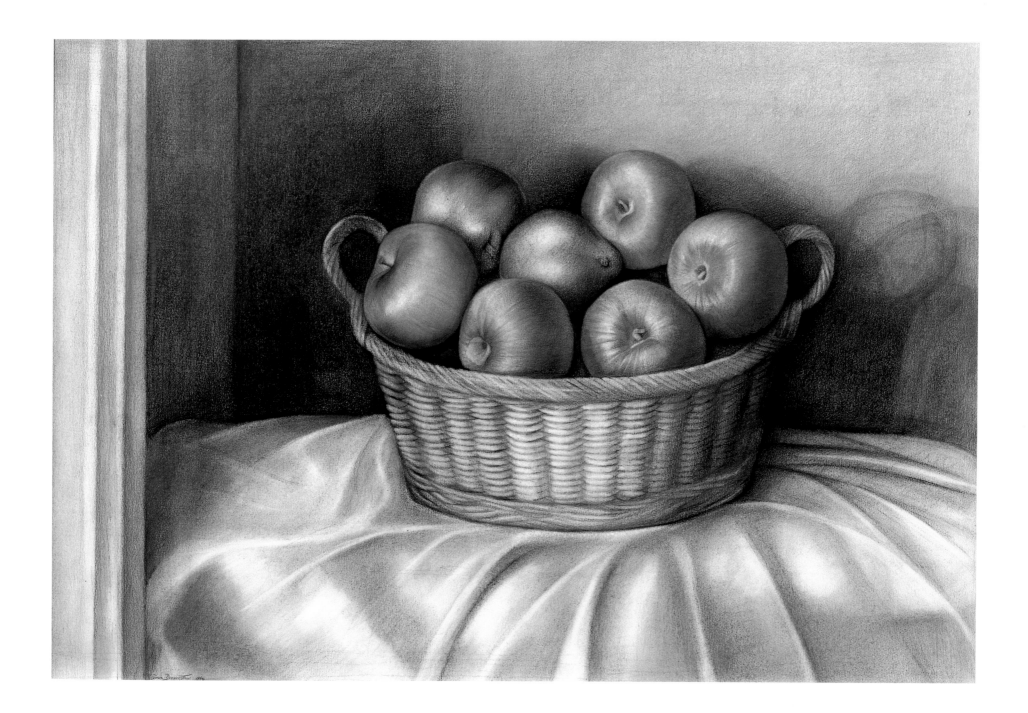

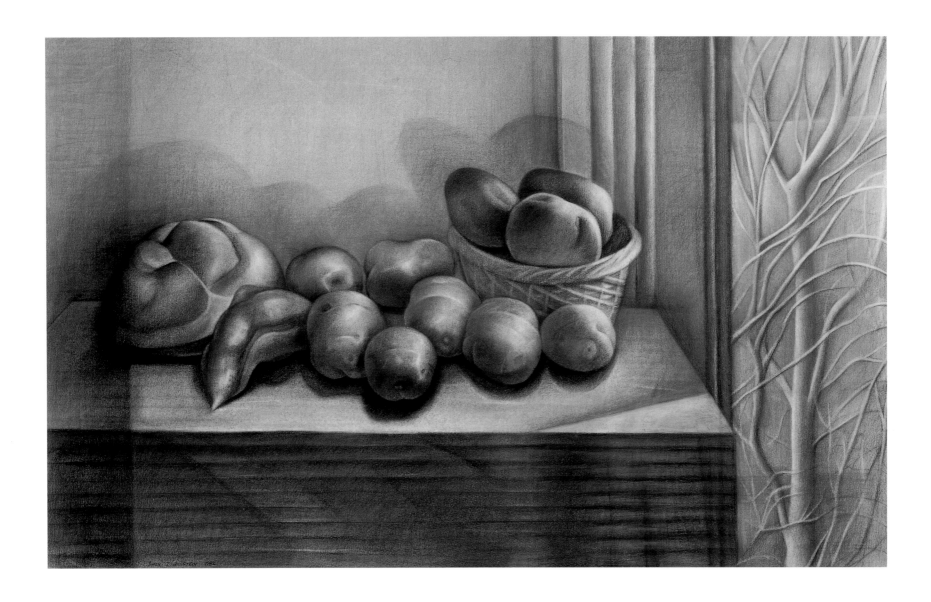

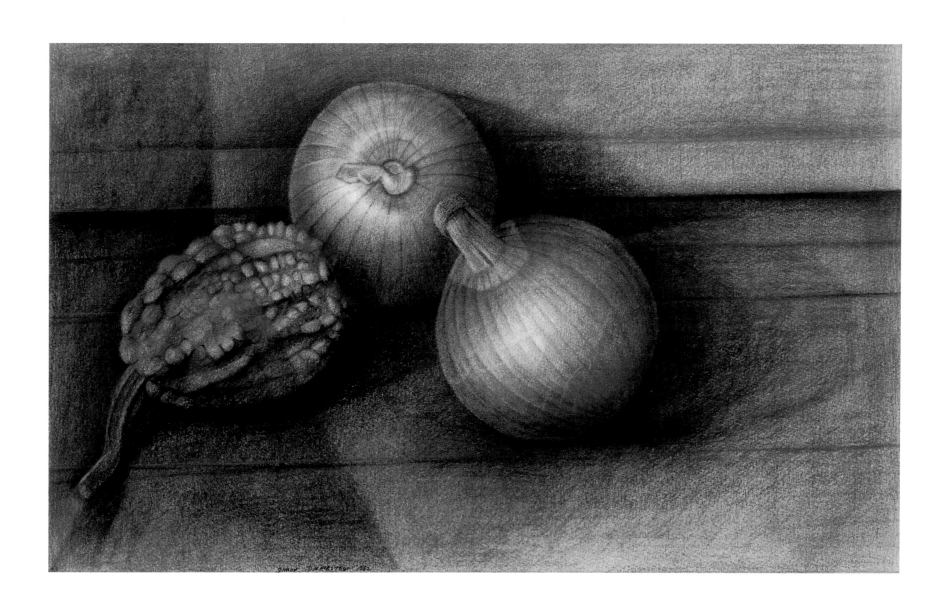

OVAL STILL LIFE
1987
Conté crayon, colored pencil, pastel
20″ × 30″ oval

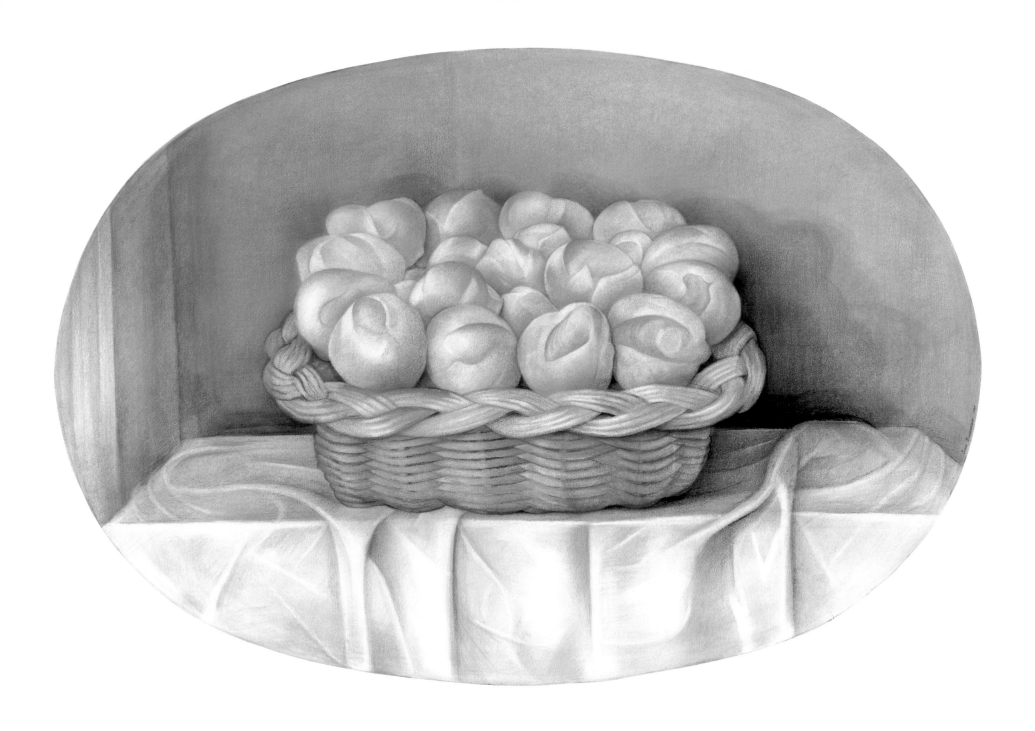

GLOXINIA
1981
Conté crayon
21⅜″ × 29½″
Mickey and Bob Swee,
New York

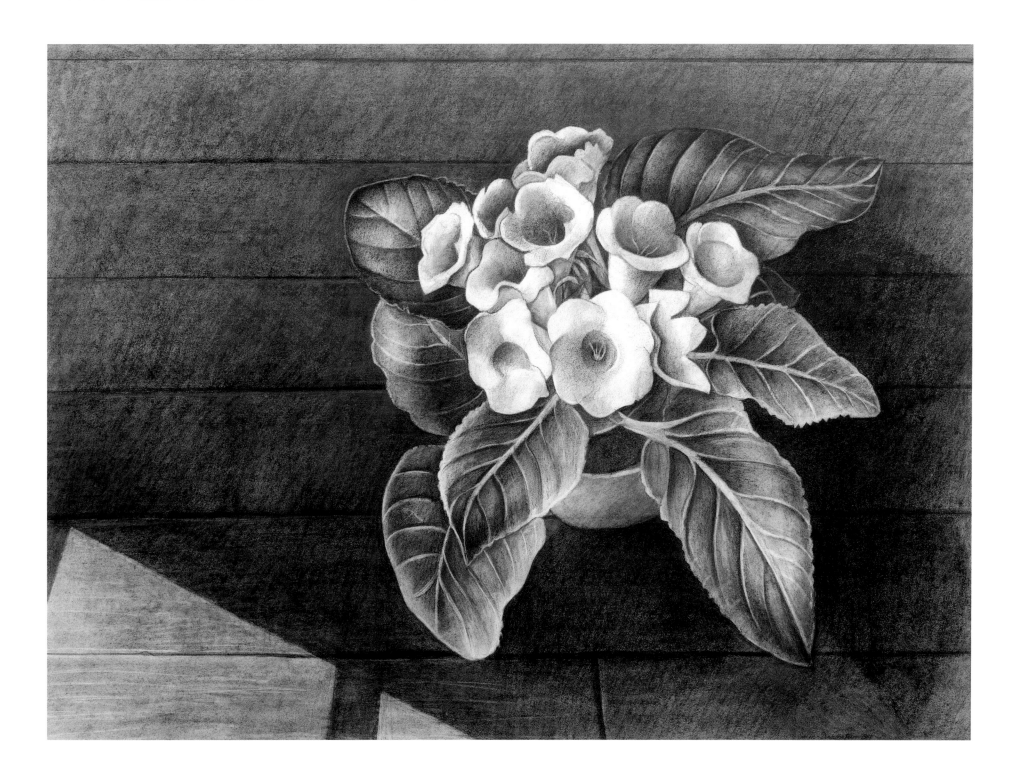

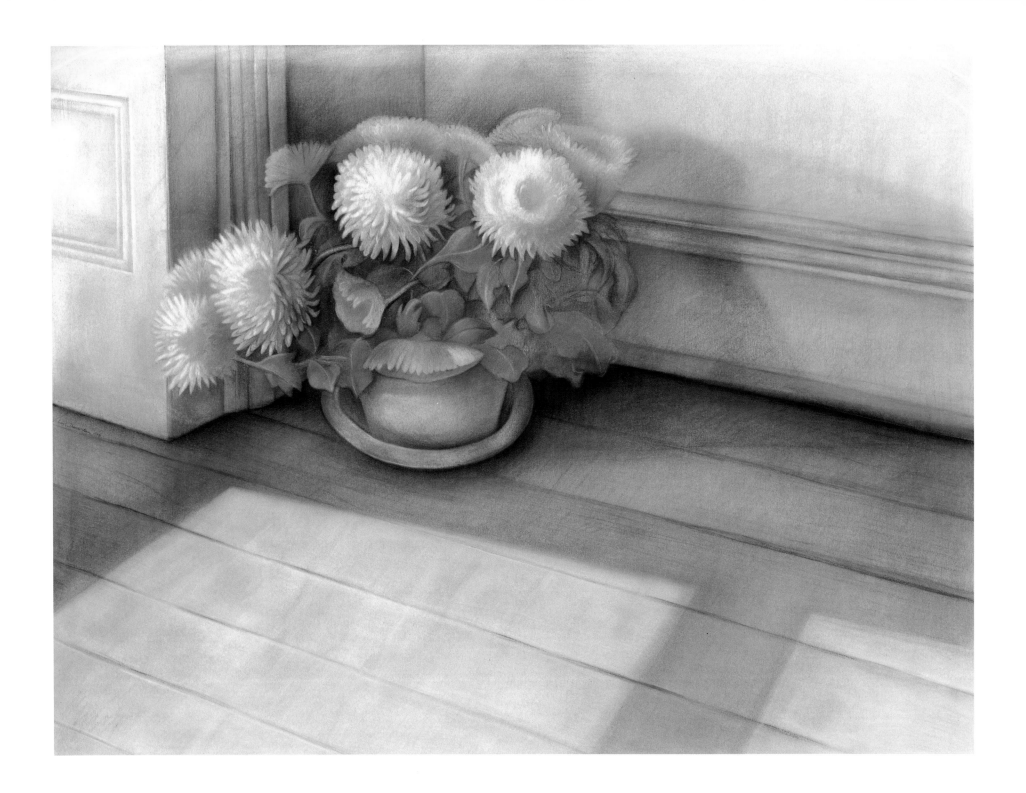

MUMS IN WINTER LIGHT
1986
Conté crayon, colored pencil, pastel
25⅛″ × 33⅞″
Mickey and Bob Swee,
New York

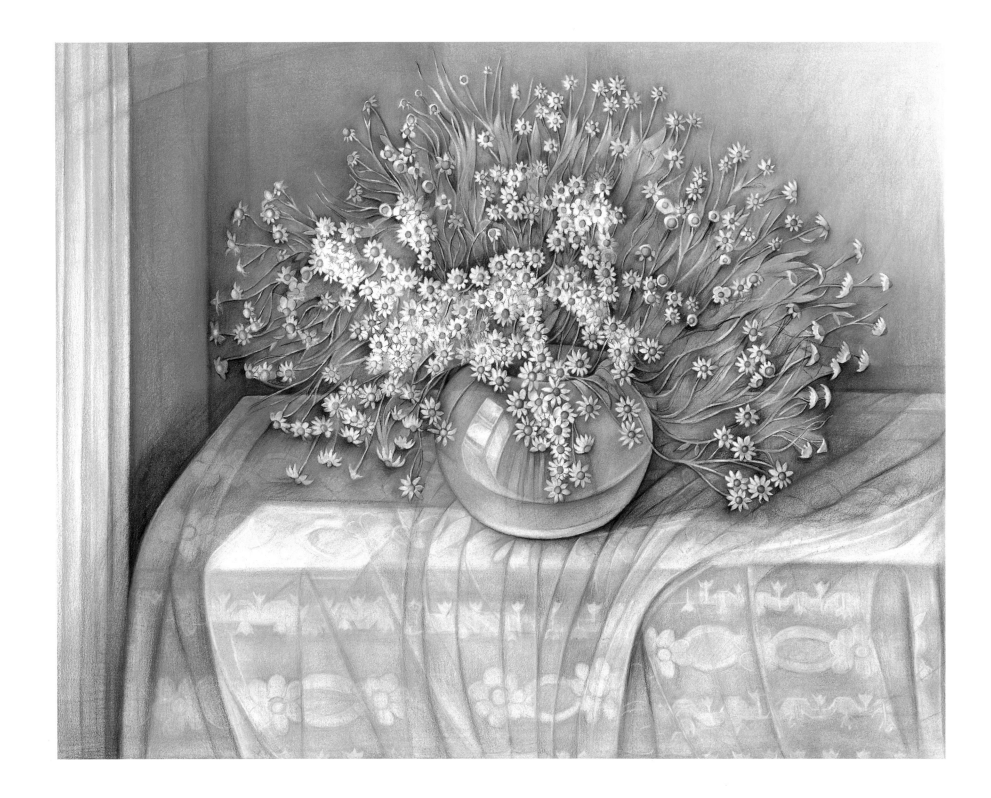

CHAMOMILE
1988
Conté crayon, colored pencil, pastel
21 ⅜″ × 27 ⅛″
Dr. Avery Ferentz,
New York

GOLDEN MUMS
1988
Conté crayon, colored pencil, pastel
29¾" × 45½"

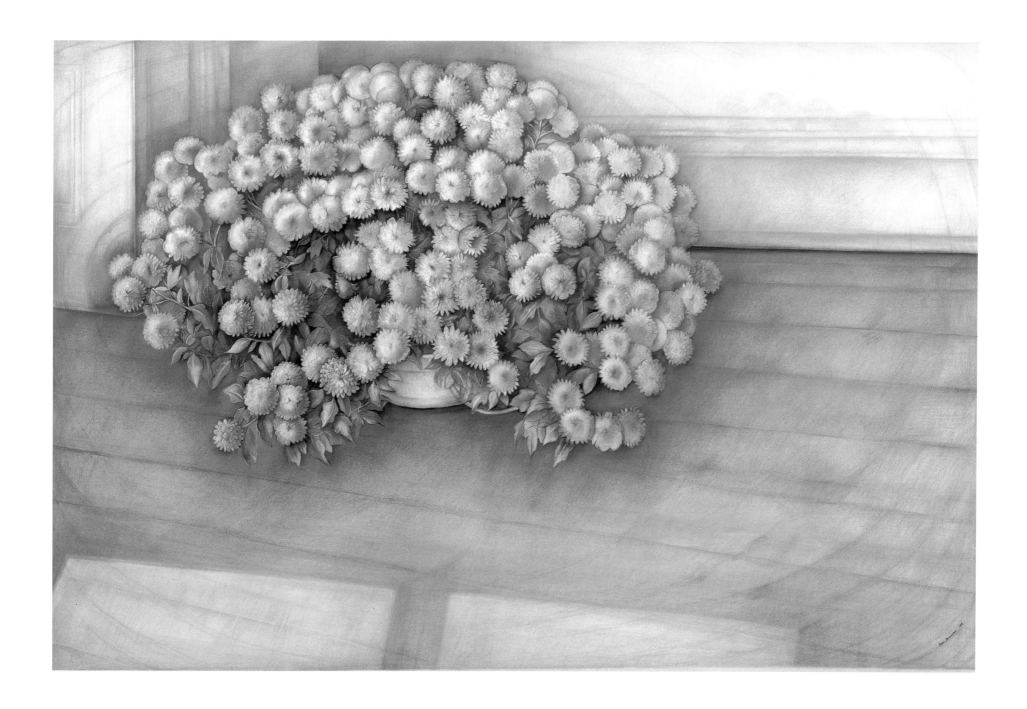

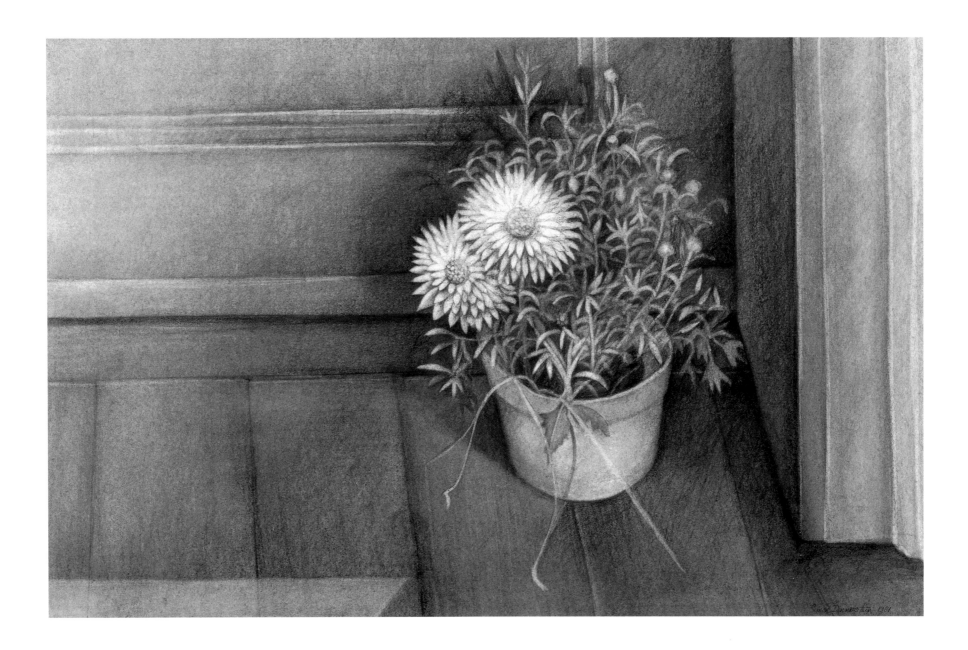

Two Chrysanthemums
1981
Conté crayon
12⅞″ × 20¼″
Dr. and Mrs. Harvey Rossel

FEBRUARY ROSES
1987
Conté crayon, colored pencil, pastel
5¾″ × 14⅞″
Mickey and Bob Swee,
New York

JUNE APPLES
1985
Conté crayon, colored pencil, pastel
6½″ × 8⅞″
Reproduced to size
Roberta and Gilbert Feldman,
New York

BROOKLYN POPPIES
1987
Conté crayon, colored pencil, pastel
6¼″ × 11¼″

›› *page 172*
ABOUT STRANGE LANDS AND PEOPLE
1984
Conté crayon, colored pencil, pastel
52 7/8″ × 38 1/2″

›› *page 173*
ABOUT STRANGE LANDS AND PEOPLE
Detail

GLORIOSA DAISIES
1987
Conté crayon, colored pencil, pastel
37 1/2″ × 24 1/2″
Vinson & Elkins,
Dallas, Texas

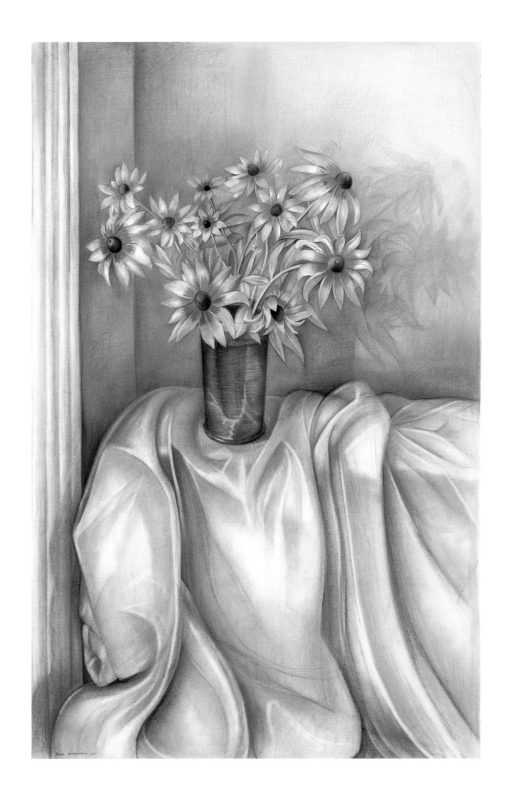

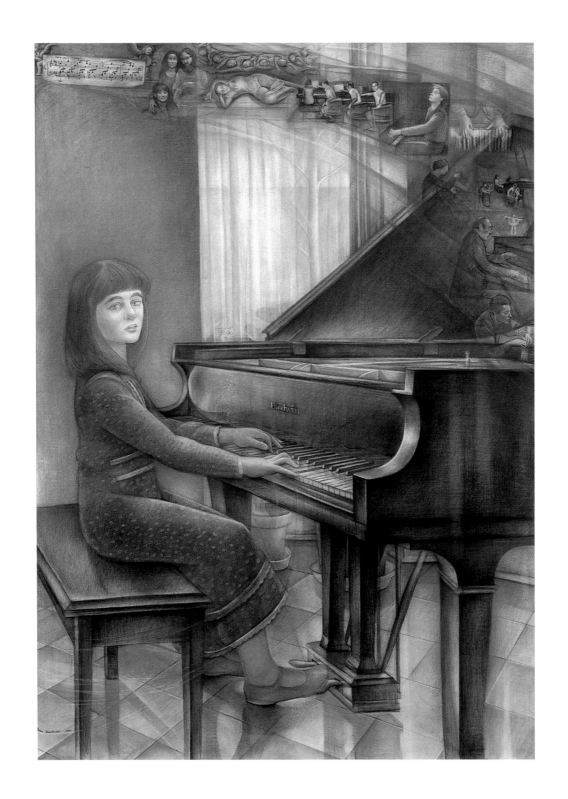

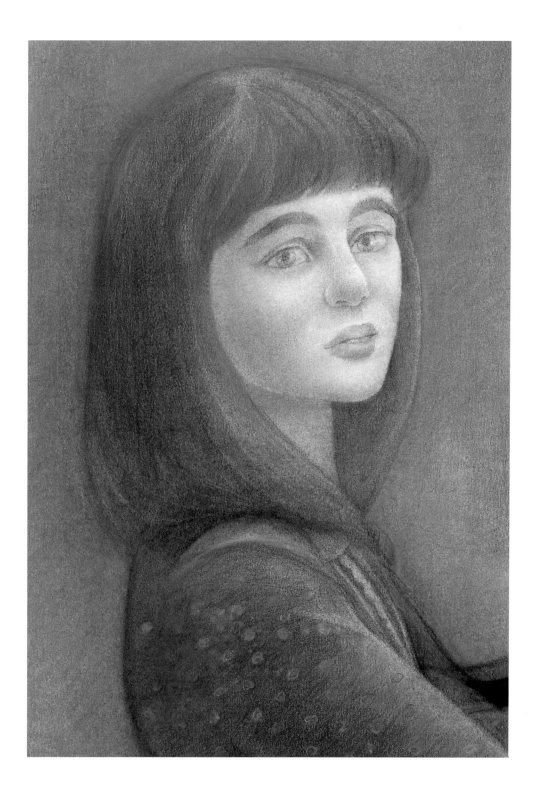

FIFTEENTH SUMMER
1987
Conté crayon, colored pencil, pastel
14¼″ × 9⅛″

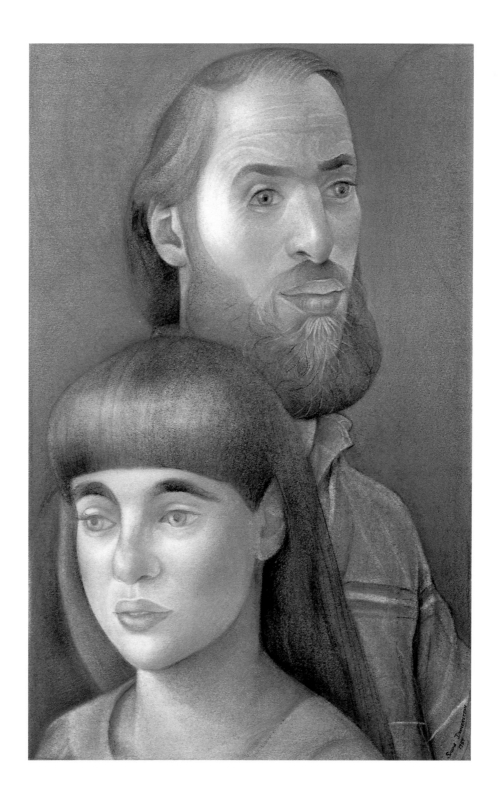

LATE AFTERNOON
1982
Conté crayon, colored pencil, pastel
29⅜″ × 43⅞″

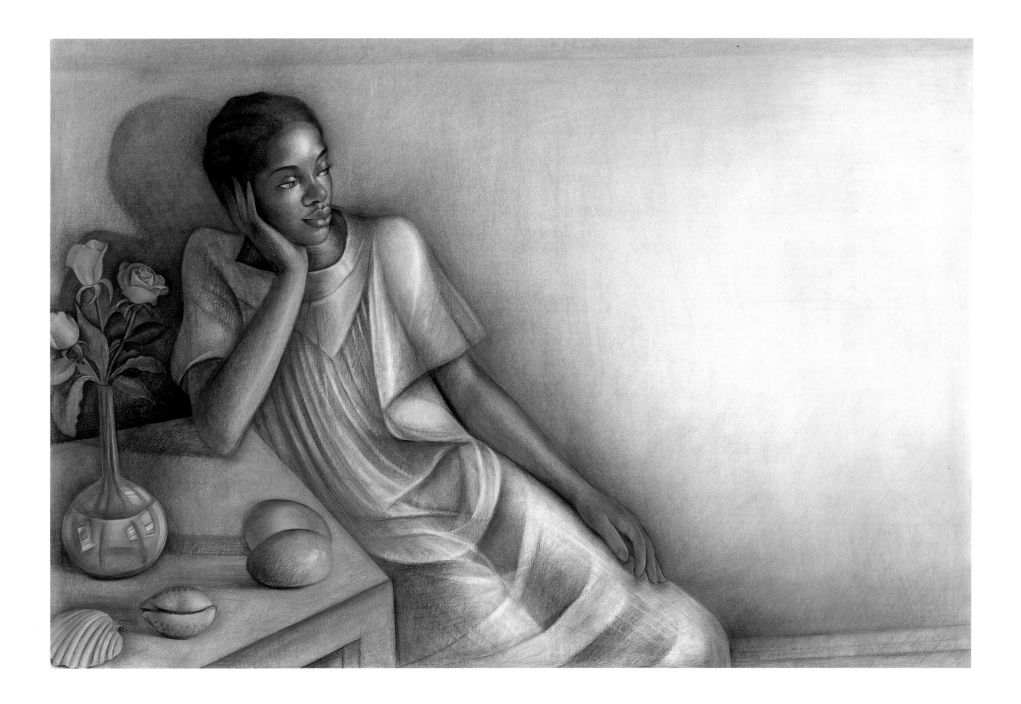

In Sleep
1983
Conté crayon, colored pencil, pastel
33½″ × 59⅛″
National Museum of American Art,
the Smithsonian Institution,
gift of the Sara Roby Foundation

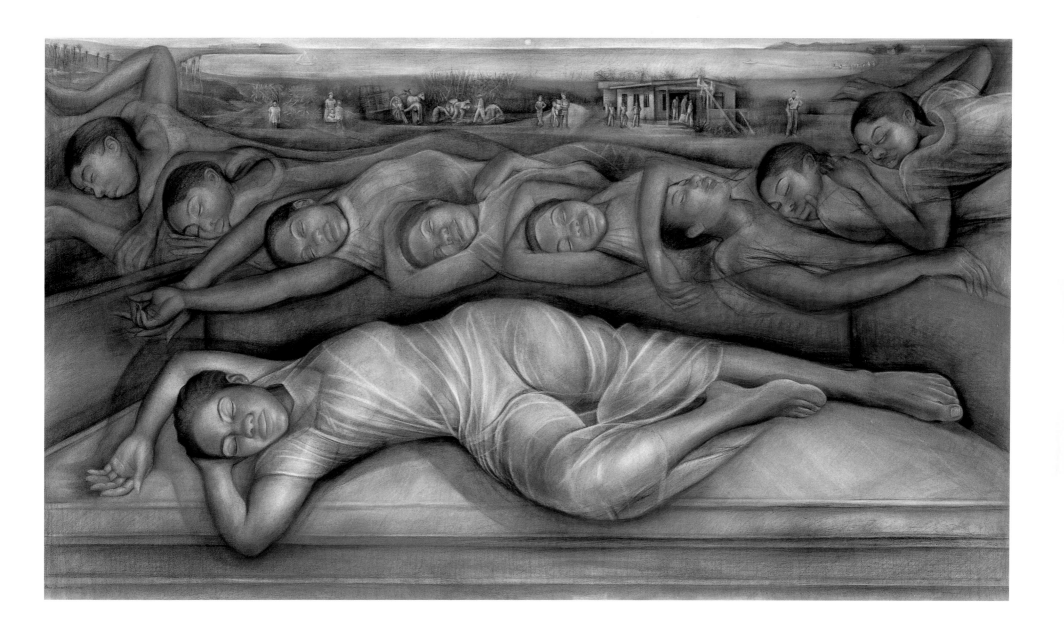

JANUARY LIGHT
1983
Conté crayon, colored pencil, pastel
43⅞″ × 29⅜″
The Martin Luther King
Labor Center, New York

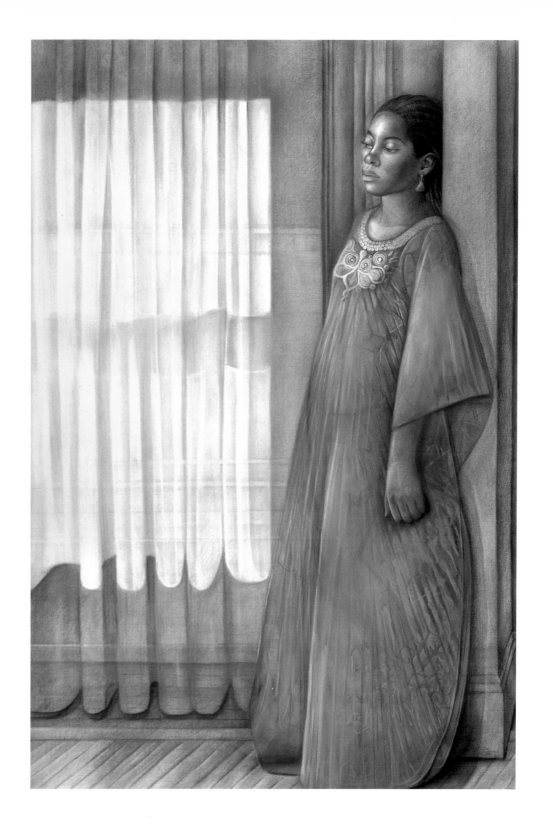

THE QUIET WOMAN
1988
Conté crayon, colored pencil, pastel
30⅛″ × 43½″

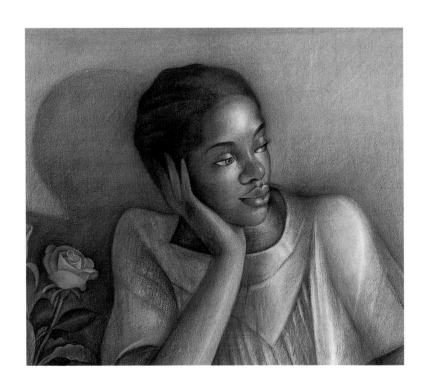

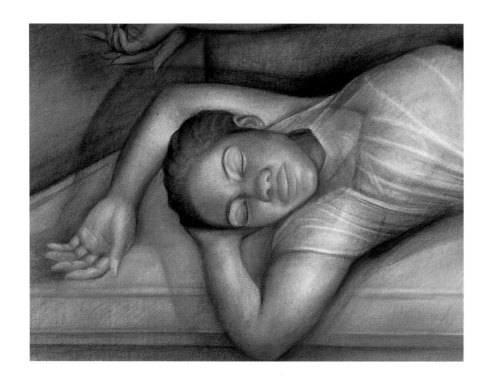

LATE AFTERNOON
Detail

IN SLEEP
Detail

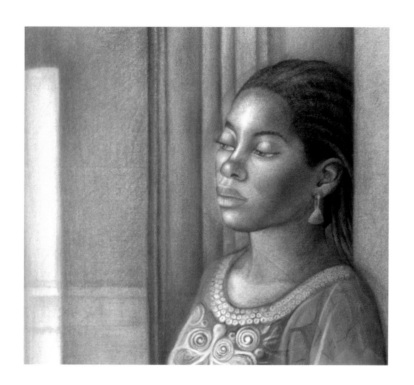

JANUARY LIGHT
Detail

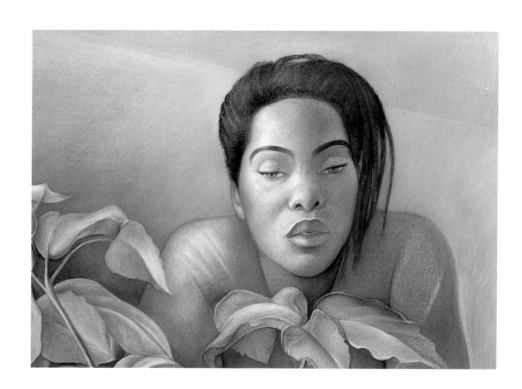

THE QUIET WOMAN
Detail

›› *page 188*
Night
1985
Conté crayon, colored pencil,
pastel, crayola, oil pastel
36½″ × 76⅜″

Red Pears
1987
Conté crayon, colored pencil,
pastel, crayola, oil pastel
5½″ × 6⅜″
Reproduced to size
Lawrence and Ellen Benz,
Bronxville, New York

›› *pages 189–91*
Night
Detail

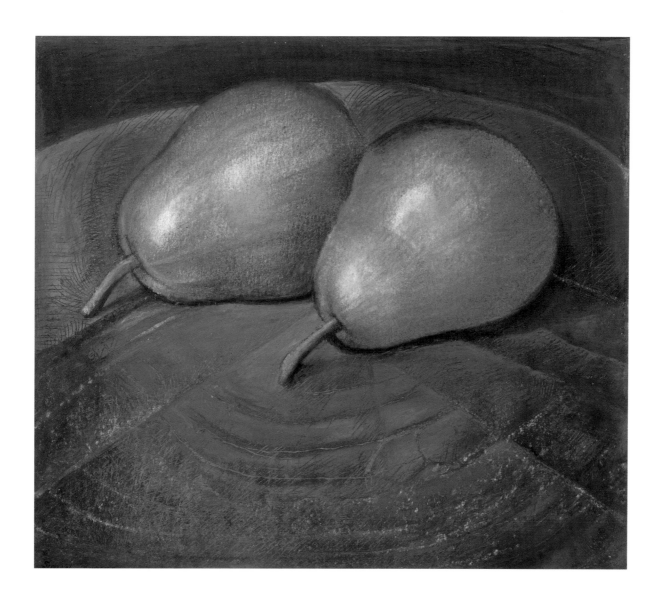

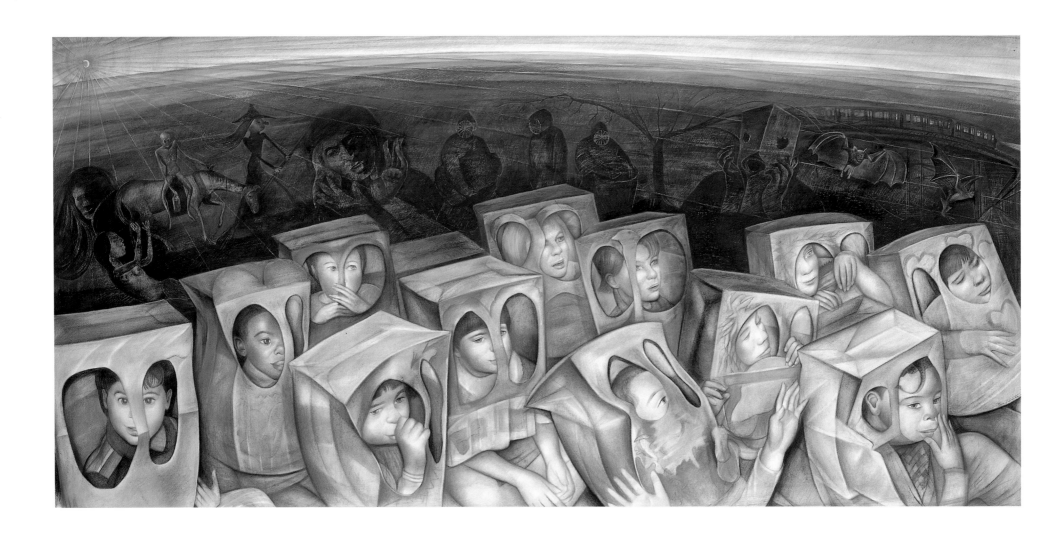

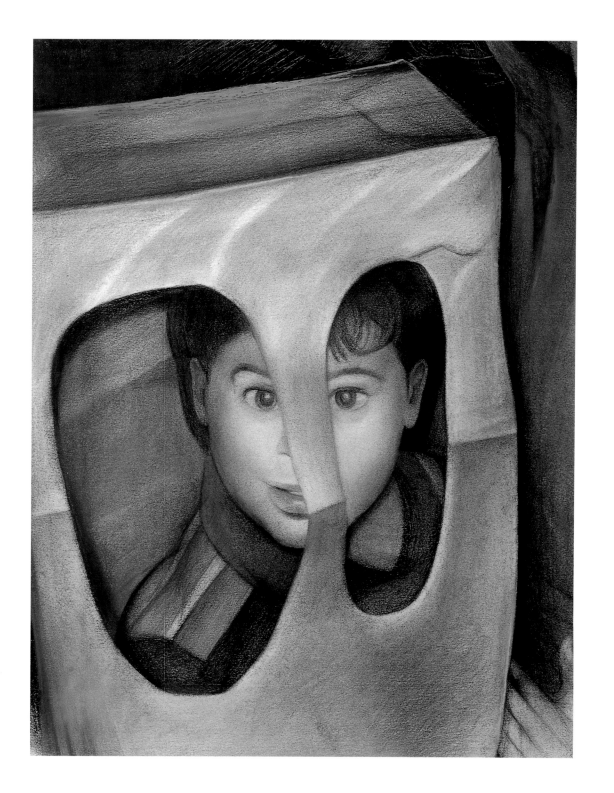

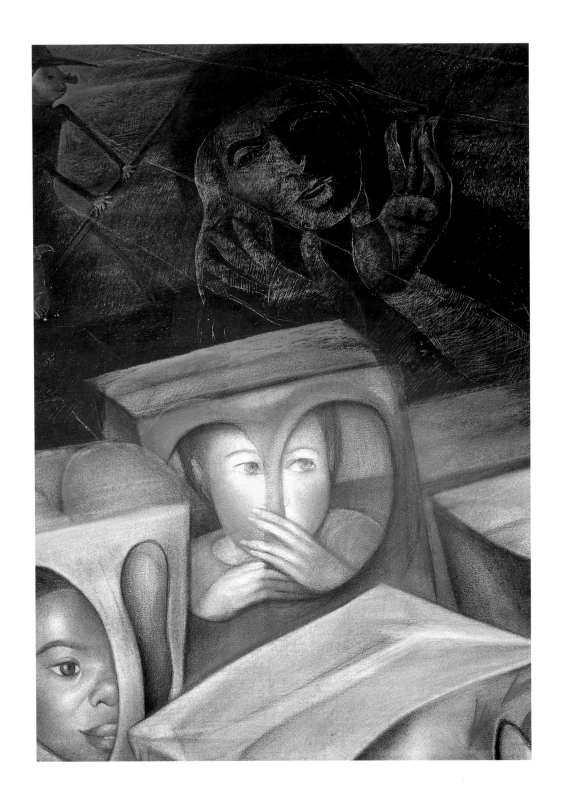

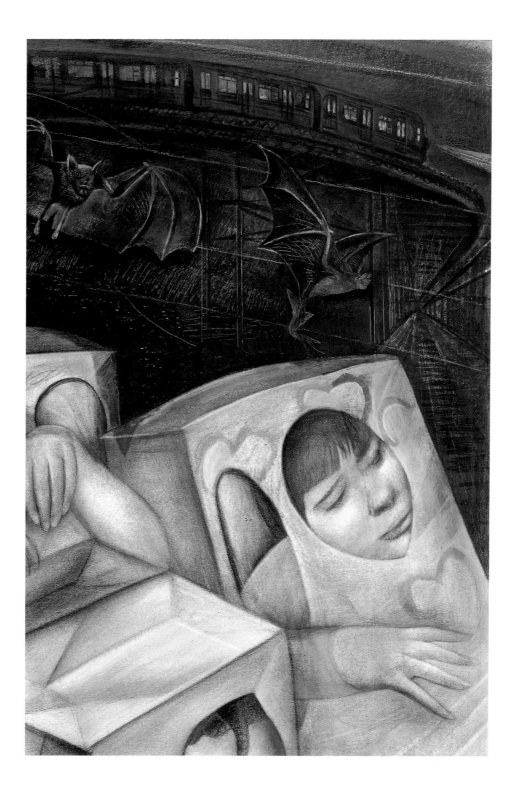

›› *page 194*
A DREAM PLAY
1986
Conté crayon, colored pencil, pastel
38¾″ × 82½″

›› *pages 195–97*
A DREAM PLAY
Detail

REFLECTION
1988–89
Conté crayon, colored pencil, pastel
11¼″ × 9″

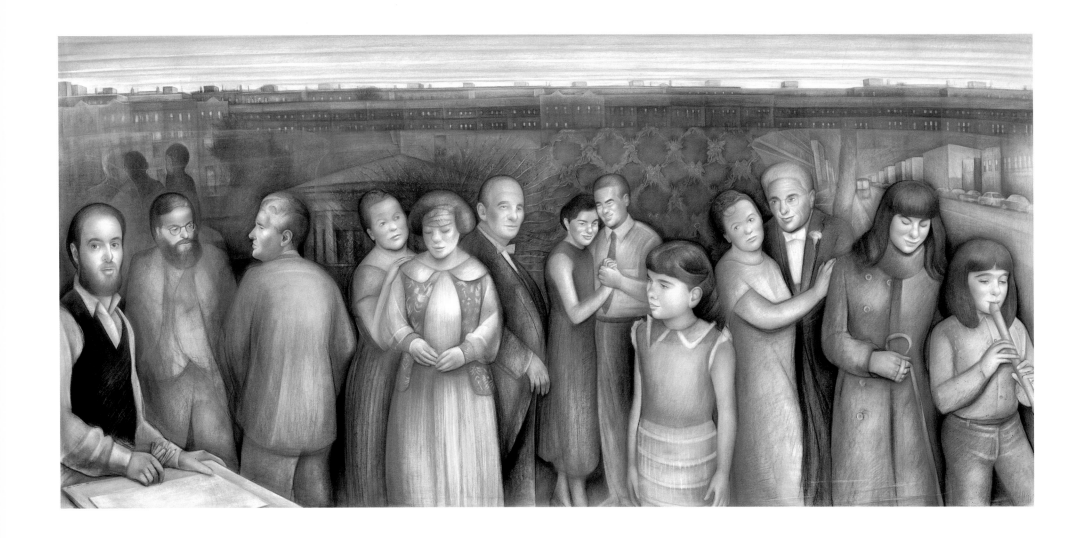

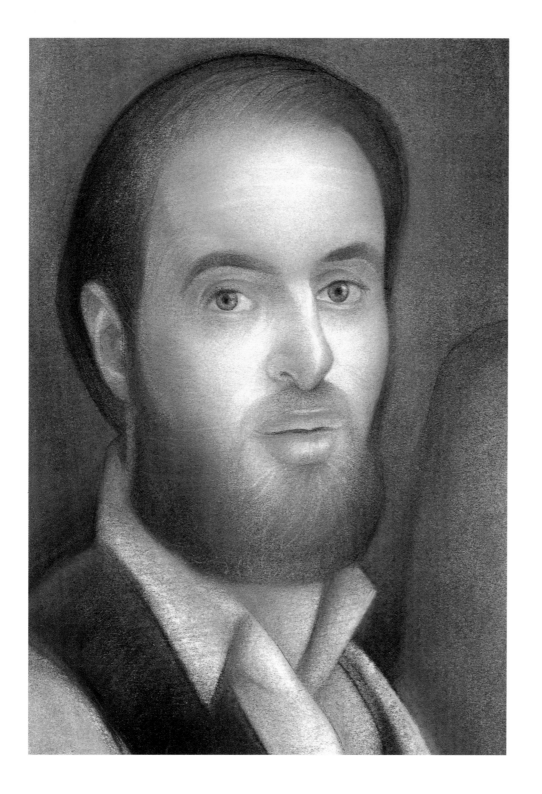

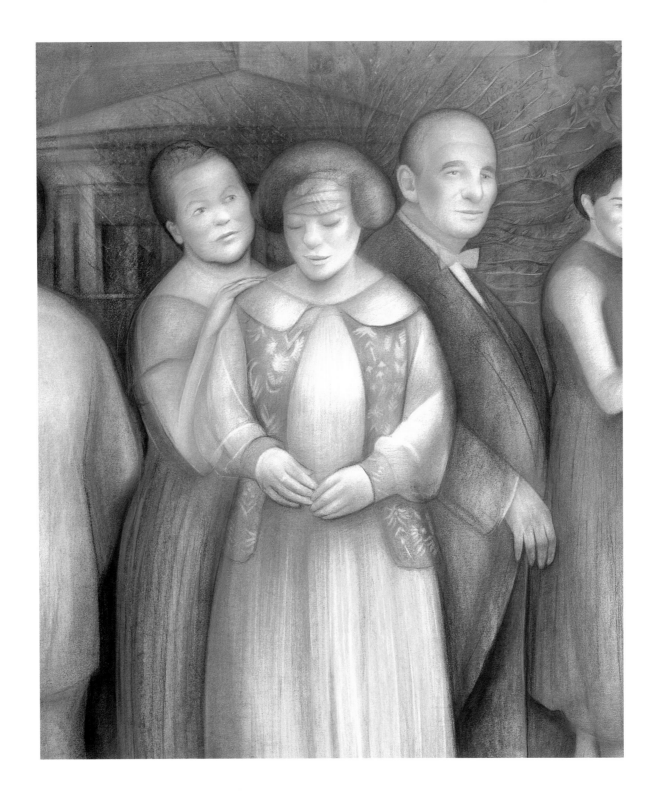

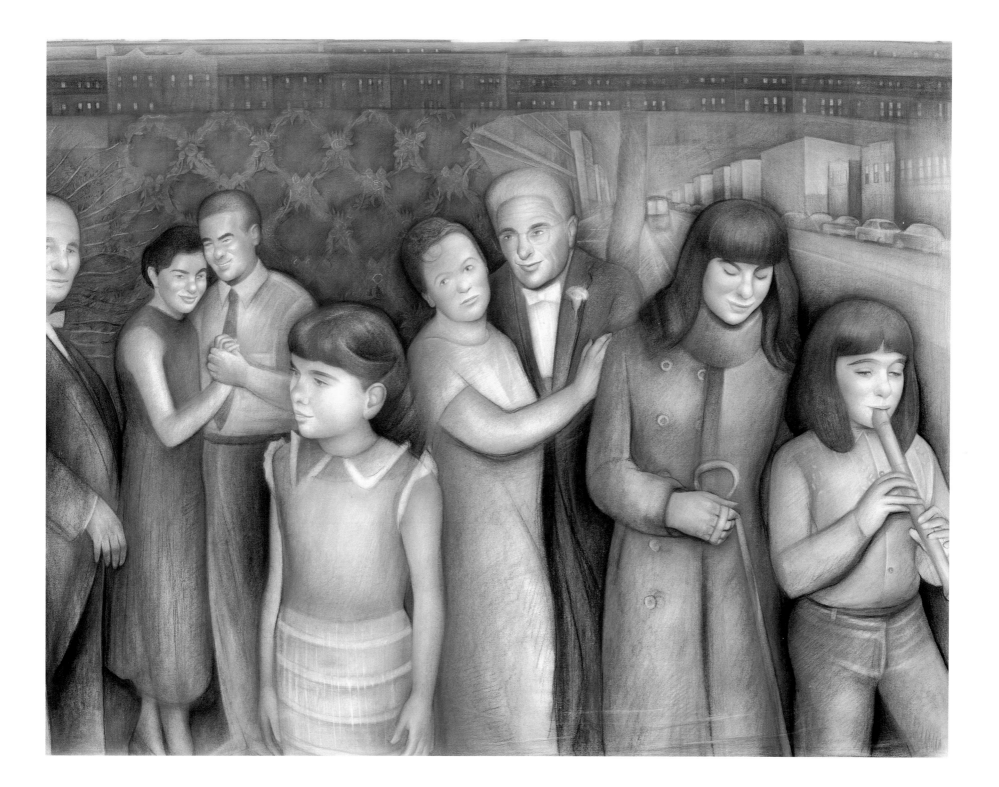

›› *pages 200–01*
Dream Palace
Detail

Dream Palace
1989
Conté crayon, colored pencil, pastel
25 ¼″ × 63 ¼″

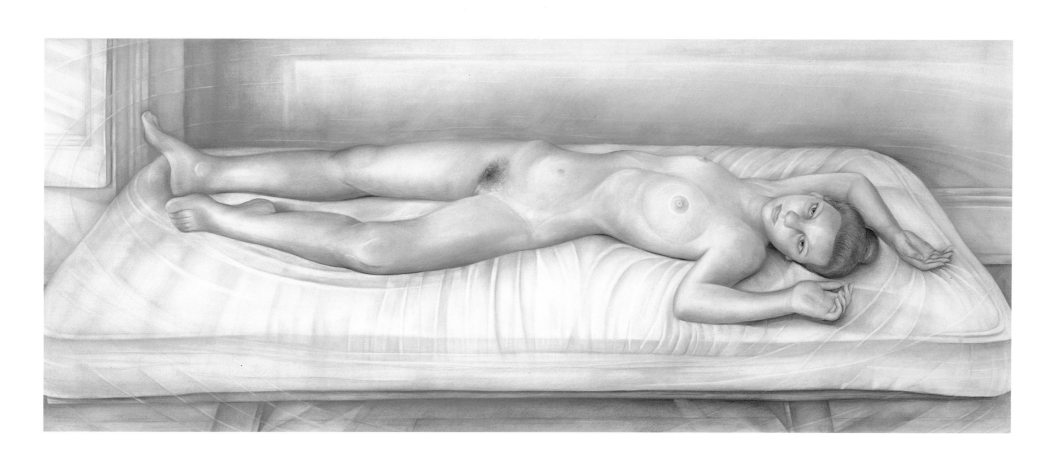

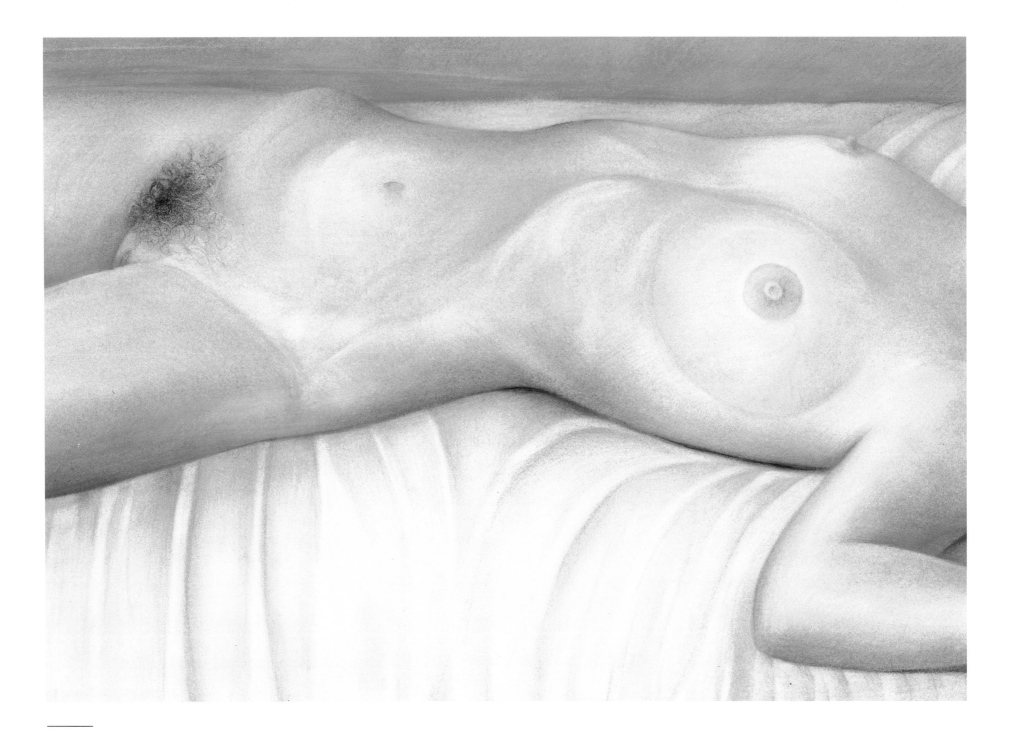

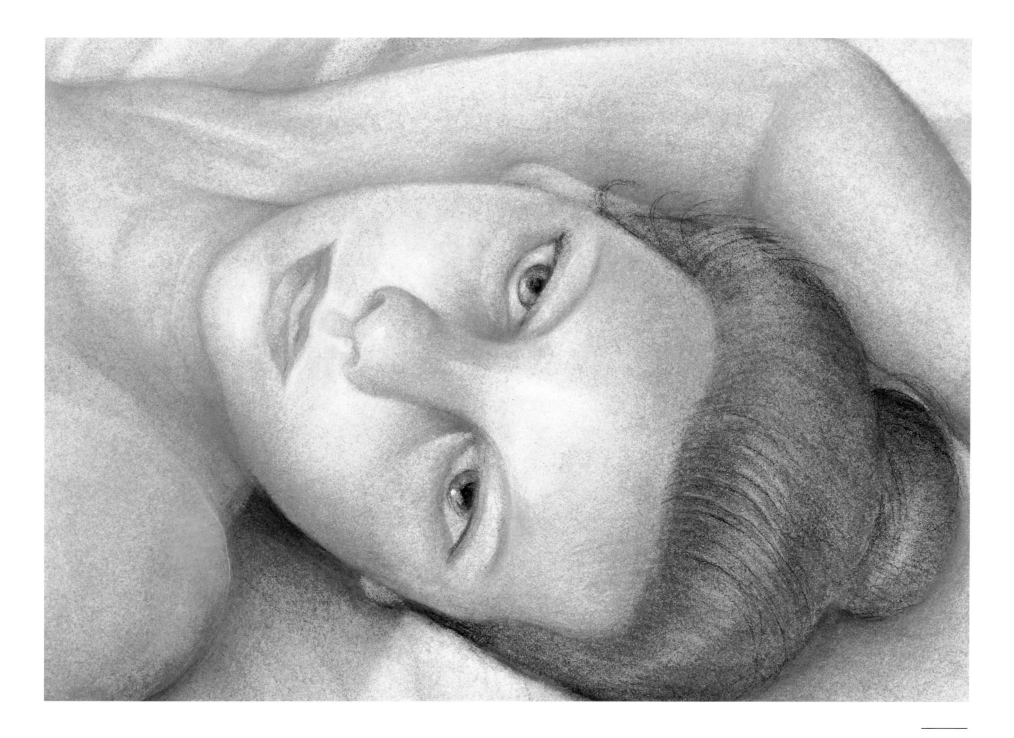

MINIATURE ROSES
1988
Conté crayon, colored pencil, pastel
8¾″ diameter

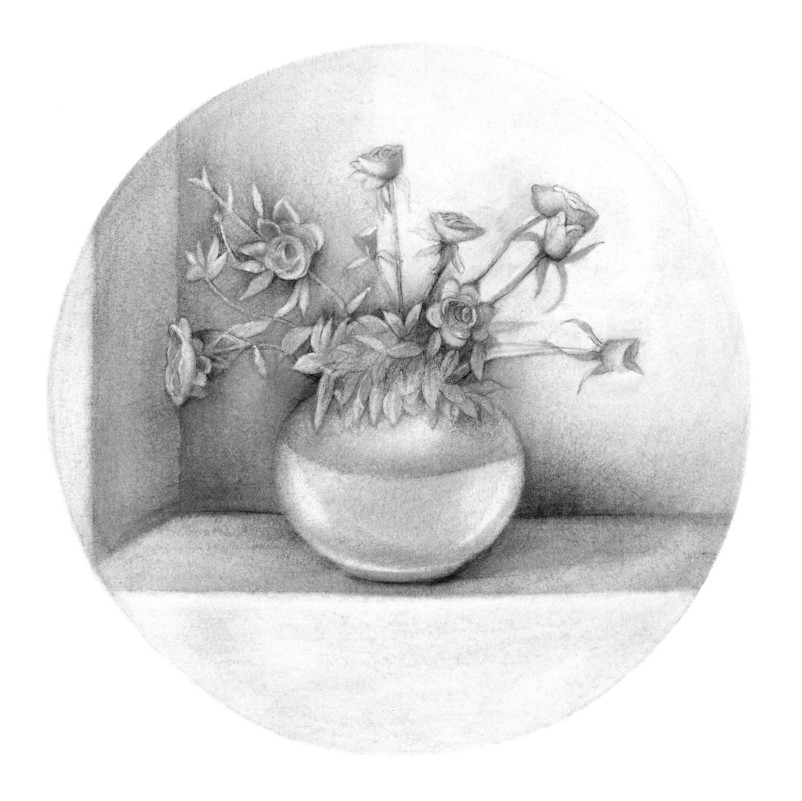

EMERGING ARTIST
1988–89
Conté crayon, colored pencil,
pastel, crayola, oil pastel
12⅝″ × 28½″

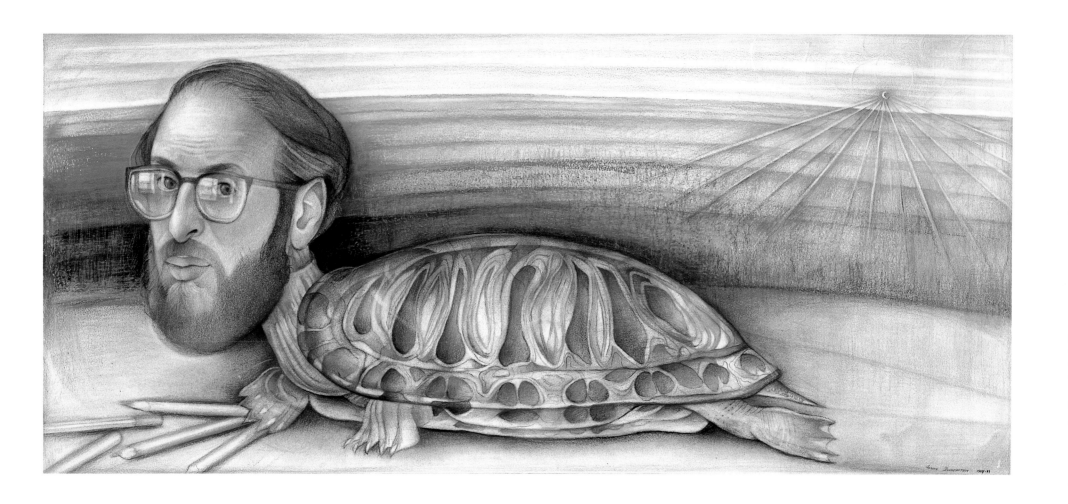

APPENDIX

IN DINNERSTEIN'S PAINTING,
AN ECHO CHAMBER

Simon Dinnerstein was born in Brooklyn in 1943, at a time when Germany was a foe to be overthrown at all costs. In 1970 that same Simon Dinnerstein went to Germany on a Fulbright scholarship. Fulbrights for Germany were easier to get than Fulbrights for France, Britain, or Italy, and Mr. Dinnerstein responded in any case to the ancient German tradition of exact plain statement in art.

He went to Kassel, a city not much visited by foreigners except in every fourth summer, when the "Documenta" exhibitions have attracted the international art world to Kassel for months on end. He lodged in the outskirts of the city, where the steeply pitched roofs of the postwar housing estate peter out one by one, and the seraphic landscape beyond is much as it was in Dürer's day.

It looked a dullish sort of place, by the standards of Manhattan. But dullness can concentrate the mind, and Mr. Dinnerstein began to paint and draw not only what was immediately in front of him but also himself, and his wife, and all the things that he had most loved in the way of past art.

It took him forever. Whether it would be ready for his show at the Staempfli Gallery, 47 East 77th Street, was long in doubt. The view from the paired windows would alone have been a year's work for many artists. Then there was the interior, with its floor-to-ceiling pinboard, its tableful of instruments shown in deep perspective, its seated portraits of the artist and of his wife with their small baby, and its encyclopedia of visual enthusiasms. Those enthusiasms included masterpieces of French and Italian painting in small-scale reproduction, air let-

ters, children's drawings, newspaper clippings and a big black letter "y," islanded on white paper. The completed picture measures 6 feet 7 inches by 13 feet.

Neither scale nor perseverance has anything to do with success in art, and Mr. Dinnerstein's triptych could be just one more painstaking failure. But it succeeds as an echo chamber, as a scrupulous representation of a suburb in the sticks, as a portrait of young people who are trying to make an honorable go of life and as an inventory of the kinds of thing that in 1975 give such people a sense of their own identity. Today is the last day of the show, but the triptych will be available to interested persons until further notice. It deserves to go to a museum.

John Russell
The New York Times
Saturday, February 8, 1975

415 First Street
Brooklyn, New York 11215
November 16, 1982

Mr. William Hull
Director
Art Museum
Penn. State University
University Park, Pennsylvania 06802

Dear Bill:

Phillip Bruno called me this past Friday to mention the news of the loan of the Triptych *to Penn. State University's Art Museum. I am very pleased about this wonderful news. I have a very special feeling for this painting and showing it in a public space is so exciting to me.*

Phillip mentioned your desire to have more information, details, and particulars about the painting. I feel somewhat at conflict about writing at great length in that there are so many words written about works of art. Moreover, the painting I have produced here is full of great layers of information dealing, as it were, with complex and subtle feelings, mysteries and "wonderment." What I would like therefore to do is spend a bit of time "free associating" about the picture. Art historians/iconographers would say that the artist "knew" great hulks of knowledge and painted out of this knowledge. I can say positively that a great deal of my thoughts regarding this work came to me after I started and also while I was finishing and during the years after! This fact is hard to understand, and I guess it is representative of the incredible complexity of psychology and thought and human motivation.

I started the painting in Germany (1971) while on a Fulbright (1970–71) and living in Hessische Lichtenau (QuentelerWeg 31) and attending an art school in Kassel, Germany, completing the picture, after three years of work, in a studio on Fourth Avenue and Twenty-fourth Street in Brooklyn. (My daughter was not born when the picture was started and was almost two years old when the work was finished.)

The imagery for the picture came to me "at one shot" in its totality! I mention this because it is a rare example of such insight; many artists work differently, myself included.

Following are a number of my thoughts: the over-all visual organization of the painting is an attempt to be abstract and formal as well as detailed and expressive; "perception" is a major theme, or the "grasping" of "what is out there" (the artist's attempt to "slow down" reality and "stop" or capture it); the presentation of tools and instruments and graphic utensils involving the measuring and the use of objectifying equipment as aides in this quest (i.e., Dürer-Melancholia); the sheer visual treat and joy in painting; the understanding of "forms of life," as in Wittgenstein's treatise on the difficulty or impossibility of language and visual identity; the various pictorial "excitements," such as other "forms of life"; the "humor" of a painting about a graphic artist (Fulbright-Graphics) and printmaker-engraver (gold leaf as copper plate), burins, engravers, etc; The Triptych was my "first" painting since being a student at the Brooklyn Museum (1964–67) and was the first time I had felt the need to express myself in paint—the time in between spent mainly on drawing and graphics (there is a "humor" in attempting a 14' "first" painting); the possibilities, mystery, and enigma and wonderful potential of "paint" with its own suppleness and beauty "as an end in and of itself"; there are the various contrasting themes of sophistication/children's drawings with paint becoming "crayon," "ink," "pen"; the duality of sophistication/naïveté as expressed in colors, but also indicative generally of an approach to the world, i.e., seeing it for the first time like a bubble that somehow can be grasped (as the "beads of knowledge" or glasperlenspiel of Magister Ludi); the organization of left and right; there are the "time" themes, as well as the sheer risk of "time," the "gamble" of time well spent to fulfill a work of art; the concepts of "seeing" vs. "perceiving" as a major theme (note the importance of the picture of two men in the right panel: "seeing" closely— "seeing" significantly vs. "seeing" closely and not seeing at all); the belief that art (in the Triptych*) is the visual counterpoint of the novel, i.e., the full measure of a man (art as a layered experience, complicated, design-oriented, enigmatic, but expressive internally as "thought" or "concept" or "idea"; ". . . the novel as a tremulation can make the whole man alive tremble. . . ."—D. H. Lawrence; the inspiration of such writers as Hardy, Mann, Dostoevski, Kafka to summarize, engulf, and "compel" a large experience of "weighted, rounded form," "fecundity," "full-bloodedness"; the use of paint as an illusion and paint (literally) as an internal vehicle toward an idea (abstraction) (thoughts of tromp l'oeil, a beautiful but limited realism); the belief in art as a "force" or "compulsion" (Starbuck/Whale—white heat and purity of form and thought); the ideas of "seriousness" and "humor" and in contrast causality and absurdity; an attempt to get at design concepts of deep space vs. close forms* *; the ideal of an ultimate viewing distance: up close vs. great distance, and optimally about 10–12' away so one can just take in the two exterior panels; an interest in peripheral "close space" vs. exterior distance, the intimate depiction of a family, as "idea," and as pinpointed and "held" in time, living together and striving to understand and "get at" what is "out there"; the use of triangulation* *as a*

design motif, or in other words, the triad, or the trinity of protection, harmony, and love and sensuality within; an interest in both internal and external movement; the rather personal and perhaps idiosyncratic theory of the "flying eye-ball ✎ "; the obsession with empiricism; the belief that paint can yield "spirit"; an organization and/or placement of the elements in the painting in terms of three, within which there is a division of "warm" exteriors and "cool" interiors ⊓ ⊓ ⊓ ; the very strong conviction that every individual has a need for identity and the search for one's axis; the very real conviction that a "seeking" life is the most meaningful in that it provides understanding (possibly indicative of the idea of "art as diary"); and ultimately the fact that we carry on alone, singly or single-minded, with this search— "grey and sweating/and only one I person/fighting and fretting." Gloria Mintz, 1965, age 13.

Ultimately it is really the visual impact of the experience of the art on the viewer that counts. I have been struck by the amount of time people spend looking at this particular painting. I do not know that this is truly an important criterion; i.e., whether this aspect really matters; I simply put it out as something I have observed, and it is rather odd and wonderful to see one's painting looked at (or "read") for 15–45 minutes.

For your practical information, the spacing should be about 3¾(–4)" (use your judgment) between the panels. The area allows for the floor board lines and general over-all perspective to line up.

Please feel free to use any or all of this information or to edit. I leave it to your good taste and judgment. Furthermore I would be curious to know how the painting is received— perhaps we could get together when you next visit New York. (I've two large drawings on exhibit now at the City Gallery, Columbus Circle—New York's Department of Cultural Affairs—announcement enclosed. I hope you would have time to see this work and that we could have a chat.)

So, again; I'm most excited!

Very sincerely,

Simon Dinnerstein

LOOKING AT

ONE'S OWN ARTWORK

In April and May of 1985, I was occupied with a large solo exhibit of my work at Gallery 1199 in the Martin Luther King Jr. Labor Center in New York City. The gallery is adjacent to the lobby of Local 1199, the Hospital and Health Care Employees Union. My father, Louis Dinnerstein, had been an active member of this union. I usually exhibit at Staempfli Gallery in New York City, but when this opportunity presented itself, especially with the large space available, I eagerly jumped at it.

Gallery 1199 is a non-profit space, so almost all of the preparations for the show were done by myself and an enthusiastic cadre of my students. Works arrived from various locations—private collectors; Pennsylvania State University; the law firm of Paul, Weiss, Rifkind, Wharton and Garrison; and the Sara Roby Foundation—on April 2, the day the show was to be hung. There were thirty-five pieces representing a fourteen-year span from 1971 through 1985. As one can imagine, the scene at the gallery when the works arrived was chaotic and most intense. Although I had produced the works, I had never really seen them all together.

In designing the show, I wanted to somehow separate the older work, mainly paintings, from the more recent series of drawings that had occupied me for the past four years. I was concerned with how the exhibit would hold together, since my work had changed during the fourteen years. Yet, even though my hand and eye had grown more sophisticated, there seemed to be a connective thread running through much of the work. A theme kept emerging: the interest in people—in the individual and in the dreams and mysteries, the visual information and enthusiasms that define human beings. I guess I am interested in art that attempts

to get at the full measure of a person. Something about D. H. Lawrence's statement that "the novel as a tremulation can make the whole man alive tremble" has always appealed to me.

The earliest painting in the show, *The Fulbright Triptych*, was begun in 1971 in Hessisch Lichtenau, near Kassel, Germany, where I had been living on a Fulbright Fellowship. At the time, I was quite interested in northern European art, and the influence of such artists as Holbein, Van Eyck, and Bellini is certainly there. Before going to Germany, I was mainly drawing and the *Triptych* actually depicts the studio of a graphic artist. In the center panel, a copperplate is shown on a table surrounded by tools for engraving—burins, scrapers, burnishers, etc. It is an enormous painting—about fourteen feet wide, counting the spacing between the panels—that shows the workshop of an artist involved in printing and drawing.

As with other images, I usually try to bring together some combination of abstract and design elements and the figure in an expressionistic context. Also, I like working with naturalistic images as a starting point. Elements of the *Triptych* did exist—the table, the views from the windows, and some of the pictures and instruments. These incidental and real elements became stepping off points for a more abstracted conception.

Many times artists work by instinct and "feel," and there are lines, elements, and themes that weave their way through a work of art in some secret and inexplicable way. The *Triptych* has a number of themes, some that I was not fully aware of until much later. On its most primary level, the painting deals with the artist and his world and family. The studio is shown, and underlying it are ideas of how perception and visual stimuli define us and give us our "axis," or understanding of the world. Images abound in this diverse, mysterious, playful, and irrational universe—reproductions of Holbein's *Portrait of Georg Gisze*; Seurat's drawing of his mother; Ludwig Wittgenstein's "forms of life"; a letter from my wife concerning an anxiety dream. The left panel shows my wife and daughter and various references to my wife's work as a teacher: children's drawings; a first day's writing assignment; a page of *o*s repeated many times; a fifth-grader's rendition of the effects of pollution on our environment; a big black letter *y* islanded on white paper. The right panel deals with my own associations—from a detail of Van Eyck's *Last Judgment* to a Soviet exit visa to a fire-spewing dinosaur. How amazing that so many associations having seemingly nothing to do with one another become part of one's consciousness.

As I looked around at my exhibit, I realized how strange and varied inspiration can be to an artist or, for that matter, how widely it may differ between artists.

For example, the imagery for *The Fulbright Triptych* came to me in its totality. There was only one study—in gold leaf for the copperplate on the table, since I was unfamiliar with the process of gilding. Many times, though, numerous studies preceded a large work of art, and in this show, I was able to display some of these studies, especially for the recent series of drawings.

Before discussing these latter works, it might be interesting to say something about the origins of the group. After completing the *Triptych* in 1974, I had my first solo exhibit (in 1975, at the Staempfli Gallery in New York City). During the following year, I was very fortunate to have received the Rome Prize Fellowship. I lived in Rome at the American Academy with my family from 1976 until early 1979. Returning to Brooklyn, I began teaching at both The New School for Social Research/Parsons School of Design and New York City Technical College. One of the classes that was especially interesting was "Life Drawing—the Figure and the Portrait." I had particular ideas for the class—about how it should be run and about the relationship between tradition and innovation. My drawings up to this point had been almost entirely in black-and-white mediums. But as I taught the class, I became fascinated with the students' use of Conté crayon in the warm brown colors, colored pencils, and pastels. It was really strange—one usually thinks of the teacher being in charge, but in this case, I watched the students work with mediums I had never worked with and learned from them.

For the recent group of drawings, I mainly worked with Rives BFK paper, which I used either by the sheet or mounted onto 100 percent rag board. To me, the appeal of the paper has to do with a number of its characteristics: it is very white; has a bit of "tooth"; is fairly heavy and can be given a good work over; and it is a wove paper and therefore more anonymous, having no pronounced texture or grain or line running through it. I am interested in a range of values in drawings, from the white of the paper to the rich, velvety deep dark of Conté crayon. The use of colored pencils (Cumberland-Derwent series) to give the luster and glow of oil is very appealing to me. Also, the pencils are not altogether different from those that my thirteen-year-old daughter draws with—an idea that appeals greatly to me.

The earliest of these drawings is *Nocturne for a Polish Worker* (1982), and here again the individual is depicted in his personal world. The man I was working with and what I wanted to communicate became so complex that somehow the broken-space, or collaged, reality seemed natural, especially as a way of dealing with the subject's memory and dreams. In considering this drawing, I wondered about the "baggage" we take with us—in terms of associations with the past, loyalties to some location or dream, irrational pushes and pulls, and secret ambiguous

longings. I want certain of my pictures, when the situation is right and natural, to address these thoughts and feelings. The same might be said for a drawing of my daughter called *About Strange Lands and People*. Somehow the dream imagery within the picture worked and was real, and thus enhanced the mood. The images seemed to pull out the "roundness" and "weight" of the person, just as the reproductions in the *Triptych* had done in a more naturalistic way.

Three of the most important recent works in this exhibit were of a young woman, Cheryl Yorke, who was a student of mine in an art appreciation class at New York City Technical College. This was an invigorating and challenging class, and it gave me a chance to talk about various periods and styles of art to young art students. One day, I noticed that one of the black students had come into class with small, delicate shells braided into her hair. Her beauty and grace had me totally transfixed. I enjoy using friends or chance acquaintances as models rather than professionals, so I asked her if she would pose for a portrait class. She agreed and modeled for my classes a number of times. It was advantageous and helpful for me to observe her, and it gave me a point of view. I started the series with *Late Afternoon* and continued with *January Light*. She was wonderful to work with, having an abundance of inner peace and depth and a glow, and yet also an extraordinary outer, formal beauty. While working on the second piece, an image came to me of her asleep, with the moon somehow present. Incredibly to me, my preparatory studies for such a complicated work took five minutes. The drawing proceeded with such ease that at times it almost seemed to me that someone was drawing along with me or guiding my hand. In the Gallery 1199 exhibit, there was a good deal of comment about these three works, especially the last, *In Sleep*. Much of the discussion centered around the meaning of this work and the various interpretations that were offered—from plantation scene to migrant workers, to William Blake and Gothic entombments, to Caribbean mysticism and Mexican realism. Since all these ideas were interesting but at great variance with my vision, it made me wonder about how much the artist really knows about what he or she has created.

A large show such as that one had completely cleared my studio. As I sat in the empty room with light patterning itself on the bare walls, I mused about my new direction. I thought of how much I admired artists such as Balthus, Lucian Freud, and Antonio López García, and about the way that both tradition and the avant-garde work naturally and beautifully in their work. This combination is what I strove for—along with an art that was accessible in different layers and complicated images to a variety of viewers: to the people in my neighborhood, to the mailman, an art gallery director, an art historian, a writer, etc. I saw lots of possi-

bilities in the direction those recent drawings might take me. Being an artist is a kind of learning experience, an unconscious autobiography. I was eager, a little nervous, and most excited to see how the next few pages of my diary would unfold.

Simon Dinnerstein
American Artist
April 1986

AFTER INGRES (MADAM HAYARD)
1967
Pencil
6½″ × 5¼″

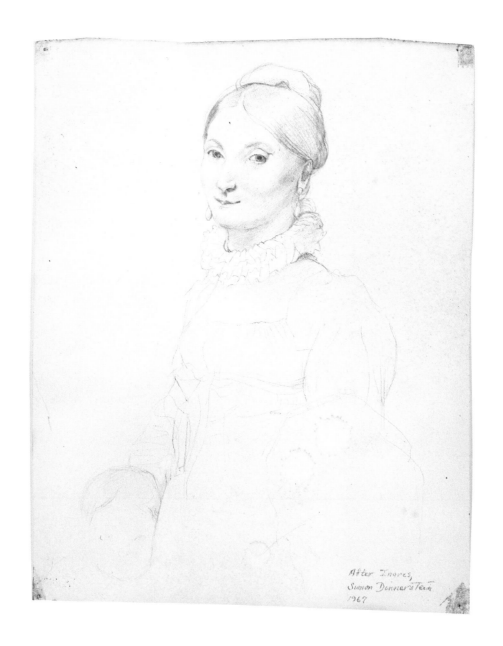

After Ingres,
Simon Denner's Teté
1967

‹‹

POLHEMUS PLACE
1969
Engraving
11¼″ × 12⅜″ (Edition 125)

›

TREE STUDY
1969
Engraving
3¹⁵⁄₁₆″ × 2³⁄₁₆″ (Edition 100)

ANGELA'S GARDEN
1970
Engraving
11 ¾″ diameter (Edition 125)

Study
NIGHT SCENE I
1982
Conté crayon, colored pencil
5 ³⁄₈″ × 3 ½″
Reproduced to size
Dr. Jeanne Fenner,
Brooklyn, New York

Study
NIGHT SCENE I
1982
Ballpoint pen
2 ³⁄₈″ × 3 ½″ (ext.)
2 ⅛″ × 3″
Reproduced to size

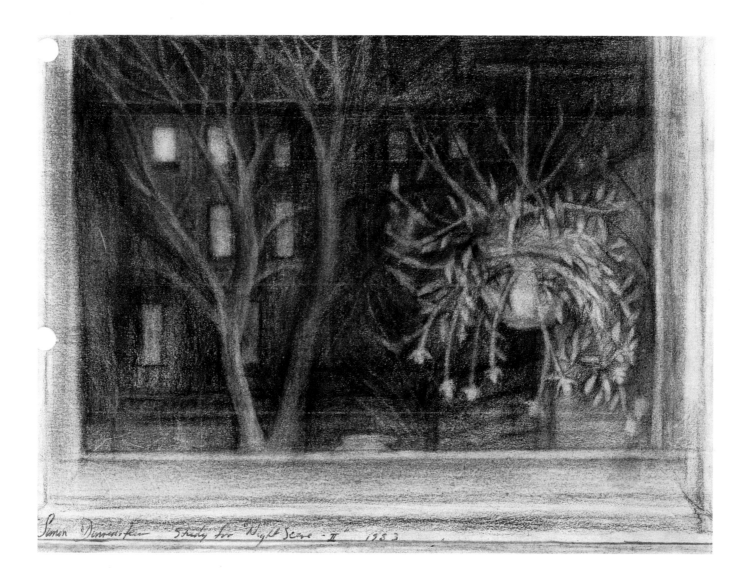

Study
NIGHT SCENE II
1983
Conté crayon
5⅜″ × 8¼″

for Salomón Mikowsky
with best wishes
Simon Dinnerstein 9·8·83

››

Study
STUDIO TABLE
1976
Charcoal, conté crayon
12⅜″ × 16¼″
Phillip A. Bruno,
New York

‹‹

Study
BOUQUET IN WINTER LIGHT
1980
Oil on canvas
7⅞″ × 10″
Dr. Solomon Mikowsky,
New York

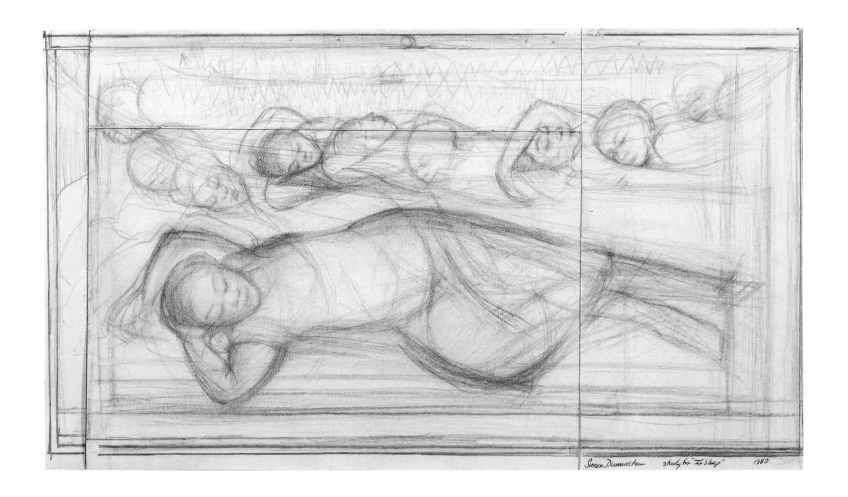

Study
In Sleep
1983
Conté crayon, colored pencil
6⅝″ × 10⅞″
Dr. Jeanne Fenner,
Brooklyn, New York

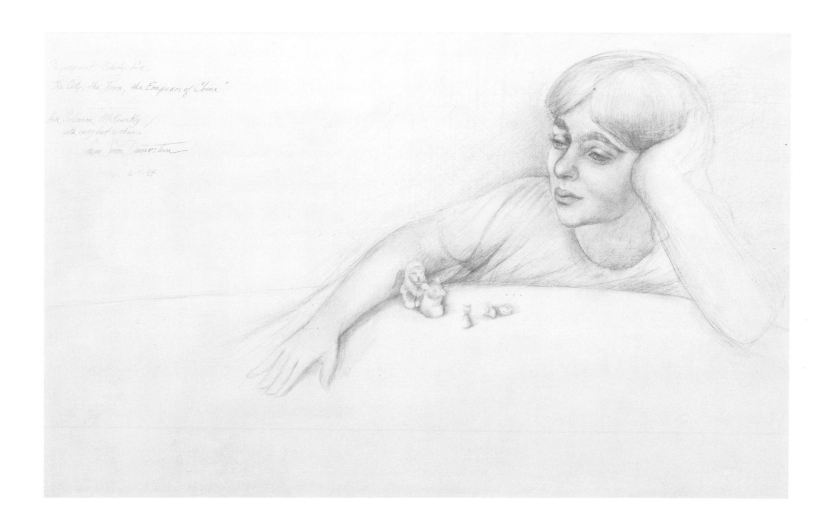

Study
THE CITY, THE TOWN, THE EMPEROR OF CHINA
1984
Silverpoint
10⅜″ × 17⅛″
Dr. Solomon Mikowsky,
New York

Study
GOLDEN MUMS
1988
Conté crayon, colored pencil, pastel
5¼″ × 8¼″
Reproduced to size
Elaine and Robert Jacobson,
New York

Study
Mid-Summer
1987
Conté crayon, colored pencil, pastel
5 ³⁄₈″ × 7 ⁵⁄₈″
Reproduced to size
Elaine and Robert Jacobson,
New York

Study
DUET
1989
Ballpoint pen
3″ × 5″

Study
DUET
1989
Ballpoint pen
2¾″ × 4¹³⁄₁₆″
3⅜″ × 6⅞″ (ext.)

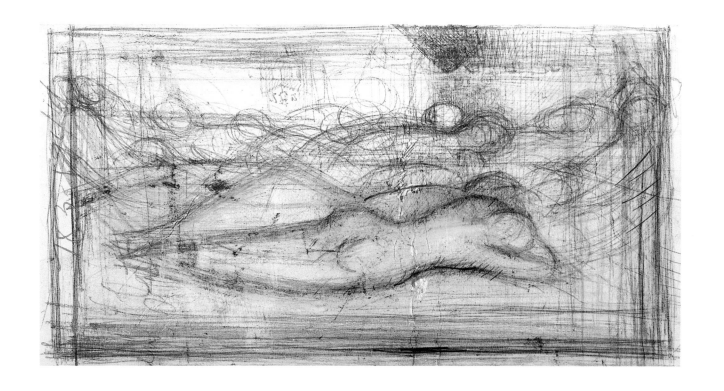

Study
LOVERS
1989
Ballpoint pen,
traces of colored pencil
3¾″ × 7½″

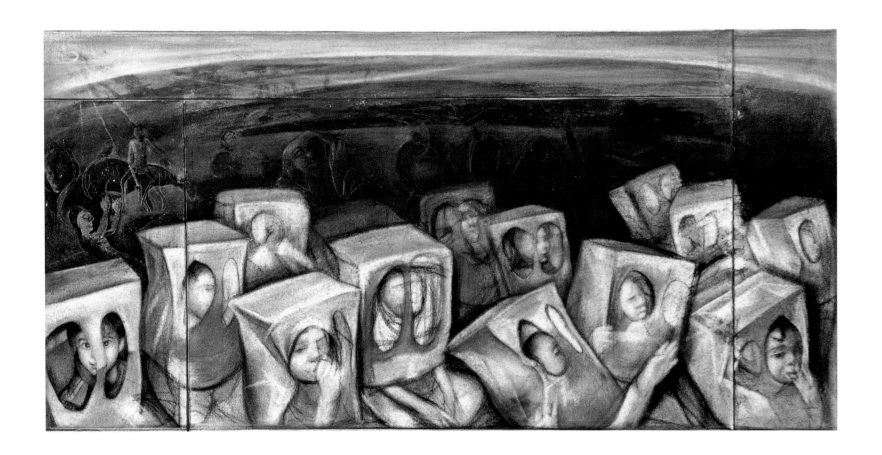

Study
NIGHT
1985
Conté crayon, colored pencil,
pastel, crayola, oil pastel
10″ × 21″
Ines and Enrique Weiss
Queens, New York

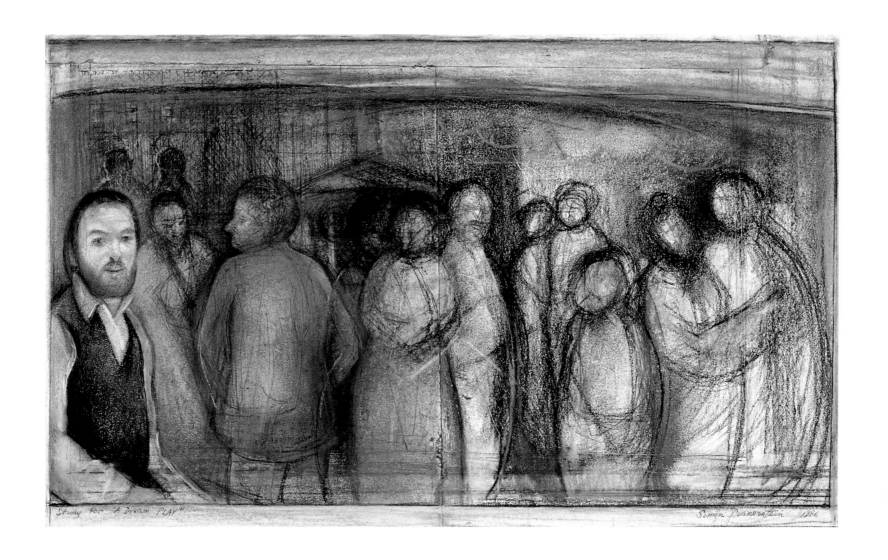

Study
A DREAM PLAY
1986
Conté crayon, colored pencil, pastel
6⅜″ × 11¼″

CHRONOLOGY AND

BIBLIOGRAPHY

CHRONOLOGY

1943	Born February 16, in Brooklyn, New York.
1965	B.A., history, The City College of New York.
1964–67	Studies painting and drawing at The Brooklyn Museum Art School with Louis Grebenak, David Levine, and Richard Mayhew.
1965	Marries Renée Sudler, August 28.
1970–71	Studies on a Fulbright grant (Graphics) in Germany. Resides in Hess. Lichtenau, near Kassel in north-central Germany and attends the Hochschule für Bildende Kunst in Kassel.
1972	Daughter, Simone Andréa born, September 18.
1975	First one-man exhibit (Staempfli Gallery, New York).
	Member of the faculty, The New School for Social Research/Parsons School of Design, New York–.
1976–78	Lives in Italy on a Rome Prize Fellowship (Painting) to the American Academy in Rome (Lazarus Fellow, Metropolitan Museum of Art).
1979	Lectures for USIS (United States Information Service) in Barcelona and Madrid, Spain.
	Adjunct lecturer, New York City Technical College (CUNY) Brooklyn, New York–.
1984	Lectures at the Palmer Museum of Art, Pennsylvania State University, University Park, Pennsylvania.
1986–87	Visiting professor (Drawing), Pratt Institute, Brooklyn, New York.
1987	Artists Fellowship (Drawing), New York Foundation for the Arts.
1988–89	Visiting artist, The Calhoun School, New York, spring semesters.
	Presently resides in Park Slope, Brooklyn, with his wife and daughter.

AWARDS

Cannon Prize, 163d Annual Exhibition, National Academy of Design, 1988

Artists Space Grant, 1987

New York Foundation for the Arts Fellowship in DRAWING, 1987

Artists Space Grant, 1985

Stefan Hirsch Memorial Award, Audubon Artists, New York, 1984

Artists Space Grant, 1983

MacDowell Colony Fellowship, 1979

Childe Hassam Purchase Award for Painting, American Academy of Arts and Letters, 1978

E. D. Foundation Grant, for study at the American Academy in Rome, 1978

Ingram Merrill Award for Painting, Ingram Merrill Foundation, 1978–79

Rome Prize Fellowship, American Academy in Rome, 1976–78 (Lazarus Fellow, Metropolitan Museum of Art)

E. D. Foundation Grant, for study at the American Academy in Rome, 1977

Childe Hassam Purchase Award for Painting, American Academy of Arts and Letters, 1977

Louis Comfort Tiffany Grant, 1976

Childe Hassam Purchase Award for Painting, American Academy of Arts and Letters, 1976

Purchase Award, DRAWINGS USA, Minnesota Museum of Art, 1975

Honourable Mention, Edwin Austin Abbey Fellowship for Mural Painting, National Academy of Design

Fulbright Fellowship, Germany, in Graphics, 1970–71

MacDowell Colony Fellowship, 1969

Purchase Award, DRAWINGS USA, Minnesota Museum of Art, 1968

First Prize, Brooklyn Museum of Art Exhibition, 1967

Scholarship to The Brooklyn Museum Art School, 1964–67

ONE-MAN EXHIBITIONS

1988	Staempfli Gallery, New York
1987	Pratt Institute, Brooklyn
1985	Gallery 1199, The Martin Luther King Labor Center, New York
1981	The New School for Social Research, New York

1979	Institute of International Education, United Nations Plaza, New York
	Staempfli Gallery, New York
1977	American Academy in Rome, Via Angelo Masina 5, Rome, Italy
1976–77	*The Fulbright Triptych*, Institute of International Education, New York
1975	Staempfli Gallery, New York

PUBLIC COLLECTIONS

National Museum of American Art, the Smithsonian Institution
Sara Roby Foundation, New York
The Martin Luther King Labor Center, New York
Palmer Museum of Art, Pennsylvania State University, University Park, Pennsylvania
Minnesota Museum of Art, St. Paul, Minnesota
The Art Gallery, University of Maryland, College Park
Muncie, Williams, Proctor Institute, Utica, New York
Museum of Art and Archaeology, University of Missouri, Columbia, Missouri
Albrecht Art Museum, Saint Joseph, Missouri
Stephens, Inc., Little Rock, Arkansas
Paul, Weiss, Rifkind, Wharton and Garrison, New York
Vinson & Elkins, Dallas, Texas

SELECTED GROUP EXHIBITIONS

Flower Market, Rome, exhibit, lobby, Port Washington Library, Port Washington, New York, December 1, 1989 through March 31, 1990

A FIGURATIVE APPROACH; Simon Dinnerstein and students from The New School for Social Research/Parsons School of Design, Plandome Gallery, North Shore Unitarian Society, Plandome, New York, 1989

Berkshire Art Association, 1988 Exhibition of Works on Paper, The Berkshire Museum, Pittsfield, Massachusetts

163d Annual Exhibition, National Academy of Design, New York, 1988

Contemporary Silverpoint Drawing, Leslie Cecil Gallery, New York, December, 1987–January, 1988

Faculty Exhibit, New York City Technical College (CUNY), Brooklyn, New York, Grace Gallery, 1987

Modern American Realism, the Sara Roby Foundation Collection, National Museum of American Art, the Smithsonian Institution, Washington, D.C., 1987

3-Man Exhibit (with Chaim Gross and Bruce Dorfman)—Inaugural Exhibit. The New School Art Gallery, The New School for Social Research, New York, 1987

Berkeley Carroll Street School Centennial, Park Slope, Brooklyn, 1986

Foundation Faculty Exhibit, Schaeffler Gallery, Pratt Institute, Brooklyn, 1986

Audubon Artists, Award Winners Exhibit, Lever House, New York, 1986

The Art of Drawing IV, organized by Staempfli Gallery, travels to the Arkansas Arts Center, MacArthur Park, Little Rock, Arkansas, 1986

The Art of Drawing IV, Staempfli Gallery, New York, 1985

Faculty Exhibit, New York City Technical College (CUNY), Brooklyn, New York, Grace Gallery, 1985

Recent Acquisitions of the Sara Roby Collection, Fair Street Museum (Nantucket Historical Society), Nantucket, Massachusetts, 1984

The Art of Drawing III, Staempfli Gallery, New York, 1984

Gifts to the Museum of Art: A Selection, Palmer Museum of Art; The Pennsylvania Art University, University Park, Pennsylvania, 1984

The Art of Drawing III, organized by Staempfli Gallery, travels to the Arkansas Arts Center, MacArthur Park, Little Rock, Arkansas, 1984

"Flower as Image in Contemporary Art," Wave Hill, Bronx, New York, 1984

Brooklyn Botanic Gardens, President's Office and Members Gallery, exhibit of *Flower Market, Rome*, extended loan, January 17, 1984–

42d Annual, Audubon Artists, National Arts Club, New York, 1984

159th Annual Exhibition, National Academy of Design, New York, 1984

Brooklyn '84, Community Gallery, the Brooklyn Museum, 1984

Fifteenth Anniversary Exhibit, the Community Gallery, Brooklyn Museum, 1984

Paul, Weiss, Rifkind, Wharton and Garrison, New York, lobby and 32d floor, exhibit of *Flower Market, Rome*, 1983

Women in Definition, The First Women's Bank, New York, 1983

Born in Brooklyn, Rotunda Gallery, Brooklyn Borough Hall, 1983

New York Artists Who Teach, City Gallery, Department of Cultural Affairs, New York, 1982

Works on Paper, Berkshire Art Museum, Pittsfield, Massachusetts, 1982

Faculty Exhibit, New York City Technical College (CUNY), Brooklyn, New York, Grace Gallery, 1982

Staempfli Gallery Group Show, Staempfli Gallery, New York, 1982

Contemporary American Landscape, Taft Museum, Cincinnati, Ohio, 1981

Newhouse Gallery Invitational, Snug Harbor Cultural Center, Staten Island, summer
 1981
Brooklynworks, Grange Gallery, Carlisle, Massachusetts, 1981
Faculty Exhibit, New York City Technical College (CUNY), Brooklyn, New York, Grace
 Gallery, 1981
The New School Art Faculty, The New School Art Center, New York, 1981
"American Drawings in Black and White," the Brooklyn Museum, 1980–81
Figurative Artists of Park Slope, Henry Street Settlement, New York, 1980
Figurative Artists of Park Slope, the Brooklyn Museum, 1980
Faculty Exhibit, New York City Technical College (CUNY), Brooklyn, New York, Grace
 Gallery, 1980
155th Annual Exhibition, National Academy of Design, New York, 1980
The New School Art Faculty, The New School Art Center, New York, 1979
100th Anniversary Exhibit, the University of Texas, Austin, Texas, 1978
Childe Hassam Exhibition, American Academy of Arts and Letters, New York, 1978
'Incontri con Artisti Stranieri a Roma,' Rondanini Gallery, Rome, Italy, 1978
Annual Exhibit, American Academy in Rome, Rome, Italy, 1978
Staempfli Gallery Group Show, Staempfli Gallery, New York, 1977
Childe Hassam Exhibition, American Academy of Arts and Letters, New York, 1977
Drawing Invitational, Fine Arts Gallery of San Diego, San Diego, California, 1977
Annual Exhibit, American Academy in Rome, Rome, Italy, 1977
Childe Hassam Exhibition, American Academy of Arts and Letters, New York, 1976
Staempfli Gallery Group Show, Staempfli Gallery, New York, 1976
The New School Art Faculty, The New School Art Center, New York, 1976
Staempfli in Houston, Davis and Long Gallery, Houston, Texas, 1976
Henry Ward Ranger Fund Exhibition, National Academy of Design, New York, 1976
Staempfli Gallery Group Show, New York, 1975
"Award Winners from the Past Ten Years," The Brooklyn Museum, 1975
'Drawings—America,' Albrecht Art Museum, Saint Joseph, Missouri, 1975
DRAWINGS USA, 7th Biennial, Minnesota Museum of Art, 1975
Childe Hassam Exhibition, American Academy of Arts and Letters, New York, 1975
Staempfli in L.A., Ankrum Gallery, Los Angeles, California, 1975
"Twentieth Century Drawings," Skidmore College, Saratoga Springs, New York, 1975
"Living American Artists and the Figure," Palmer Museum of Art, Pennsylvania State
 University, 1974
"Indoors," FAR Gallery, New York, 1973
Staempfli Gallery Group Show, New York, 1973
Brooklyn Museum Art School Faculty Exhibit, Brooklyn Museum Art School, 1972
27th Annual Audubon Artists, National Academy of Design, New York, 1969

14th Drawing and Small Sculpture Show, Ball State University, Muncie, Indiana, 1968
DRAWINGS USA, 4th Biennial, Minnesota Museum of Art, Saint Paul, Minnesota, 1968
58th Connecticut Academy of Fine Arts Exhibition, Wadsworth Atheneum, Hartford, Connecticut, 1968
29th Annual Society of the Four Arts, Palm Beach, Florida, 1967

TEACHING

The Calhoun School, New York, Artist in Residence, 1988, 1989
Visiting Professor (Drawing), Pratt Institute, Brooklyn, New York, 1986–87
New York City Technical College (CUNY), Brooklyn, New York (adjunct instructor), 1979–
The New School for Social Research/Parsons School of Design, New York, 1975–76, 1979–
The Brooklyn Museum Art School, 1972–73

LECTURES

Port Washington Public Library, Port Washington, New York, 1990
Palmer Museum of Art, Pennsylvania State University, 1984
Madrid and Barcelona, Spain, for USIS (United States Information Service), 1979
American Academy in Rome, 1977, 1978

ARTICLES
AND REVIEWS

Abrams, Ruth D. "Previews—Simon Dinnerstein: Staempfli Gallery." *Pictures on Exhibit*, New York, February 1975, p. 11. Reproduction of *Mansard Kitchen*.

Alequín, Rafael Martinez. "Simon Dinnerstein: People's Artist." *Brooklyn Free Press*, May 27, 1988, pp. 12, 13, and cover. Reproduces *Fifteenth Summer, A Dream Play, Late Afternoon, In Sleep.*

André, Michael. "Simon Dinnerstein." *Art News*, March, 1975, pp. 112, 113, 114. Reproduces the left panel of *The Fulbright Triptych.*

Art World. "Exhibitions." February 16/March 16, 1979, vol. 3, no. 6, p. 12. Reproduction of *Flower Market, Rome.*

Attenzione Magazine, New York. "Views and Reviews: Simon Dinnerstein at The New School." July, August, 1981, p. 24. Features a reproduction of *Flower Market, Rome.*

Basescu, Nancy. "Simon Dinnerstein, Artist-in-Residence." Newsletter of The Calhoun School, New York, Spring 1988, p. 13. Reproduction of *A Dream Play.*

Boies, Elaine. "Newhouse show an affair by invitation only." *Staten Island Advance*, July 10, 1981, p. B 3. Reproduction of *Two Musicians.*

Bonati, Charles. "BAA show: works on paper." (Berkshire Art Association), the *Berkshire Eagle*, October 6, 1988, p. C 3, B 10.

Breslow, Stephen P. "Art/ 'Newhouse Invitational' powerful, probing, shocking." *Staten Island Advance*, July 17, 1981, p. C 5.

Brooklyn Hispano. *"Nueva Exhibicion per artistes de Brooklyn en el Muse de Brooklyn."* Febrero, 1984, p. 12. Reproduction of *In Sleep.*

Brooklyn Museum Calendar, "Interior/Exterior: Figurative Artists of Park Slope." May, 1980. Highlights the painting *Gregory's Party.*

Bulletin, Friends of the Palmer Museum of Art, Pennsylvania State University, University Park, Pennsylvania, 1984. "What Friends Do, What You Can Do." Highlights *The Fulbright Triptych.*

Centre Daily Times, Pennsylvania. "Museum Acquires Triptych." December 16, 1982, p. C-2. Includes a discussion of and reproduction of *The Fulbright Triptych.*

Centre Daily Times, Pennsylvania. "Exhibit Features Recent Acquisitions." February 16, 1984, p. 6. Includes a discussion of and reproduction of *The Fulbright Triptych.*

Dinnerstein, Simon. "Looking At One's Own Artwork." *American Artist*, April, 1986, pp. 68–71, 98, 100, 101. Reproduces *About Strange Lands and People, The Fulbright Triptych, Nocturne, January Light.*

Fleminger, Susan. "Artists Return Home for Born in Brooklyn Exhibit at Rotunda Gallery." *Prospect Press*, July 7–20, 1983, p. 14. Highlights the drawing *Late Afternoon.*

Gruen, John. "On Art: Simon Dinnerstein." *The Soho Weekly News*, February 6, 1975, p. 12.

Hempel, Toby Anne. "Artists 'Born in Brooklyn' Return." *Canarsie Digest*, Brooklyn, New York, July 4, 1983, p. 4B.

Local 1199 News—Calendar, discussion of Simon Dinnerstein's One-Man Exhibit, March, 1985, p. 12. Reproduces *In Sleep.*

MacDowell Colony News, Spring, 1980, p. 4. Features a studio photo, including the paintings *Alexander Studio* and *Pansies, Peterborough.*

MUSE, Annual of the Museum of Art and Archaeology, University of Missouri-Columbia, no. 12, 1978. "Acquisitions, 1977." p. 13. Reproduces *In Sleep.*

Pennsylvania State University News, University Park, Pennsylvania. "Focus on the Arts: Museum Purchase." vol. 12, no. 8, December 16, 1982. Reproduces *The Fulbright Triptych*.

Phoenix, Brooklyn, New York. "This Brooklyn Museum Show Expands the Horizon of Community Art." pp. 9–11. Reproduces *In Sleep* on pp. 1, 11.

Russell, John. "In Dinnerstein's Painting, an Echo Chamber," the *New York Times*, February 8, 1975, p. 21 (reproduction of *The Kelton Press*).

Schiff, Bennett. "On a Roman hill scholars dwell in an estate of mind." *Smithsonian*, March 1978. Includes a studio photo, American Academy in Rome, featuring the artist, his daughter, the model, Teresa Gregorini, the paintings, *Flower Market, Rome, The Birthday Dress, Roman Afternoon*.

Sonenklar, Carol. "More Than Just People in the Art of Simon Dinnerstein." *Prospect Press*, Brooklyn, April 4–17, 1985, pp. 17, 18. Reproduces *Kim*.

Staempfli, George. Introduction for first One-Man Show, Catalog, Staempfli Gallery, 1975. Reproduces *Marie Bilderl, Mansard Kitchen, The Fulbright Triptych*.

Turetsky, Doug. "Simon Dinnerstein: Artist in the Round." *Brooklyn Affairs*, vol. 2, no. 3, April, 1985, pp. 6–7. Features numerous reproductions.

Weihs, Lina. "Dinnerstein Back From Rome." *Home Reporter and Sunset News*, Park Slope Edition, Park Slope, Brooklyn, February 23, 1979, p. P-2. Reproduces *Flower Market, Rome*.

Wolff, Theodore F. Review of the National Academy of Design's 163d Annual Exhibition. *The Christian Science Monitor*, April 25, 1988, p. 21.

Zagarese, Ezio, "*Simon Dinnerstein Espone ALL'ACCADEMIA AMERICANA-A-ROMA*," Gazzetta Di Mantova. 9 Ottobre, 1977, Pagina 3. Reproduces *Teresa*.

Romaine, Shirley. "Interview: Simon Dinnerstein." Art Scene on Long Island, Cable Vision, Channel 44 (August 22 and 23, 1989, 7–7:30 P.M.) and Channel 20 (November 13, 1989, 6:30–7 P.M.).

Brown, Clint. *Drawing from Life*. Holt, Rinehart & Winston, 1990. Reproduces *Arnold* and *Marie Bilderl*.

Acknowledgments

I want to thank Steven Tucker, who, over the course of the past few years and during an intense four-day session last May, took most of the photographs for this book. Steve's care, respect, and sense of perfectionism are much appreciated.

To the Fulbright Commission and the American Academy in Rome, which respectively provided sponsorship for a year's study in Germany and a two-and-a-half-year stay in Italy, I owe deep gratitude. This time was precious, invigorating, and deeply challenging. I would also like to mention the Ingram Merrill, Louis Comfort Tiffany, and E. D. foundations, whose additional financial support made my fellowship to the American Academy in Rome possible. With real dignity, the Macdowell Colony also allowed for wonderful support, time, and space when it was most needed. Note should also be made of the fine training I received at the Brooklyn Museum Art School, where I studied on a scholarship. My teacher, Louis Grebenak, is fondly remembered for opening me up to the beauty of abstract form in art and for introducing me to the work of the French artist, Ingres.

Appreciation to Antonio López García, a deeply inspired artist, whose show in 1968 taught me a great deal about "modernism" and being a figurative artist. His work and example stretched the possibilities of the subject in a work of art into a deeply personal terrain, highly poetic, somewhat uncategorical, certainly non-academic. In this context, recognition to George Staempfli, who, in what I would like to think of as an act of extraordinary daring, bought a large unfinished work of mine, *The Fulbright Triptych*, and entirely financed its completion over the next two years. This singular action, highly encouraging and dramatic, literally turned around the early stages of my career. Thanks also to Philip Bruno, long-time co-director at Staempfli Gallery, for his help and care in representing my work.

Acknowledgment should also go to The New School for Social Research/Parsons School in New York where I have taught since 1975. I have grown so much during this period because of the very talented, demanding, and interested students I have encountered both at the school and privately. Mention should be made of the numerous friends and models who have posed for me over the years. They have taught me a great deal about life and their generosity of spirit has truly affected my art. A few, Cheryl Yorke, Teresa Gregorini, Arnold Friedman, and Simone Dinnerstein should be noted in particular.

To the late Ernst Tritsch, I owe special thanks for his advice and encouragement. Thanks also to William Hull, Director Emeritus of the Palmer Museum of Art, Pennsylvania State University, for his very personal involvement with my work. I am grateful to Peter Nevreaumont for his advice and intelligence regarding questions connected with publishing and layout. Also, thanks to Mickey Swee and Barth Healey for their all-purpose support and comradery.

One could not have a better friend over these past twenty-five years than Howard Zuckerman. His is a rare combination: intellect, humor, curiosity, integrity. He is probably the personification of the idea that one really great friend is more meaningful than many acquaintances.

I am indebted to my brother and sister-in-law, Harvey and Lois Dinnerstein, artist and art historian, for their personal honesty, sense of values, and love of art; they have served as "significant others." In a like manner, I wish to acknowledge the memory of my parents, Louis and Sarah Dinnerstein, who gave me so much through their example. Though ostensibly located in the middle class, somehow they seemed almost oddly bohemian in their "apartness" from the prevailing trend toward consumerism and materialism.

Thanks to the staff at The University of Arkansas Press, and especially John Coghlan, director of production, who took such personal care in coordinating the development of this book. I appreciate the efforts of my editor, Scot Danforth, who worked so thoughtfully on the text. Special thanks to Chiquita Babb for the clear and beautifully designed format she provided for my pictures. For Miller Williams, distinguished poet and director of the Press, deep gratitude for encouraging me to undertake this very complicated and emotional project. Also, to Miller, for his personal commitment to art and poetry that goes past veneer into a much deeper realm.

Not quite last, for my daughter Simone, who has, with her sensitivity, intellect, and special love of music, taught me so much about life. She has helped me to "listen" as well as to "see," and she proves to be a constant source of inspiration.

Finally, for my wife, Renée; I could not imagine a luckier day than the one in which I first met her. My work and life would never have become what it has but not for her warmth, insight, imagination, and love. For her, this book is dedicated.

Simon Dinnerstein
Brooklyn, New York
November 1989

LIST OF PHOTOGRAPHERS

Mid-Summer—Steven Tucker
The Kelton Press—Peter A. Juley and Son
Tree Study—Peter A. Juley and Son
Windows #1—Steven Tucker
From Naoko's Window—Peter A. Juley and Son
1:30 at Dave and Nancy's—Peter A. Juley and Son
Garfield Place, Brooklyn—Steven Tucker
MacDowell Window—Peter A. Juley and Son
Windows #3—Peter A. Juley and Son
Roxbury Summer—Bruce C. Jones
Pat—Steven Tucker
Angela's Garden—Steven Tucker
Windows #2—Peter A. Juley and Son
N's Kitchen—Bruce C. Jones
Renée—Peter A. Juley and Son
Bruno's Motor—Peter A. Juley and Son
Mansard Kitchen—Peter A. Juley and Son
German Vegetables—Peter A. Juley and Son
Marie Bilderl—Peter A. Juley and Son
8th Month—Steven Tucker
9th Month—Steven Tucker
Arnold—Detail—Steven Tucker
Arnold—Steven Tucker

The Quiet Woman—Steven Tucker
Red Pears—Steven Tucker
Night—Eric Pollitzer
Night—Detail—Steven Tucker
Night—Detail—Steven Tucker
Night—Detail—Steven Tucker
Reflection—Steven Tucker
A Dream Play—Steven Tucker
A Dream Play—Detail—Steven Tucker
A Dream Play—Detail—Steven Tucker
A Dream Play—Detail—Steven Tucker
Dream Palace—Steven Tucker
Dream Palace—Detail—Steven Tucker
Dream Palace—Detail—Steven Tucker
Emerging Artist—Steven Tucker
After Ingres (Madam Hayard)—Steven Tucker
Polhemus Place—Steven Tucker
Tree Study—Steven Tucker
Angela's Garden—Steven Tucker
Study, Night Scene I—Steven Tucker
Study, Night Scene II—Steven Tucker
Study, Bouquet in Winter Light—Steven Tucker
Study, Studio Table—Steven Tucker
Study, In Sleep—Steven Tucker
Study, The City, the Town, the Emperor of China—Steven Tucker
Study, Mid-Summer—Steven Tucker
Study, Golden Mums—Steven Tucker
Study, Duet—Steven Tucker
Study, Duet—Steven Tucker
Study, Lovers—Steven Tucker
Study, Night—Steven Tucker
Study, A Dream Play—Steven Tucker
Reflection—Steven Tucker
Self-Portrait—Steven Tucker
Tree Study—Peter A. Juley and Son
Bruno's Motor—Peter A. Juley and Son
Miniature Roses—Steven Tucker

TITLE INDEX